PENGUI

Can we help it if we're
Fabulous?

Peter Mathia

Can we help it if we're Fabulous?

And other thoughts on being a woman

PETA MATHIAS

PENGUIN BOOKS

PENGUIN BOOKS
Published by the Penguin Group
Penguin Group (NZ), 67 Apollo Drive, Rosedale,
North Shore 0632, New Zealand (a division of Pearson New Zealand Ltd)
Penguin Group (USA) Inc., 375 Hudson Street,
New York, New York 10014, USA
Penguin Group (Canada), 90 Eglinton Avenue East, Suite 700, Toronto,
Ontario, M4P 2Y3, Canada (a division of Pearson Penguin Canada Inc.)
Penguin Books Ltd, 80 Strand, London, WC2R 0RL, England
Penguin Ireland, 25 St Stephen's Green,
Dublin 2, Ireland (a division of Penguin Books Ltd)
Penguin Group (Australia), 250 Camberwell Road, Camberwell,
Victoria 3124, Australia (a division of Pearson Australia Group Pty Ltd)
Penguin Books India Pvt Ltd, 11, Community Centre,
Panchsheel Park, New Delhi - 110 017, India
Penguin Books (South Africa) (Pty) Ltd, 24 Sturdee Avenue,
Rosebank, Johannesburg 2196, South Africa

Penguin Books Ltd, Registered Offices: 80 Strand, London, WC2R 0RL, England

First published by Penguin Group (NZ), 2008
5 7 9 10 8 6 4

Copyright © Peta Mathias 2008

The right of Peta Mathias to be identified as the author of this work in terms of
section 96 of the Copyright Act 1994 is hereby asserted.

Designed and illustrated by Anna Egan-Reid
Typeset by Pindar New Zealand
Printed in Australia by McPherson's Printing Group

All rights reserved. Without limiting the rights under copyright reserved above,
no part of this publication may be reproduced, stored in or introduced into
a retrieval system, or transmitted, in any form or by any means (electronic,
mechanical, photocopying, recording or otherwise), without the prior written
permission of both the copyright owner and the above publisher of this book.

ISBN 978-0-14-300804-0
A catalogue record for this book is available
from the National Library of New Zealand.

CONTENTS

1	FASHION: ASSET MANAGEMENT	11
2	FOOD: IF I SMELL A DROP OF TRUFFLE OIL I'LL SCREAM	41
3	RELATIONSHIPS: RELAX – WE'RE ALL DYSFUNCTIONAL	71
4	WORK: IS IT A PERSONALITY DISORDER?	95
5	TRAVEL: UNDER THE INFLUENCE OF THE NOMAD	117
6	HEALTH, HORMONES & BEAUTY: NATURE IS YOUR ENEMY	151
7	MUSIC & SINGING: A CRY FROM THE HEART	179
8	SEX & LOVE: WHY IT MAKES US BLIND	203
9	HAPPINESS: HOW TO TELL WHETHER YOU'RE HAPPY OR JUST EASY TO PLEASE	225
10	MEN: SO MANY MEN, SO FEW BULLETS	243

Dedication

To my mother Ann – this is all your fault. And to my sisters, Keriann and Desirée, my sisters-in-law, Sharyn, Pip and Lou, and my nieces, Estée, Jessica and Alba.

Acknowledgements

Thank you to the women who allowed me to interview them – your generosity and candidness is only what I would have expected of you – and to the women who answered the long questionnaires.

INTRODUCTION

Believe it or not, more than 99 per cent of male and female genes are exactly the same. That tiny 1 per cent influences each and every cell in our bodies, making our brain chemistry different, our hormones different, our thoughts, feelings and emotions different. The female brain is deeply affected by hormones – they shape our mood, values, behaviour and sexuality. Our brains can change a whopping 25 per cent every month and, as we all know, that is quite difficult to live with.

The technical research in this book is extremely reliable and that's where it ends. All the quoted surveys are suspicious in my opinion – everyone lies their heads off in surveys. I once said that I had outrageous G-spot orgasms in a survey – I don't even know where my G-spot is and strongly suspect it doesn't exist. All the other information has been gleaned from my haphazard life and my friends' experiences, and we are all highly flawed characters. All resemblances to real people are not coincidental. Nobody could make my friends up – the only sane people

among the lot of them are the doctor and the shrink.

In the health and beauty chapter I discovered that the answer to the question, 'Do I look fat in this?' is 'Yes and so what?' The sex chapter made me realise there's no point in having a trick pelvis if there ain't no love. The relationship chapter answered my question, 'Am I liberated or do I just have concentration problems?' (The trick is to make it look like you're liberated.) The most important piece of advice in the travel section is that it doesn't matter where you are going or for how long – you only need one suitcase. I've got one thing to say to you about fashion – there are no more rules except where white shoes are concerned: there is absolutely no occasion for wearing them unless you are a nurse or a bride.

We are living in an era of incredible wealth where food and gastronomy are concerned. Never before have we had so much choice, so much information and so many sundried tomatoes – so don't blow it. Don't pollute your temple with junk food. In my music and singing chapter you'll learn that there is no excuse for karaoke and you'll find out why good music transforms our lives and speeds us to states of intense happiness and emotional ecstasy. From the chapter on work you'll learn why you shouldn't put all your eggs in one bastard. If you want to change career, go and look at your school reports – it's very sobering and will show you where you went wrong in becoming an archaeologist when you were clearly meant to be a fashion designer. When you read what I have to say about health, beauty and hormones you'll be extremely disappointed. I'm very sorry to say that yes, you do have to eat your fruit and vegetables, you do have to stop smoking, but it's never too early in the day to have a glass of red wine.

INTRODUCTION

It is said that the recipe for happiness is good health and a bad memory. If you're not born with a positive attitude – develop one quickly. Happy people do not have a secret. They are just naturally reckless and poetic and instinctively turn negative things around quickly.

This book covers subjects of interest to me and things I have experienced. This is why there aren't chapters on religion and spirituality, or exercise and sports. Wait – I do have experience of these things, which is how I knew not to write about them. You want religion? Look inwards. You want exercise? Walk to the wine shop. You can believe everything I have to say about food and travel because I know what I'm talking about, but I would treat the chapter on men with suspicion – it is a subject I have selflessly studied for most of my life and I have neither understood nor learned a thing. Because I'd never asked a man what he wanted in a woman, I decided to throw some questions out to my male friends. Niagara Falls! They couldn't stop – a torrent of endless information poured out of them. Whoever said men don't talk? Women are the point of our lives, they said, we spend our whole existence trying to figure out what they want, how to get them, how to get them to stay, how to get rid of them, how to make them happy.

What qualifies me to pontificate on the state of womanhood? Nothing, but I've been around the block a few times. Also, I am the eldest of six children, a registered nurse, failed singer, a chef and a writer. All these trades are dependent on a person being nosy and fascinated by other people's lives.

1
FASHION: ASSET MANAGEMENT

Phyllis Diller said that the reason women don't play football is because eleven of them would never agree to wear the same outfit in public. Clothes are not for warmth, modesty or necessity. They are there to tell the story of you – who you are, what you do, how you feel about yourself, how you feel about the world. They convey your deepest complexes and display your highest self-esteem. A woman who wears jeans and a shapeless tee shirt day after day is saying, 'Hello. I don't want you to notice me because I have low self-esteem. I'd like my hidden beauty to stay hidden if you don't mind.' A woman who wears a tight red wrap dress and high heels is saying, 'Hello. Go ahead honey, have a good look – what you see is what you get.' A woman dressed in Laura Ashley is saying, 'Hello. I'm Pollyanna. I'd prefer you to think I had my children without having sex and that I only eat organic food.' A woman who's wearing a cowboy hat and a black tee shirt, is

poured into skinny, studded leather jeans, and is shod in powder blue Doc Martens is saying, 'Hello. I'm a radical diesel dyke with a fun streak and a weakness for straight women.' A woman wearing Issey Miyake Pleats Please is saying, 'Yes. I'm a stylish intellectual. I should have gone to art school. I wear Miyake because I travel endlessly, darling, don't iron and I'm fabulous.'

EARLY INFLUENCES

We all get our first ideas about fashion from our families, at school and at church. In my childhood nuns were a source of crucial and compelling mystery. Naturally, I was determined to get to the bottom of their fashion sense. Anyone who wore so many layers in the summer heat had to have something to hide. It stood to reason. There were no mysteries to my mother's clothes – she wore a bra, knickers and a sun frock all summer. But the nun's mediaeval outfit of black stockings, black shoes, long black habit, black veil and white head gear begged explanation. How could I have known that this look was the precursor to the standard magazine editor's outfit? I looked under their long robes (I was only five years old) and I found out what a strap felt like.

At primary school we girls wore heavy black shoes, thick black socks, a black pleated serge uniform with a yellow and black striped tie, black hat and black cardie. Tiny, innocent children all dressed in black to ward off the backsliding and heathenism waiting at every corner. Even at five a girl had to be vigilant. With my freckles, black curly hair and striped tie, I looked like an ambulant pedestrian crossing. This might be why I don't wear black now.

My secondary school uniform changed a little with the addition of the colour blue, which was rather lovely. Underneath were such titivations as suspender belts – white ones. Black was sinful. When I asked if I could have black underwear, I was told not to be a dirty girl. The boarders had their underwear controlled much more closely than day girls. Bikini briefs, which had just come into fashion in the sixties, were the height of depravity. Girls were encouraged to undress and bathe in a light cotton robe so as not to be tempted by their bodies. Due to a sustained outcry the nuns eventually dropped this nonsense but it remained mandatory to wear underpants to the waist. When boarders were caught with bikini briefs in their drawers, so to speak, the offending items took a trip to the incinerator, where they belonged, thank you very much. The tripe coloured, lisle stockings were bullet proof and our bras would have survived a nuclear holocaust. That any determined boy got past all this to impregnate anyone is one of the remaining scientific mysteries of our time.

Formal balls were the order of the day when I started nursing in 1968 and petals was the hairdo. I was quite good at sewing so I made myself a gown of navy blue organza with tiny white dots on it, empire line with a white ruffle around the low neck. Black eyeliner, brown arcs of eye shadow, false eyelashes and pale pink lipstick were the minimum requirement. The father said, 'Careful you don't lose your balance, girl.' The mother said, 'You look much better without make-up, Peta.' Mothers. What did they know? Better without make-up? By this time I wouldn't have even considered going to the toilet in the morning without make-up. False eyelashes were only for big dos; the rest of the

time three layers of mascara plastered on with tiny brushes and spit sufficed.

In the seventies it didn't take long for me to become fully engaged in the hippy revolution, but most of my straight nursing friends didn't join me. How could this be? How could you live in society, be at a formative stage in your life, and not be moved at all by what was going on all around you? How could you carry on with the old values and conservative mind-set when you were being offered freedom, excitement and unprecedented supplies of alfalfa sprouts? How was it possible that a girl would continue wearing tasteful camel Angora twin sets, pearls, pantyhose and hairspray when she could be decked out in macramé coats, antique white lace from the Salvation Army shop, sandals and beads? Then there was the question of armpits. How could anyone be so gross as to shave off their natural, God-given woman hair when they should not be bending to the male conspiracy to reduce women's strength? After I graduated and left nursing behind I was gainfully employed sewing beautiful clothes for the Brown Street market, just like the ones I made for myself. Selling the pin-tucked, white cotton and Liberty print, ribbon bedecked dresses I produced at home on my sewing machine was much more fun than irrigating people's kidneys at Auckland Hospital.

BRAS

The bosom fascists tried to tell us that wearing bras gave you cancer. The theory was that those saviours of dignity, our pink lacy bras, constricted the lymph nodes in the armpits and

prevented toxins from being flushed out of our bodies. According to some doctors, breast fat stores many of the chemicals and toxins that enter the body and wearing a bra can impede the exit of such poisons. Why would all those chemicals go straight to our breasts? A bra is not a straight jacket – it's just a support mechanism. Unless you are really stupid and wear your bra too small or too tight (which apparently a lot of women do), there doesn't seem to be any connection between that undergarment and breast cancer. You might get out of breath, though, from a too-tight bra pressing on your ribcage and diaphragm.

G-STRINGS

Don't start me on G-strings. Nobody had ever heard of a G-string before some stripper convinced people they were a great idea – the most revolting, uncomfortable garment in the history of the world. It looks awful, damages your skin, and causes infections. The string part is the problem – it causes genital inflammation, which spreads bacteria and fungus like thrush. None of this applies to strippers and burlesque dancers because the G-string is part of their uniform.

SHAPE CONTROL

When we burned our bras in the seventies we also burned our girdles and any other restricting undergarments, but we kept our garters for the bedroom. Anyone who had to wear suspender belts and stockings to school cannot bring themselves to see these bulletproof inconveniences as sexy. Everyone went au

naturale, your real girl shape was perfectly okay – we were all beautiful and fabulous in our own ways. Comfort was the order of the day. Well that's all over. Believe it or not, we are again subjecting ourselves to tight, hot, sticky nylon spandex to make sure the curves sit where God intended them, not where Nature has mistakenly moved them. New shape control underwear has exploded on to the fashion scene, with annual sales of more than $356 million in England and $735 million in the US. Trinny and Susannah's Magic Knickers and Control Pants are walking out of the shops in hordes, the US brand Spanx is a sell-out on websites like Figleaves.com, and Rago Waist Cinchers have increased sales by 200 per cent in the last year. In 2007, from April to June, Marks & Spencer sold five pairs of Control Pants a minute – 7670 pairs a day. Who knew there was so much elastic in the world?

Why are we doing this? Because we're sick of dieting and exercising and we too want to look like Scarlett Johansson or Kylie Minogue. Most people don't get to see us naked anyway, so why not cheat? Fashion designers ask us to wear impossibly waisted suits, nipped-in dresses, high-waisted trousers and pencil skirts. You can drop up to two dress sizes in the time it takes you to pull on a super shaper slip. According to Trinny and Susannah, the absolute secret to wearing clothes you never thought you could even look at is helpful underwear. Doctors warn that shape control garments can cause deep vein thrombosis and may compress nerves by restricting the supply of blood to the legs. Since when did anyone listen to what a doctor thinks when faced with a great fifties-style dress with big flowers all over it?

ASSET MANAGEMENT

This is where truth in advertising comes in. Be careful what your clothing is saying subliminally. There's no point in wearing tight black leather and Versace if you're not prepared to put out and haven't worked through your father issues; no point in chador if you've got Gucci underneath (although I'm sure Arab men see the point); no point in wearing counter-culture-fuck-the-establishment black if you go to shows called *The Sound of Music*. Just like there's no point in hanging out in a funky inner-city suburb in designer tee shirts if you live in Whatever Heights and your maid irons your jeans. We know who you are. Elitism? No. Truth in advertising. Be true to yourself. Having said that, being true to yourself might not be a good ploy if you are boring – in that case it's okay to deceive. There's a great Zen saying – act as if and soon you will become.

Why do women wear black – are there that many funerals in the world? If you're not Italian, a nun or a magazine editor, there's no excuse for it. Okay, so if you're going to wear black it has to be for the right reasons and you have to have the right attitude, otherwise you're just black-lite. If you're not one of the above, you have to be a left-wing intellectual, in public relations or a manic depressive to wear black. And don't smile when you wear black – look fuck-off and mysterious or people won't know you're depressed, they'll just think your teeth are sewn together. And it has to be the right black – dead black. Don't mix blacks. And dye your hair black too. The biggest lie in the world after, 'but darling you're the one I really love', is 'black makes you look thinner'. Fat people in black just look dowdy and surprisingly like fat people in black. Fat people in colour look fabulous and

happy and sexy. My friend Tanah is a voluptuous woman and she wears tight colourful tops, fitting pants, red lipstick and a beautiful smile. She looks gorgeous.

In asset management there are two schools of thought: the wear-what-you-like-it's-nobody's-business school, and the wear-what-suits-you-to-best-show-off-your-assets school. Intellectually, I belong to the first school; culturally, I belong to the second. When I was growing up my mother was fashionable. She always dressed beautifully and made it clear to me that I would go to prison if I wore brown and purple on the same day. There are now no rules, but that doesn't give you a licence to kill – you still have to be in touch with reality.

Here's an example of what not to do. Let's call this woman Marigold. I've known her for years and she's a classic example of bad asset management. We all know the type. Marigold has large, wrinkled, flabby breasts, so she wears very low cut tops to expose them. She is overweight, so she wears transparent dresses with G-strings. Her arms are flabby, so she wears sleeveless tops. She has great legs, so she covers them up. She has lovely skin, so she roasts in the sun for hours. The effect is grotesque, she sort of suspects it, her friends are powerless to change her, and she's now in her early sixties, desperately peddling backwards. If Marigold wore beautiful, stylish clothes that covered the bad bits and revealed the good bits, she would be a truly stunning woman. Her comment to this would be: I have no complexes. My comment would be: for the sake of everyone else, get some.

Dressing inappropriately for your age is not only an external problem – it's also internal. You need to find out why you can't let go of being in your twenties. It is very hard to accept, especially

if you were beautiful and relied on attention and compliments to feel good. A therapist would probably get you to make two lists: the good things and the bad things about being twenty, thirty, forty ... Wearing young clothes doesn't make you look young – it makes you look tragic and lost and strangers feel sorry for you. If you are wearing clothes from another era in your life it doesn't just mean you're out of fashion, because who cares, it means you haven't gone on to the next wonderful stage in your life. You are different in your thirties, forties, fifties – your hair changes colour, your body changes shape, you are different inside and none of it is bad, it is just different.

The world hasn't seen my arms for ten years, but it does see my breasts occasionally because they're still under control. Nobody is going to lose sleep over my legs, so I don't wear short skirts. If you've got great legs, show them. Asset control. Also, nobody ever benefited from loose clothing – we all look better in fitted clothes, no matter what shape we are. Girls, if you don't have a drop-dead body, I don't want to see your pubic hair or love handles in low-cut jeans, thanks. Just because it's fashionable, doesn't make it okay. One of my nieces wears low-cut jeans and low-cut tops but she's a six foot goddess with a drop-dead body. Most of us aren't.

I remember when a dated, wannabe queen voted me the worst-dressed woman in the country something like three years in a row. On a morning television show I was being interviewed about this and other things (like my fabulous dress sense) and the host had hidden this lump of ectoplasm off-stage. She asked me if I was ready to forgive him. The jerk was waiting in the wings for my forgiveness. I replied no. When might I be ready?

How long did I think a person should be punished? I replied that I am Irish and that we don't do forgiveness – we're still weeping over things people did to us two hundred years ago and that the punishment was for life. It's a sub-division of the Don't Fuck With Me syndrome. This worst-dressed woman story got a lot of press, mostly I think because journalists know I suffer from DFWM syndrome and can therefore be relied upon to spit acid. In another interview I thanked the ectoplasm for curing my constipation problems. I had a photo of him and his worst-dressed list on the wall next to my toilet and every time I looked at him, it all came away.

IRREVERENT, WITTY AND UNPREDICTABLE

When I lived in Paris in the eighties the fashion buzz words were 'irreverent', 'witty' and 'unpredictable'. I couldn't see what was new in that – it sounded like what I had been doing for the last twenty years. Fashion writers can always be counted on to use the word 'story' at least thirty-seven times in an article. We had the English Tea Dance Story, the Decadent Opulence Story, the Bolivian Mountain Girl Story and the Dominatrix Story. Do these people seriously sit at their desks and think up these 'stories'? Have they ever been to Bolivia? Do they know that Bolivian mountain girls wear the same dress and no knickers every day of the year? I know this because I went to Bolivia. I didn't see a 'story' in two weeks. Naturally, the fashion conscious girl out there in La Vie Ordinaire Story related instantly to being irreverent, witty and unpredictable. Not. Any well-brought-up girl wouldn't have known what dominatrix meant. I only

happened to know because across the road from my apartment in Paris there was a huge poster of a girl lashed together with a complicated arrangement of chains and whips. Her name was Madame Dominatrix. I put two and two together.

After carefully analysing the photos in Vogue I came to the conclusion that irreverent, witty and unpredictable meant revival psychedelic (like it wasn't bad enough the first time), leopard print platforms (again) and hot pants (less than one per cent of the population can wear them). The hot pants made me extremely nervous – why do fashion editors tell you to commit such acts against decency? I admit I am a fashion victim, but there are certain rules:

1. Do not wear white shoes ever, under any conditions, unless you are a nurse or a bride.
2. Do not appear at the breakfast table in transparent clothing, no matter what charming lies your lover told you the night before.
3. Do not wear mini or micro clothing if you have Botticelli thighs.
4. Do not go from the gym to your favourite café. Go home, for God's sake, take off that ridiculous gear and wash.

I was the first person in New Zealand to wear red and pink together on the same day, in spite of my mother's advice. I was a Romany gypsy long before Vivienne Westwood made it a story. Against a clearly documented moral code, I wore red lace petticoats under my starchy white nurse's uniforms. The most important fashion rule drummed into my sisters and me from birth was: never wear something you wouldn't want to have an

accident in. Only two types of girls broke this rule: your cousin from Te Puke, and the girl next door who had pierced ears and dyed hair. All other bien élevé girls were trained to always wear clean, snowy underwear and to wear black only at funerals.

It took me my childhood to absorb the unwritten laws of fashion ritual and now here was Vogue introducing me to a whole new fashion concept that raised more questions than it answered. For example, did this mean I could now wear rhinestone wedges at ten in the morning? Could I put leopard skin with paisley? How would I know it's me if I'm wearing Hermes instead of Gaultier? And what about hot pants? My friend Trudy was a model and wore short everything, but she was six feet tall – and that was only counting her legs. I was five foot four with ankles only a mother could love.

There are two kinds of fashion: runway or haute couture, which only Saudi princesses can afford; and street or off-the-rack fashion, which you and I wear. In the nineties the knowledgeable fashion victim dressed for attitude, dressed to kill, or at the very least maim. Sexiness was hard and violent, power dressing was out – thank God – and contempt dressing was in. We're talking trashy thongs, spiky stilettos, patent leather straps, black leather, sex shop styling, bondage detailing and fetish-inspired boots. Believe it or not, real fur was replacing fake fur and the fashion writers were saying 'dominatrix' again. Are we so lacking in ideas that we are recycling those stupid giant shoulder pads, leopard skin prints, feathers, fishnet stockings and hot-pants? At least heroin chic is out. I mean how much purple eye shadow can you wear under your eyes anyhow, and do you have any idea how difficult it is to peroxide your hair and keep the roots black?

The name of the game in the noughts is that there is no more name – every woman wears what she wants, everything is in and everything is out. Nobody has the cultural authority to dictate fashion. The days of rules flew through the glass ceiling – it's all deconstruction and jolly anarchy. It makes me anxious – it could end in tears. How can a person who was brought up by Vogue in unflinching service to an impossible ideal that was completely arbitrary, unsociable and would never be seen on our home shores anyway, now be expected to adjust to the fashion industry kowtowing to the consumer? This is role reversal at its most confusing. Young Parisian girls wear ridiculously high platform shoes and the boys, who seem to be getting taller, wear tight black jeans and black tee shirts. Even though they fall over at the idea of exercise and appear to eat lots, they remain slim and sexy.

When I was in Paris once, a well-known French fashion magazine dressed a model in Christian Lacroix clothes, and then asked people in the street four questions:

1. Do you like these clothes?
2. Would you wear them and if so where?
3. How much do you think they cost?
4. Who is the designer?

The model was dressed in a lime green, see-through lace top, blue lace gloves; red and black print flares and a long flowery coat. Most people loved them, would love to wear them (but only in private), grossly underestimated the price, and a third of them guessed the designer. Men liked the idea of their women dressing like this, but women were much more realistic,

knowing they could neither afford nor look good in such clothes in a million years. The most interesting things were that the clothes looked as though they came from a Salvation Army shop and that most people mistook them for Jean-Paul Gaultier.

A statement is all I ask, even if it is not to my taste. Every time I meet an intellectual I go into an anaphylactic shock caused by their dress sense and serious lack of lipstick. Don't tell me – San Francisco 1968? Here's the look: home-made jumpers, holey tights, stained glass broaches, purple silk scarves, grey hair, no make-up and excess baggage. These are au naturale, no pathetic artifice, I-am-who-I-am, real women. I'm all for pathetic artifice – a slash of lipstick (not pink, thank you), a line of eyebrow, and a rondelle of blusher transform a woman from plain to sparkling in thirty seconds. No woman over thirty should leave the house without at least lipstick on – not even to put the rubbish out. Why frighten the dog? Keep your nails manicured, do your hair, and have pride in your appearance. And another thing – there's no point in looking at yourself in the morning. Just crawl along the hall on your belly from the bedroom to the bathroom and remove all mirrors and lights on the way. Don't go near a light or a mirror until the make-up is on and you are clothed.

There's also such a thing as appropriate dress for the weather. What my country cousins outside Melbourne do in the case of vile weather is go out in it, embrace the elements, argue with God and access their inner idiots. Hello? This is a peculiarly Anglo-Saxon madness, closely linked to party games like Murder and Monopoly. Except in this game there is no point, no winner and no reward. In the Let's Go For A Walk In The Tempest game you get your hairdo all fab, wear thread-bare clothes, throw a hand-

embroidered shawl over your shoulders, and set out with people who have clearly just been discharged from the French Legion. You return with gangrene, ruined hair and a rictus where a smile would have sufficed. If you're a bad weather freak, wear boots, an army coat, ski-glasses – and don't bother people who prefer to stay indoors with a glass of sherry and a cigarette.

Louise

Louise Pilkington has been the glamorous, gracious owner of Servilles Ponsonby hair salon for twelve years. She has always wanted to be a hairdresser and loves it. On the day I interviewed her she was wearing a vintage-style sundress cinched with a wide belt at the waist, fitting cardigan and high-wedged sandals. Louise has a very pretty, open face, a radiant smile, hazel eyes and, at the moment, dark blonde hair. She has absolutely gorgeous olive skin. The sort of girl you can't stop staring at. I asked her why she wears clothes.

'Mostly for entertainment and fun – for me it's like an art form. My mother was always fashionable in an eclectic way and my grandmother was a master seamstress who made formal, complex, refined garments with incredible detail. As a child, I was also very inspired by our outrageous neighbour who used to dress me up. She would go on big shopping trips to Australia and Europe and once came home with an entirely pink outfit for me. I was in ecstasy. I use clothes and hairstyles to alter my mood and I enjoy being a chameleon. Of course the downside is you're

never invisible. If I'm having an I Don't Want Attention day I wear black or something ordinary.'

'What does your wardrobe look like?'

'It's big and very organised. Everything is laid out in order of garment, colour, accessories, jewellery, shoes. Everything is visible, so it's easy to put the look of the day together. I think of a theme in the morning like cowboy, sexy secretary, business-like, bohemian . . . my inspiration comes from many places – the street, movies, designers.'

'What's the worst fashion crime you have committed?'

'Once, in the eighties, I wore bright coral shimmer right up to my eyebrows. Another time I wore a square block of thick red eye make-up. And there was the time I dyed my hair blonde and put purple fudge in it.'

'Should women wear what they want whether it suits them or not?'

'No, I don't think so, because that attitude is coming from a place of neglect and self-destructiveness. Wearing a tight white top with your fat belly hanging out means you are out of touch with your self-respect. I think the "what not to wear" television shows are good because they teach you a lot about body shape. It makes sense to gracefully cover the bad parts and lovingly reveal the good parts. For example, I have a big bust and no hips, so I wear fitting clothes – I would never wear a dress that fell straight from the breast like a sack. It's not about being fashionable; it's about having social graces and dressing appropriately. If you look fabulous it gives you the confidence you are

maybe not feeling. Women must free themselves up and play with their looks – if Coco can invent, so can you.'

'Who really cares? Is fashion important in the great scheme of things?'

'Yes and no. Fashion is not as superficial as it appears – the superficial side is just social ego. Fashion and hairstyles are important in historical terms – they tell a story. The world would be a dull place without fashion and hairdos – it would be like food without spices.'

'Tell me about your relationship with shoes?' Big smile.

'Shoes are the most important part of your wardrobe – if they are not finished well, are shoddy, dirty or ugly then that's how your whole look becomes. Your shoes make or break you and you can always judge a man by his shoes. I broke up with a guy once in the eighties because he wore white commandos.' Bursts into laughter.

'Where is fashion at now and where is it going?'

'Right now designers are really pushing the boundaries – fashion is very theatrical, bright, lots of mixing of styles and prints. I style hair in international shows in Milan, Paris and New York and it's all very movie-like at the moment.'

MAGNIFICENT MARNI

I have had love affairs with many designers over the years: Jean-Paul Gaultier, Trelise Cooper, Issey Miyake, Zambesi, Prada, Marilyn Sainty . . . and my present infatuation is with Marni, the glorious but covert Italian brand. Consuelo Castiglioni is

the avant-garde, creative force behind this family label. Marni doesn't advertise in fashion magazines, has catwalk shows at unglamorous times of the day like ten o'clock in the morning, and the designer hates attracting attention to herself. This is not your typical, over-the-top, sparkly, sexy Italian look – this is a loose, round-cornered look in unusual painted prints and gorgeous colours with hand-made, almost crafty details like necklaces from leather, chains, crochet and coloured discs. Marni clothes are not designed to be looked at – they are designed to be worn easily, make a woman look beautiful without exaggerated sexiness and exposure, and can be mixed and matched with previous seasons' pieces. They are eclectic rather than conventional, and designed for women who wish to be stylish and comfortable. The clothes feel soft and feminine and unrestrictive.

SMOKE AND MIRRORS

A mirror has now been invented that cannot only tell you that you are the most beautiful of them all, but can help your friends to do the same thing. A New York designer has installed a mirror equipped with infrared technology which sends a live video feed to any cellphone, email or personal digital assistant device selected by the shopper. So you're in Paris, decide in a wild and crazy lapse of judgement that you would look good in Versace. With the help of these mirrors your mother, who's in Sydney, can watch you trying the garment on and drag you back to reality with a text that says 'STOP that right now'. But that's not all. Shoppers can also use touch screens on the three-panel mirror

to choose matching shoes or accessories. The left-hand panel has a touch screen that allows a customer to select a different outfit and then see how it looks on her in the centre mirror without physically putting on the dress. The right-hand panel has a screen offering more information about other shoes or accessories. How cool is that!

'ONE OF THESE DAYS THESE BOOTS ARE GONNA WALK ALL OVER YOU'

> 'To be carried by shoes, winged by them. To wear dreams on one's feet is to begin to give reality to one's dreams.'
>
> ROGER VIVIER, MASTER SHOE DESIGNER

Scientific studies have shown that if a woman has no lust for shoes she is probably dead from the neck down. According to the UK Woolwich Survey, 29 per cent of women spend more time looking for shoes than they do for a lifelong partner. The average woman owns nineteen pairs of shoes, a small percentage own a hundred, and the Imelda Marcos syndrome is spreading. As with bras, many women buy shoes too small and no one cares whether they're comfortable or not.

A good way to find out if a man is suitable as a life partner is to ask him some simple shoe questions – the sort of things any woman would know. Who is Robert Clergerie? Why do high heels make women sexy? Is it essential to buy designer shoes? What are your thoughts on drinking alcohol out of shoes? He should also be made to open your wardrobe and tell you who designed all the shoes without looking at the labels. This simple

tactic will identify the right man and the right shoe in one campaign.

Shoes have, throughout the centuries, been symbols of wealth and status. It is incredibly complicated to construct a good shoe. The first thing that is made is the 'last' – a hand-made wooden replica of the foot. The last determines the contour of the arch and how evenly the woman's weight will be distributed throughout the foot and it requires great skill to make. Every shoe style has its own last. The maker has to figure out how the foot will move inside the eventual shoe. Ascertaining the girth and contour of the instep and the ball of the foot is the most important thing because this is where the weight falls when the foot is walking. The shoe itself has many parts: the toe box, which is the front part, the vamp, which is just above that, the throat, which is the top line going around the foot, the heel breast, which is the inside of the heel, and the shank, which is the arch support. Now you make the shoe: the pattern-maker traces out the shoe's upper and lining, forms the toe box, adds the counter (stiffener for the back of the shoe) and soaks the leather so it is malleable. Then it is stretched over the last and nailed in place. It sits there for a couple of weeks, then the sole and heel are attached.

High heeled shoes for practical reasons, such as horse riding, date back to pre-Christian times, but the first time heels were worn for fashion was in 1533, when Catherine de Médici brought hers from Italy to France to wear when she married the Duc d'Orléans. One of the most brilliant ever shoe designers, Roger Vivier, made the Queen Elizabeth's wedding shoes – gold kidskin high heels studded with garnets. Wearing high heels

makes a woman powerful, especially in the seduction game. Psychologically, you are leading rather than following. Sexually, you become either the subject or the object of men's slathering desire. Shoes are a mode of escape from unsatisfactory lives – Cinderella found her prince because of a shoe. It is impossible to cower in high heels because your centre of gravity is forced forward. The lower back arches, the legs lengthen, the calves become shapelier, and the arches are raised. Hence the erotic connection – the foot is forced into the same vertical position described by sex researcher Alfred Kinsey when he looked at the way a woman's foot points forward in line with her leg during orgasm. The average increase in the protrusion of a woman's buttocks when she wears heels is 25 per cent. Also, erect ankles and extended legs are the biological signal for sexual availability in the animal world. Wearing high heels is also good for you because by walking in them, you are necessarily exercising your pelvic floor muscles.

They say men are like lino – they just want to be walked over. There is a subversive plot out there that says our bodies are not designed for high heels. Not designed for high heels? So why did God invent lino? Why did he create Christian Louboutin who specialises in 'toe cleavage'? They say we might fall over, develop hammertoes, break our knees, twist our ankles and get back deformities. At the very least, we were told, we'd end up with 'barking dogs' – slang for aching feet. Or worse still, psychological problems if deprived of them – I'm five foot four and I need to be six foot. If you are prevented from buying shoes (which define you), you lose your identity. When we ignored these 'warnings' and kept wearing the sexiest invention in

history (after the pill), they then came up with the fertility plot – high heels make the pelvis tip forward, causing the organs in it to be pushed together. Realistically, what usually happens is that high heels become too uncomfortable to wear in quotidian situations, but they should definitely be retained for glamorous, special occasions. Special occasions can be found inside the bedroom and outside of it. Heels give you an instant uplift – surgery without the knife.

You are never too fat or too old to buy another pair of heels, especially a well-constructed, designer pair. The more shoes a woman owns, the better person she turns out to be. A good shoe is a work of art, especially a heel. If you would like to try wearing high heels but think you could only manage Saturday night, start with good ones. Designer shoes are made individually and, like dresses, some fit your foot better than others.

Wearing high heels is a learned art. Don't try and walk in them the way you would normally walk in flat shoes – it's like trying to sing an aria with no training. You just make a fool of yourself. Allow your body to follow the shape of the shoe. Don't try and make the shoe fit the way you walk – this leads to pain and humiliation. Remember, you wear your shoes; they don't wear you. Keep your head up and your shoulders back and don't look down – we're talking grace and posture here. Your weight should be centred over the heel, not the toe. Slow down, take smaller steps and shorten your stride. You'll glide. My friend Ginnie calls really high heels 'one way shoes' – you can walk to the party in them, you won't wear them home. Style goddesses never remove high heels if they are uncomfortable – they just make sure they never hurt by fitting gel pads into them.

FASHION: ASSET MANAGEMENT

Shoes trigger memories and emotions as surely as music does. When I see my nieces' baby shoes I feel a sentimental lump in my throat. When I smell ballet shoes I am straight back in that wondrous world of tutus, pliés and performance anxiety. For a lot of important events in my life, I can remember what shoes I was wearing at the time. Strapped at school: heavy black rain-soaked lace-ups. Nursing: heavy white rain-soaked lace-ups. Fell in love for first time: sandals with straps to the knee. Boots in bed: cowboy boots from Seattle worn in Canada. Got married: black patent leather shoes with red stiletto heels. Gastronomic tour of Northern Italy: Pucci mules. Last birthday party: 15 centimetre perspex platforms.

The **BALLET SHOE** is a flat soft shoe, made of satin or leather, danced in by ballerinas and walked in, with a flat leather sole added, by slim girls wearing capri pants, dark glasses and a silk Hermes scarf tied at the back.

Close to the ballet shoe but much less glam is the **SLIPPER**, which has fallen from deliciously refined to very dowdy in some quarters. Slippers were originally designed to last one night – so fine and delicate you only wore them in the bedroom. They were just slips of beautiful nothingness – a bit of brocaded silk, satin or velvet, which barely covered the foot. They showed how wealthy and stylish you were. Ornate slippers are still worn for special occasions these days, such as weddings and formal evening events, where they are designed to only be worn once. They're reminiscent of a world of caprice, innocence and romance.

STILETTOS made their first appearance in the early fifties. Most of the stiletto-styling kudos belongs to two brilliant cobblers –

Salvatore Ferragamo and Roger Vivier. No self-respecting sex bomb would be seen without them. They went out of fashion in the sixties and seventies when we were busy burning bras and being au naturale, but thankfully they sashayed back in the door as the power suits of the eighties took to the boardrooms. They got marginally lower in the nineties. This year they are outrageous – only a trained specialist could wear them.

Most fabulous modern shoes were invented by Ferragamo and the WEDGE is no exception. He invented it in 1936. Brazilian Carmen Miranda, who was only five foot tall, burst onto the Hollywood scene wearing glittering eight inch wedges. A wedge is not a platform. A wedge is like a stiletto but filled in with cork, giving you a safer centre of gravity. A platform is lots of fun, looks great, but it does feel a bit like walking around on a dictionary.

MULES were originally boudoir shoes associated with glamour and sexiness. They are traditionally only worn inside. They have marabou stork feathers on the toe and are high and backless, thus leaving the foot half-covered and half-naked. One thinks of Marilyn Monroe and Diana Dors tottering around coquettishly in pale pink or black feathered mules. They are very nineteen-fifties and signal utter sinfulness. These days the mule style has been adapted for outdoors and the feathers replaced with other decoration.

The COURT SHOE or pump came to light in 1555 and comes from the French word poumpe, the name of the slipper worn by footmen. Once women got hold of them for their comfort and had them made out of patent leather, pumps became very fashionable for dancing. The modern court shoe is low-cut, stylish, low-heeled, usually black, favoured by airline

stewardesses, Jackie Kennedy and bridesmaids, who dye them to match their frocks. This shoe says respectability and good taste. I've never worn one in my life.

There's something terribly romantic and je ne sais quoi about wearing shoes made of canvas and string. They are disposable and chic at the same time and absolutely spell sunshine. Invented by Spanish farmers and originally called alpargatas, the soles of these canvas shoes were made from esparto grass. When they got to the south of France in the early nineties they became known as ESPADRILLES. You just threw them away at the end of summer. These days a lot of espadrilles, traditionally made from rope, have a wedge in them. Normally it would be impossible to walk in a high heel or platform in cobbled southern France, but you can navigate difficult surfaces in light cork espadrilles!

FLIP-FLOPS, or jandals as they are called in New Zealand where they were patented in 1957, are the cheapest, most democratic footwear in the world and are made of rubber. Their design was stolen from the Japanese zori sandal and they are made for the beach – sand slides in and out and you can safely walk on shells and rocks. They are absolutely brilliant and a lot of New Zealanders see no reason to ever wear anything else. Flip-flops have lost all pretence of being beachwear now and variations of them are worn by both sexes, the glitterati, the poor and the rich. To wear these shoes successfully you must have clean, pedicured, nail-polished feet and make an effort to not walk like a duck.

TRAINERS or running shoes are for sports training and running, funnily enough. They are specifically engineered to cushion and support the feet. They are not to be worn anywhere else – they

are ugly, unflattering and gauche. This also goes for the ugly sports clothes worn with them. I have often wondered how running shoes made the transition into everyday life and one day I found the answer: they became acceptable street wear when thousands of women walked to work in suits and sneakers during the 1980 New York City transit strike.

The BOOT has always been fashionable. From Joan of Arc to the laced and hooked dainty boots of the eighteenth century, to the Beatle boot and the cowboy boot, to Doc Martens and the tall pointy boots of today. Boots always make a statement. I once bought a pair of Patrick Cox boots with sharp toes, missing ankles, laces, and very high toilet seat-shaped heels. I thought it would be fun to stand in them for five minutes on a Saturday night. I knew there was no question of walking but even when I just sat in them they had the most extraordinary effect on men. It's true what they say. They proved that men are just like lino, waiting to be walked on. The minute I walked into a room with these boots on, half the men lay down on the floor and begged, 'beat me' (slight exaggeration). This didn't happen in France – I wore them to a conference at home and a staid old architect got down on the floor and licked them for God's sake!

SHOPPING

This brings me to shopping. You know the old saying – I've been shopping for forty years and I still have nothing to wear. Whoever convinced the world that you had to be happy all the time hit on a great scam. It is normal to be miserable at least 50 per cent of the time. That's why God invented shopping and gin.

Also, it's normal to shop just like it is normal to eat and store fat – we buy more than we need 'just in case' there's ever a shortage of shoes, cookbooks or black bras with pink lace. The law of the universe with money is you have to spend it to allow more to come in, so it is your fiscal duty to buy that Marni.

Apparently we hoard as many clothes as we do shoes. This is how eBay and Trade Me survive – it's a goldmine for them. Retail therapy is indulged in to cut down on psychiatry bills. I would much rather shop than vomit out my tedious 'issues' to a shrink. New clothes make you feel fabulous – the shrink makes you realise how hideous you really are. Truly compulsive shopping is called oniomania. It's routine and obsessive. You never stop thinking about it, you hide it, you always do it alone, and you do it to the detriment of family relationships. That's not what I have.

THE FUTURE

According to strategic think tanks, there's a new target audience for fashion designers –SOLs (sexy older ladies). They want to be sensational, stylish and sexy. It's all part of the feminisation of society, which has come about because of the changing roles of women: the well-documented 'man drought'; putting off having babies until later in life; and the continuing stream of women entering the workforce. And what do you need at work? Good clothes and good shoes.

WISDOM GAINED

- Find out what suits you and if you are in doubt, ask a teenager – they are merciless.
- Bolivian shawls look good in Bolivia; Vietnamese silk dresses look great in Saigon; straw lavender picker's hats look heavenly in Provence. All these things look ridiculous when you get home.
- Buy the fabulous expensive shoes – you can always sell them on eBay.
- A smile is the most fashionable and flattering thing you can wear.

2
FOOD: IF I SMELL A DROP OF TRUFFLE OIL I'LL SCREAM

Without being profligate, I can say that food is the meaning of my life – trying to get more of it, trying to eat less of it, making it, making money out of it, loving it, hating it. My first cooking teacher was my mother and the first cooking lesson I had was in primary school. We wore little hats and aprons and made things like sponges, roasts, cup cakes and macaroni cheese. It was heaven. I always thought it was amazing that you put something wet and gloopy into an oven and forty-five minutes later it came out as a cake. I couldn't understand how it happened – where did the other stuff go? My mother used one cookbook throughout my entire childhood – the *Edmonds Cookery Book*, famous for such crimes against humanity as kidney soup, onion sauce and tongue mould. Fortunately, she never tried any of this rubbish on us – save for gloopy white onion wallpaper glue with Christmas dinner or occasionally corned beef – but she must

have used it as a guide for cooking steak (half an hour), roasts (three hours) and mince (an hour).

In Britain recently a survey found that people under twenty-five years of age had no idea what spotted dick, brawn and scrag end of neck were. They were repulsed by the idea of offal, haddocks' heads and squirrel pie. People over sixty are often happy to forget these dishes as they represent rationing, chilblains and the cheapest meat at the butcher. Does anyone now use blood to thicken a sauce? What is sweetened milk set with rennet called? Increased prosperity and constraints on time has meant offal, long-cooking cuts and desserts such as steamed puddings have disappeared from young people's kitchens.

Or is the tide turning? Are we now feeling jaded from our fast, changing lives; do our bellies long for gentle, caressing food; are we generally needing a quiet cup of tea and the light ministrations of a sponge cake? I think one doesn't want always to be stimulated, impressed or moved to tears by a meal. Sometimes one requires the unsurprising, the reliable, the prosaic. Everywhere I go I find fried chicken livers, tea for two served in the old family silver, Louise slices, stewed apples, steak and chips. There are those who long for the flippant, zingy, cheerful food and the simple, revealing clothes of summer to be over so that they can at last start cooking comfortable, flavour-layered stews and wear the lush, fabric-layered clothes of winter.

Truth and memory are tricky things – they can't be trusted and often let you down. There is a difference between what is technically true and what your memory tells you is true. My memory tells me that the potatoes my father grew in our

back garden were the sweetest, nuttiest, most delicious tubers I have ever eaten. Just to conjure up that culinary memory makes my taste buds ache. For many dark years we suffered a potato taste famine, an anaesthetised state from which we are just emerging. Fortunately, we now have access to many potato varieties, including heritage potatoes, which are properly labelled by type and cooking method.

In my twenties I painted and decorated entire houses every six months, taught hopeless male flatmates to cook and clean, threw huge dinner parties, cooked and cooked and cooked. Cooking and eating made me happy and acted as a form of therapy – the shopping, chopping, stirring, slurping was calming. Homemade food tasted better, but the best part was the gratitude, music to an aspiring earth mother's ears. I was never too tired to make extra food because food was love. As a child I had eaten voraciously from anxiety but now it was for pure pleasure. I derived as much pleasure from eating as I did from living. As soon as I'd finished one meal I was already planning the next. It crossed my mind that I should be a chef but my friends said, 'Don't be dramatic, you are going to be a nurse. Who ever heard of a woman chef?' 'Who ever heard of' is the major reason people can pretend for years – for their whole lives even – that the earth is flat, the Pope is infallible and there is no such thing as an orgasm.

It was only when I moved to Canada in my mid-twenties that I discovered fabulous magazines like *American Gourmet* and bibles like *The Joy of Cooking*. *The Joy of Cooking* was huge and dense and it taught me to make hollandaise and béarnaise sauces, surely the pinnacle of sophistication and worldliness

and a far cry from gloopy white sauce. Anyone could make white sauce, but only someone like Julia Child could make a béarnaise because it involved timing, technique and terrifying amounts of butter. Even once you had mastered it, it could still split on you afterwards if you left it lying around a hot kitchen on a summer's day. Partnered with steak or lamb, sharp, tarragony béarnaise just made you want to lie down and listen to your heart beating. *Gourmet Magazine,* with its fabulous photos and intelligent restaurant reviews, made me fall in love with cooking. I carried dozens of those magazines around the world for thirty years, dog-eared, fat-splattered and yellowing.

In those days I would burst into tears if a sauce split, a soufflé didn't soufflé, or beef Wellington ended up with soggy pastry. I used to make insane things like Bombe Alaska, where you cover a block of ice-cream with meringue and bake it so quickly in the oven that the ice-cream doesn't melt. You get a cold inside and a hot outside. Have you ever made a real consommé? Complete madness, but I thought it was desperately fabulous to see the egg whites floating to the top. My sister taught me to make apple strudel but no, I had to make it with real, hand-pulled strudel pastry and then had to slit the throats of friends who said things like 'Why don't you just buy some filo pastry like your sister said?' In Montreal I met other people who were mad about food and every Sunday we would do a restaurant crawl, which was especially good in winter. You start in the morning with coffee and a croissant, walk to another place for eggs benedict, walk through the park to another for pasta and champagne, go to a Sunday concert, walk to the next place for cake and coffee . . . Those were the halcyon days when we ate and ate and never got fat.

In 1980 I moved to Paris to live, love and eat for ten years. There I discovered fresh outdoor markets, cheese and wine. I opened a restaurant in the 5th arrondissement and discovered exhaustion, anorexia and insanity. My French husband Alexy, who died, used to make Lapsang Souchong tea in a white china teapot and pour it into white china tea cups. I don't want to get sentimental but it's the thing I most remember about him. He never used a strainer because the leaves keep the flavour intense. He spent hours in salons du thé drinking different kinds of tea and indulging in little cakes, idle chatter and morbid newspaper perusal. Sometimes I would make tea but if it was the wrong type, he would explain why. Some tea is drunk with milk, some with lemon and some at certain times of the day. Mint tea is drunk in the afternoon because it's a light, refreshing tea to be taken when one wishes to be calm and relaxed. That's why God invented English Breakfast tea for the morning because it's a stimulant and full of caffeine to get you ambulant.

Because he was French he was of the opinion that lamb is always served with beans, not with sweet potato, peas, gratin dauphinoise or any other bit of reinvention of history that I, an uncivilised foreigner, cared to impose. He thought it was vulgar colonialism to tamper with old recipes and ancient tea ceremonies because they are not thus comme par hazard, they are thus for solid gastronomic, geographical and historical reasons.

'In the old days when gigot leg of lamb was served, the only vegetables available were dried flageolet beans and they go well with it. They don't drown out the delicate flavour of the lamb, unlike mint sauce. Quel horreur,' he would say.

'But you need the acidity of the vinegar to cut the fat of the lamb,' I would reply.

'So roast the lamb with rosemary and lemons.'

When I left France in 1990 the world was gradually being taken over by sundried tomatoes, rocket, flaky sea salt, quince paste, dukkah, crème brûlée, 70 per cent cocoa chocolate and buffalo mozzarella. Now it's micro-greens, quinoa, cavalo nero, purple potatoes, ciabatta and prosciutto. But get this – the more competent I became with food, the simpler it became. When you're young it's all about impressing and experimenting and as you get older it's about being at one with the universe and accessing your inner regional cook. 'Regional' is code for easy. Your friends and family will not love you more for Tetsuya's floating islands, which bleed chocolate. It's cruel but true. They will love you for Nigella's plum pudding. They will especially love you if you look like Nigella, which is also cruel but true. The point of cooking is to share the love around, have people feel comfortable and go for delicious rather than death-defying. And another thing, here's my solution for the very common problem of being too intimidated to invite your very good cook friends to dinner: one, never talk to them again; two get in up-market takeaways. Your cook friends just want to be with you. I am sick of the I Can't Cook excuse.

I have noticed that we cook less and less but buy more and more cookbooks, watch food telly and eat out more. This is called transference. We sit up in bed and read cookbooks like novels because we miss the preparation, smell, colour and cooking of food and the profound pleasure and satisfaction it gives us. You know the old saying, 'there's nothing like curling

up in bed with a good book or someone who's read one', well it's getting a bit like that with cuisine: there's nothing like eating a good meal or being with someone who's eaten one. Over the years I have had literary love affairs with Mark Kurlansky, Marcella Hazan, Robert Carrier and Elizabeth David, to name but a few. I have read wonderful food literature such as *Like Water for Chocolate* by Laura Esquivel, *Kitchen Confidential* by Anthony Bourdain, *The Book of Salt* by Monique Truong and *My Year of Meat* by Ruth Ozeki. I am currently in love with Maggie Beer, Hugh Fearnley-Whittingstall, M.F.K. Fisher and Paula Wolfert. I have my moments with food critic A.A. Gill. I really like that he says, 'If the food is not good, complain; if the food is terrible, don't pay for it.'

THE PHILOSOPHY OF EATING

Eating is the cheapest and easiest way to make yourself and other people happy, and therein lies the rub – we seem to operate on the assumption that more food means more happiness. Only sex comes second and in my opinion food is slightly more reliable. Desire drives us to enjoy both. Now that we can get Italian buffalo mozzarella in the deli and have been led to believe that vine-ripened tomatoes are the most miraculous thing (what else would a tomato grow on?), we can have ecstasy in five minutes if we wish. You just stroll outside and pick some basil from the garden, slice the ruby red tomatoes and snowy white cheese and arrange in overlapping layers, drizzle with extra virgin olive oil, sprinkle with sea salt and freshly ground black pepper. Pour a glass of rosé, sit

down and eat your creation. I defy you to not groan out loud with joy.

I am lucky enough to be part of the oldest profession on earth (second only to that other profession). The first thing we do when we enter this world, after screaming our heads off in fright, is eat. We drink our mother's milk and from then on in we never stop eating and thinking about food. We also never stop talking. We eat and talk with our mouths, so cooking and eating become another form of communicating – a 'mother tongue', if you like. Sharing food with people is a way of showing love. Food and the smell of food evoke memories of people, places and feelings with almost the same intensity as music. The perfume of lavender lollies makes me think of my grandmother and how much she loved me. The smell of frying onions makes me think of a boyfriend I had who used to fry them to trick me into thinking he was cooking a delicious meal, when he'd actually be heating up a frozen dinner in the microwave. Food and feelings intertwine and thereby live long in our memories.

COOKING WITH JAMIE

I had just run into the house after a day in the coal mine and what happened? Jamie Oliver was on the telly. I was hungry and had to eat very soon or my teeth would start bleeding. Simultaneous situations that had to be dealt to with intelligence, panache, and no in-house medical help. Here's how to cook a smashing meal in the ad breaks of the *Jamie at Home* show.

I'm a huge fan of Jamie Oliver because he has proved that speaking in a funny accent with a cute speech impediment is no

obstacle to fame and fortune. Here's the recipe: Jamie is in his garden making love to peas and broad beans and talking about slugs and ladybirds, but there's nothing hard core happening yet. I take this opportunity to fling open the fridge door and look. There is a professional way to look in a fridge. If you just scan, you'll die of hunger or a broken heart, whichever comes first. You must quickly but methodically touch everything on each shelf then touch everything in the crispers at the bottom. Okay, so now might be a good time to get rid of that opened rosé in the door – past your almost bleeding teeth into your blood stream, where it will alter your mood immediately and you will find yourself in the south of France.

Now Jamie is smashing broad beans and peas in his mortar and pestle, throwing in some mint then grinding in olive oil and pecorino cheese. Then (somehow in the garden with the slugs) grilled bread appears on a plate, the smashed broad bean paste gets plopped on top, and torn buffalo mozzarella floats down from heaven to complete it. Ad break. I have computed lamb chops, fennel bulb, lemons and this fantastic French spreadable goat cheese called Soignon. With the grace of a ballerina I whip the oven up to high, grab a frypan and put a bed of fresh thyme sprigs in it. On top of that goes the lamb, lots of sea salt and lemon juice and then another duvet of thyme. Grab the fennel and throw that in the frypan too, watch Jamie eating pea and broad bean shoots. Oven now hot, slide in pan and cook for exactly ten minutes.

Ad break. I can't eat just lamb and fennel – people will think I'm not trying. I open the pantry. Joy! A shining jar of huge El Navarrico butter beans smiles at me. Jamie is now in the

cute, messy-but-approachable kitchen making perfect, easy meatballs. Yeah, yeah. I wake up when I smell my chops, whip them out and while they are resting, microwave the butter beans. Oooh, I really like the broad bean and lemon rind quenelles he's making with tzatziki sauce.

Throw thyme away, put lamb and fennel on plate; slather beans with lots of goat cheese and lemon juice. Sit down. Jamie walks down garden path into sunset.

FAST FOOD

In the United States, the Slow Food movement is finally starting to have an impact, which coincides with American food writers' and academics' utter horror at the gigantic, obese people that country has produced. But the demonisation of fat is a fairly recent thing. Formerly a sign of prestige and power, fat now signifies shame and powerlessness, ignorance and sickness. This is the only time in history when rich people are thin and poor people are fat. Being thin for the sake of looks is anti-evolutionary, which is why it's so hard to maintain the stick look. Fat protected us and ensured the survival of our species. We needed it in times of shortage and our bodies are trained to hold on to it. Obesity is basically the chronic consumption of energy (calories) in excess of that used by the body. We are now storing much more fat than is necessary for survival.

United States food experts say that Americans were deliberately educated to over-eat by big business, which makes the food cheap and over-abundant. Large portions encourage people to eat more; as does cheap food. I think junk food, fast

food, soft drinks – any food high in fat or sugar – should be heavily taxed in the same way cigarettes are. Food labelling must increase and advertising high-calorie, low-nutrient foods should be controlled. School and hospital food must be healthy; fruit and vegetables subsidised and de-taxed; and physical activity encouraged. It's a political problem as much as anything else – we have to make fruit and vegetables cheaper to buy than junk food. Fat and sugar are the new nicotine and should carry danger warnings from the Surgeon General. Get out of the car and walk. Throw away the gear stick and dance!

Evidence points to the fact that celebrity chefs have a lot of influence – people trust them and listen to them. People like Rick Stein have integrity, knowledge and passion. They beg the viewer to eat sexy, real food rather than unsexy, mass-produced food. The message is you have to eat seasonal and buy local. Local growers are our lifeblood, literally, and if you don't support them agri-food will take over and you'll be eating hormone-poisoned beef for the rest of your life. I challenge you to deliberately go forth and stuff yourselves with traditional, nutritious food that was made with love. Fast food is often junk food and junk food is a pestilence. Don't think you are saving time by eating 'fast food'. Saving time for what? The afterlife? To watch more TV? To make more money then die of a heart attack at forty-five? You would do yourself a big favour by calmly chopping up a few carrots, throwing some vine tomatoes and a piece of fish in the oven for ten minutes, and opening a bottle of pinot noir.

You are depriving yourself of pleasure by not cooking and you are teaching your children faulty eating habits by letting them eat fast food. A child's sense of taste is much stronger than

an adult's. At birth we have an average of 10,000 taste buds; by the age of eighty only around 3,000 remain. Food like Pizza Hut, KFC, McDonald's and Burger King are loaded with fat, sugar and salt. In fact, according to St George's Hospital Medical School in London, these foods are almost as salty as seawater. Eat fast food for breakfast and you will raise your blood pressure, which makes your heart work harder and sets you up for stress for the rest of the day. If you give a person canned food, you are giving them a factory to eat.

A variety of high quality, fresh ingredients make cooking easier and more enjoyable. Try to seek out the goods of small, specialty producers who are the crafts people of the food world – handmade cheese, jam made in small batches, quality controlled chocolate, good bread made with respect to proper raising time and high grade flour. The word quality means food produced with a commitment to taste and texture, made in the correct way with no short cuts. I don't believe in getting the right ingredients at any price – this is just a fine dining version of the dreaded globalisation – chefs should cook with what's in season and linger patiently all year for heritage potatoes, spring lamb and oysters. If we lose the myriad tastes of regional produce and don't eat food at its optimal ripeness, then we lose whatever food culture we inherited.

SLOW FOOD

The Slow Food movement isn't about cooking slowly, it's about eating slowly, enjoying eating and laughing and talking with your family and friends. Gastronomes and food enthusiasts are

sensitive to the protection of local cuisines, animal breeds and vegetable species. Slow Food works to counter the degrading effects of industrial and fast food culture which are standardising taste. By eating fast food like McDonald's and KFC you are not only having a degrading experience physically, you are disrespecting what it means to have a food culture and the uniqueness that implies. Someone on the other side of the world could be eating exactly the same meal – how unromantic is that?

I love the wholesome, uncomplicated meals that the Slow Food movement encourages. I'm over hillocks of food, I'm over decoration, and I'm over showing off. I want to be able to identify the taste of what I'm eating. If I so much as smell a drop of truffle oil I'll scream. A perfect example of what I mean is the wonderful Italian restaurant, Maria Pia's Trattoria in Wellington. Pia cooks home-made pasta, home-made sausages, home-made bread and simple delicious meals – all made fresh daily. She's swamped – you have to reserve a week in advance. She refuses to compromise and cooks exactly the way her mother did, going so far as to personally bring in fresh mozzarella from her home town in Puglia. She will not serve food that is out of season and out of its optimum ripeness. In late summer she bottles the Italian tomatoes she buys from an old Italian man who grows them in his back yard; in winter she can always have the best tomatoes, with sunshine seemingly still flowing through them.

Regarding slow-cooked stews, do not give in to haste – it will not reward you. Eat with your fingers – you will be surprised how many memories of childhood hand-eating, unpolluted by hard steel forks, will flood back. The fact that we desperately

miss slow-cooked food is evidenced by the extraordinary popularity of the humble lamb shank, which restaurants now can't even take off their summer menus, so afraid are they of the masses rising up in shank riot.

Natalia

Natalia Schamroth is a multi-award winning chef and food writer who, with her partner Carl, runs the fabulous Engine Room restaurant in Auckland. Her unassuming demeanour is in complete contrast to her skill and success. Natalia's exotic good looks and sweet charm make her smile look as if the sun has just come out and poured all over you. I asked her why she cooks and how it makes her feel.

'I cook because I have always cooked – it's in my blood. From a very young age I was cooking in the kitchen with Mum, Dad and the grandmothers. I cook because I am so greedy that I need to be able to cook whatever I feel like eating. Recreating dishes I have eaten the world over and have others experience those tastes is a wonderful feeling. It is immensely satisfying – cooking for others who love to eat as much as I do. Cooking makes me feel desperate to eat!'

'Do you think you should eat what you like or eat what suits your age, body shape and health needs?'

'I think you probably should eat for health if you have a medical condition, but since I don't I eat anything and everything. It's only when I have trouble zipping up my

size 18 stove pipe jeans that I think I should perhaps eat for health. Cottage cheese on Vogel's bread for a week. I eat to experience tastes and textures, not for what it will do to my body, not just for sustenance.'

'Is cooking important and why?'

'Of course cooking is important – how else would we get to eat! It is about sharing and family, tradition, memories, being part of a team. It's about adrenaline (in a commercial environment) and, did I say, eating? I'm not sure which came first, the cooking or the eating. I don't stop thinking about eating at all, ever. When I was eleven my younger sister and I used to come home from school and make Pommes Anna as an afternoon snack. We were happy to wait the forty minutes' preparation and cooking time to have something we really craved.'

'Is your attitude to eating and cooking different from your mother's?'

'My mother is a typical Jewish mother – cook too much, keep topping up everyone's plates, don't leave the table until everything has been consumed, and then there are four more courses after that. And NOTHING gets left, nothing goes in the bin. Fair enough, she grew up with parents who were Holocaust survivors. Mum now cooks because she needs to get dinner on the table (I guess that is what happens after years of cooking for kids). I cook because I want to share with everyone; I want people to taste the good stuff. I cook more extravagantly, lots of extra virgin olive oil, lots of butter, lots of salt (too much she says).'

'What has been your most criminal cooking behaviour?'

'Maybe the avocado cheese cake I made when I was twelve was pretty criminal – and bloody disgusting. Oh and some nutbar I worked for in Israel made me wrap up a whole salmon in plastic and steam it in the dishwasher, but the dishwasher wouldn't do anything but wash!'

'Tell me about your relationship with chocolate.'

'Breakfast. Cote d'or Bouches. Empty box. These are words that spring to mind at the mention of chocolate. My mum once took my sisters and me for hot chocolate in Paris. It was a bowl of liquid, silky, warm ganache and it was sublime. Cadbury's drinking chocolate never has quite measured up after that heavenly experience. Chocolate is definitely a breakfast thing for me. It should be eaten slowly and savoured. It is gold.'

'Where is food and cooking at these days and where is it going?'

'Simple and casual. Obviously organic. I love that farmers' markets are becoming more prevalent. Seasonal and back to basics is where food is headed. I think that is why The Engine Room concept has worked so well. We aim to execute simplicity to the highest possible standard. Molecular gastronomy is funky but I think just a phase. We are loving comfort food, food that is not intimidating. Most of all it is produce driven. People want to know where their food is coming from more than ever before. Then they cook it simply.'

ORGANICS

In his book *Table Talk*, controversial British food critic A.A. Gill says that although he applauds and supports the aims of environmentally careful producers, he thinks 'organic' has been polluted with cynicism, sentiment, sloppy practice and lies, to the point where it is intellectually and practically bankrupt. In his opinion organic does not mean additive-free; it means some additives and not others. Organic does not mean your food hasn't been washed with chemicals, frozen or kept fresh with gas, or that it hasn't clocked up huge food miles. It does not mean the food is healthier, or that it's fresher, tastier or better – or that you will live longer. Organically farmed animals didn't necessarily have a happier life and death. Organic does not mean that the people who sowed, picked, packed and slaughtered were treated fairly or paid properly. Gill maintains that organic has become a them-and-us story: them wot eats cheap battery rubbish and us who eat expensive, designer, snobby, pure food. Organic is a conceit of the well heeled.

Just after Gill's book was published in 2007, a bombshell hit British newspapers. The biggest study ever into organic food found that it is indeed more nutritious than ordinary produce and may help to lengthen people's lives. The evidence from the £12 million, four-year, European Union-funded project is that organic fruit and vegetables contain as much as a whopping 40 per cent more antioxidants. They have higher levels of iron, copper, zinc, vitamin C and flavonoids, all of which cut the risk of cancer and heart disease. Levels of antioxidants in milk from organic herds were up to 90 per cent higher than in milk from conventional herds and had higher levels of omega-3 fatty acids.

The British organic market has expanded in recent years, growing by 25 per cent annually on average, and is now worth nearly £2 billion a year. Organic food is usually around 30 per cent more expensive than regular food and supermarket organic milk is 18 per cent more expensive. Last year a ten-year study by the University of California comparing organic tomatoes with regular ones found double the level of flavonoids (an antioxidant thought to reduce the risk of heart disease). It stands to reason that if your food has more 'food value' necessarily your health will be better.

CHOCOLATE

Chocolate – that heart of darkness, that dangerously addictive drug, that corrupter of cocoa virgins. According to research, six women out of ten prefer chocolate to sex. This can't be true – they must be making love to gerbils. Nevertheless, few foods inspire passion and loyalty on the scale that chocolate does. I think the trick is to combine the two – if your partner says, 'Stop eating so much chocolate, you're getting fat', just go straight to the chocolate box and bring it to bed.

Chocolate sharpens your mind and helps you combat fatigue, insomnia, ageing and uncharitable thoughts. Two squares of 70 per cent cocoa chocolate a day are as effective as aspirin in preventing blood clots. Like most people, I have eaten chocolate all my life and it has always been associated with 'special treat'. As children our chocolates and lollies were rationed; our parents wanted neither high murderhouse bills nor hyperglycaemic werewolves instead of children. Strangely, we accepted this,

which created a culture for us around chocolate: sweet-toothed Dad brought plain dark chocolate home for us on Friday nights after work; our wealthy and doting grandparents brought expensive chocolates in boxes with beautiful ladies on the lid at Christmas time.

But it wasn't until I went to live in France that I became a genuine chocophile, seduced by the blatantly pornographic displays in those precious, glass-plated shops called chocolatiers. In Paris, at Angelina's tearooms on rue de Rivoli, I tasted for the first time a chocolate drink made with real chocolate and cream. You could almost stand a spoon up in it. It took me a while to get used to quality chocolate, with its high cocoa content and slight bitterness, because I had been brought up to enjoy confectionery polluted by sugar and milk. Clearly the work of Satan.

If you have ever tasted a 'grand cru' chocolate, you will know it is like tasting a grand cru wine. Good chocolate can be recognised by its uniform dark, glossy surface and its silky smooth feel. It breaks cleanly in your fingers, and in your mouth it will break with a crisp snap. As you eat it melts in your mouth and you'll be aware of its silky, uncloying texture, smooth but not fatty, and its deep, rich flavour with a pleasant bitterness and a lingering, fruity finish. Are you still sitting up or have you been asked to leave the room?

Chocolate contains small amounts of theobromine and caffeine, which are uppers and which also cause or augment the release of endorphins, natural opiates that reduce pain – the same chemicals that create the runner's high. It has also been found to contain trace levels of anandamide, a substance that mildly mimics the effects of marijuana by acting on the same

receptors in the brain. It increases levels of serotonin, which alleviates depression. The phenol in chocolate, a chemical found in wine, reduces the risk of heart disease by preventing the formation of plaque in coronary arteries. One and a half ounces of good chocolate contains as much phenol as a five-ounce glass of red wine. As you can see from this impressive research, although you would have to eat kilograms of the stuff to get as stoned as you can from one joint, you would be ruining your health by not eating chocolate. Eating chocolate is a form of hooliganism – we don't need it, we want it, and we don't care if it's not sensible.

VEGETABLES

I don't know whether it is because my Irish mother imbedded potato DNA in my cells or because they taste so violently good, but I and the rest of my family have always been mad for them. We are not alone. Over fifty varieties of potato are grown and 87 per cent of us eat them at least three times a week. My sister makes a rather moreish roast potato dish which I demand every time I visit her country seat. The goodness of this dish rests entirely in the choice of potato and the simple method. The fact that they are cooked with love must surely add a soupçon of flavour. You peel the spuds, scratch them with a fork and then roast them. The southern French have only just discovered potato purée; one cannot leave the house without being assaulted by ten different kinds of mashed spud, usually involving olive oil and cream. Never follow a recipe that says, 'take 500 grams of potatoes' – it is the work of the devil because it is extremely

important which type of potato is used in a recipe. The size, constitution, taste, colour and variety all matter. When buying, choose spuds that are firm, unblemished and have soil on them. Washed potatoes are to be avoided just as you would avoid a fast food outlet – walk quickly past and think of sugared violets. When you get home, store your potatoes in a cool, dark place – not in plastic.

All cooks love vegetables – we love choosing them in the shop, cleaning, chopping, smelling and dreaming while we do it. Vegetable cookery is therapeutic, the colours are enchanting and you feel good afterwards. For example, I have always loved leeks – I find them sweet and lovable, especially when very finely guillotined and laid to rest in lots of cream with a little white wine and fresh tarragon or chervil. You know what I mean? Have a glass of rosé and try it, maybe on toasted sourdough. This love of vegetables is in direct contrast to vegetarians, who are just mad and looking for attention. Vegetarianism is a personal choice but you don't do it for health. We need meat in our diet to keep us strong and healthy and to maintain a good fashion sense. Have you ever noticed the terrible way vegetarians dress? Spare me. Researchers made vegetarians eat meat for two months and they became stronger and faster because of the iron. They also put top athletes on a vegetarian diet for a month and they lost strength. That being said, don't eat too much red meat because of the risk of heart disease and cancer. There does seem to be proof that eating super foods like blueberries, tomatoes, spinach and red wine, fights ageing.

BREAD & PASTRY

Something cooks really like doing to calm their nerves and accrue family good points is make bread. I'm not interested in domestic bread makers, although before I stick my nose too far in the air, I do have to admit that I have tasted machine bread with good texture and taste. None of us has to make bread for sustenance – we make it to save on the psychologist's bills. If you can't see the point in kneading bread, do it anyway then come back and tell me it was a waste of time. In the time it takes to make bread and the pleasure it gives you, you will discover you don't need to share your fetid feelings after all. Winter is the time to get into muscle toning activities, such as lifting more red wine to your lips, making rabbit terrines where you chop everything by hand and rip the hazelnuts open with your bare teeth, and producing your own pasta and pastry.

The great thing about making good pastry at home, is that you feel powerful and in control of your universe. It's not easy to make, therefore your friends and family know without a shadow of doubt that if you turn up with an apple tart encased in home-made, handmade puff pastry, you are expressing truly, madly, deeply, how much you love them. Either that or you are a big fat show off and, quite frankly, if you come from a family like mine, where my diabetic brothers call themselves the 'prick brothers' and my nephew opens the school ball dressed in Borat's unforgettable testicular swimsuit, your game needs to be right up there. Anyone can make short pastry – you just work half the amount of butter into whatever amount of flour you have chosen and stop looking for attention. But the thought of making the justly feared puff pastry makes the buttocks of most folk clench.

Real puff pastry requires secret codes, precise turns, subtle finger marks and the Knights Templar handshake. Faux puff pastry simply requires time and patience. Originally, pastry was made from flour and water and was the container in which a stew was cooked – like an oven within an oven. It was hard and inedible. You cracked it open when the food was ready, ate the stew, and threw away the pastry case. Because the peasants were so hungry, they started eating the pastry, which was horrible, so the cooks added salt and some sort of fat like goose fat, lard, oil or butter to make it more palatable. The rest is history – pastry making became an art form and there are chefs in France who have only ever been patissiers all their lives. It's the job of an anal-compulsive mathematician as there is no guess work – everything is precisely measured, worked and timed. There's no pinch of this and pinch of that sort of anarchy. To my mind it's the best job in a professional kitchen, aside from dishwasher, because you have to operate in a cool area away from the madness of the main kitchen.

The reason puff pastry puffs is because the butter is not worked into the flour with the fingers; instead, it is ironed in layers with a rolling pin. When heated in the oven, these invisible layers expand and puff up; producing that most refined of culinary experiences – light, sensitive, delicate pastry, unlike any other kind. You have to keep everything cold, including the rolling pin, and layer the butter in, bit by bit, resting the pastry in the fridge in between each roll. It is so worth it that you would be forgiven for eating it comme ça.

EGGS

We've all had run-ins with eggs – soufflés that went nowhere, omelettes with no yolks because some mad doctor told us it would help our cholesterol, soft boiled ovums where the white was still like snot. And then there's the significant other, who, in spite of years of obedience training, insists on crowding you, the expert egg cooker, while you work. According to exotic animal trainers you can teach a hyena to pirouette and an elephant to paint, so you should be able to teach a partner to stop interfering. Here's the exotic animal training reward part for the irritating, interfering partner: place a bowl of fried bacon on the other side of the room. The exotic animal – your partner – will crawl on his belly to the bacon because no one, including vegetarians, can resist fried salty pig fat. While he's distracted, enjoy your calm space in the kitchen, cooking the omelette. Now serve it to your grateful partner, who will swoon at the primal feast of eggs and butter you have seen fit to place before him.

APHRODISIACS

Except maybe for garlic, which increases blood flow, there's no such thing as aphrodisiac food. This is a pity because we need all the help we can get. Anglo-Saxons are probably the least sexy people in the world after Asian businessmen, Finnish poets and Bolivian politicians. People have talked of the powers of truffles, paua, oysters, crabs, crabapples, skink (the reptile), the blood and still-beating heart of a snake, and a variety of endangered animals. Some people believe the boundless enthusiasm for aphrodisiacs through the ages ultimately represents mankind's

search for life's essence, for a divine substance that, like gods and goddesses, has the power to beget and prolong life and, like the foods those deities eat, will provide ecstasy, energy and immortality. In other words, if you eat what a goddess eats, you will become one sexy mama.

The belief that some foods are aphrodisiac is irrational, metaphysical and arbitrary, like religious dietary restrictions, sacred food, forbidden food, vegetarianism and allergies. Very, very few humans suffer from genuine food allergies and there is not one skerrick of scientific proof that any food enhances sexual arousal or performance. The belief that certain foods are magical or linked to sexuality is ancient and occurs in cultures of every level of sophistication. The only possible explanation for these beliefs is that they make one feel part of a group, give one identity and permit one to make outrageous culinary demands in restaurants. I don't agree with chefs who pander to this irrational neuroticism. A chef spends hours composing and testing a balanced menu for diners – it is extremely impolite to ask for changes to satisfy your ego. However, I would say, just as you can tell what a man is like in bed by the way he dances, you can make similar deductions by the way he eats asparagus. The only connection between food and sex I can think of is that they are both very sensual experiences and that you only have to break a fig open to get a sexual message. Could anyone miss the metaphor of an oyster? The truth is, all food is aphrodisiac, all food cooked for a lover is sensual. Food has the power to transport you with happiness and love and we all know that eating and dancing lead to sex.

GOOD HOSTS

Good hosts fit into the category of people who nourish their guests in such a way that it is only afterwards you realise how rare and sophisticated fine hospitality is. The good hosts I know and love usually do not come from a background of hospitality but instinctively know how to pander to different types of guests. Bad hosts usually feel it is their duty to entertain and elucidate. I will request elucidation if I wish for it.

Husbands are usually more sinful in the compulsive sharing department. Men can sometimes be slow on picking up social clues such as a guest hiding in the linen cupboard, a guest's head falling into their soup bowl, or a guest reading in the field out back with earplugs in.

Good hosts not only nourish your body, they provide food for thought. They are not only interested in what goes into your mouth but also in what comes out of it. There are not only many courses, but also much discourse. Good hosts don't deal in polite, no opinion, no risk conversation. When they're not in the kitchen they're at the table expecting you to show signs of intelligence or to say something they don't already know. Just as a dinner party can be a blood sport; it can also be the closest thing you get to an Oxford debate if you're lucky. Exotic table linen, a candelabra, crystal glasses and silver cutlery mean nothing. Anyone can do that. Not everyone can make the food and the conversation good. The mark of a good host is knowing when to stop; so is it the mark of a good cook. No fussy confusing of flavours – just honest, clean, properly cooked food. It's not till your host has closed the door and you're out on the street that you'll be overcome by how much you have missed being in the tender embrace of good hosts.

WEIGHT & HEALTH

The world is full of people who count calories (surely the most criminal activity ever invented), measure kilojoules and check the protein content of each ingredient. Apparently they do this in order to be able to work well and to look good. The only way to lose weight is to eat fewer calories than you use. If you eat more calories than you burn, you will put on weight, no matter how much you exercise. If you eat fewer calories than you burn, you will lose weight. All diets are the same and they all work on this principle, no matter what fancy language and techniques they use. Dieting has sadly become a part of women's lives, as if working, running the world and populating it weren't enough. It is unbelievably difficult to have to care about how much you eat. We all know how it works – you eat what you want till you're full then you do it again at lunch time, then you do it again at dinner. You have done this all your life and you've always been a normal weight for your height and age. And then one day, without changing anything, you're not your normal weight. The horrible, wicked thing is that you're older; hormonal changes mean that you don't need as much food. That's the simple fact of it. So you are faced with the ghastly proposition of limiting the one thing that gives you the most pleasure the most often.

A really good way to not enjoy food is to believe the rubbish you read about it. Take detoxing for example. As a registered nurse, I have never believed that the normal body is toxic. Research has finally shown that our bodies are extremely efficient machines that automatically detox – they don't require any help. I went to the Golden Door health retreat in Australia once and subjected myself to no sugar, salt, coffee, wheat, meat,

dairy, fat or alcohol for a week. Instead, I ate mountains of fruit and vegetables. At the end of the retreat I felt no different, had lost only two kilograms and have never driven so fast to a hotel with unlimited supplies of gin and tonic in my life.

GLOBAL FOOD TRENDS

In terms of global trends, London chefs are still doing fusion, but other chefs at restaurants like the River Café and Moro are getting simpler and simpler, with the emphasis being on the quality of the primary ingredient. While Peter Gordon is whipping up such exotic treats as wasabi marinated beef with green mango and nashi pear, smoked lamb with tamarillo and ginger salsa and chocolate stew with quince aioli, other 'modern British' chefs will offer salt-roasted organic chicken with braised vegetables and that's exactly what you'll get – the most beautiful piece of bird you've ever eaten with just its juices and some braised broad beans, peas and artichokes. Or you'll get a slice of wood roasted fish with capers and parsley on your plate and a small hillock of wilted chard. In spite of what people say, fusion food cooked by experts is still alive and well in Europe, especially France, where they are slowly emerging from under the yoke of tradition and experimenting a bit more. Lighter, cleaner food is definitely on the menu – this year the Michelin Guide said that Tokyo now has the best food and cooking in the world.

The big trend in terms of food is that the privileged world now lives to eat rather than eats to live. People are living longer, are more affluent, and are more frequently eating for pleasure and demanding up-market, sophisticated products. Lots of

niche markets are being created. People want a peak experience – they want to die with only the memories of the great meals they have eaten. Who would have thought that boring old salt would become a designer product? Consumers also want to know exactly what they are eating and what's in it. They want it to be safe, promote long life and health, and not harm the environment. But most of all what people want is taste. We must continue to produce food that tastes good and is good for us.

Exhaustive research has now given us the final word on nutrition and health: Japanese eat little fat and have fewer heart attacks than we do; Mexicans eat a lot of fat and have fewer heart attacks than we do; Chinese drink little red wine and have fewer heart attacks than we do; Italians drink gallons of red wine and have fewer heart attacks than we do; Germans stuff themselves with beer, sausages and fat and have fewer heart attacks than we do. The conclusion of this research is obvious – eat and drink what you like. Speaking English is what is killing us.

WISDOM GAINED

- The happiness food brings is fleeting, thank God, which necessitates frequent repetition.
- Eat what you want – a little bit of what you fancy does you good.
- Your body is a temple with curved walls.
- Cook when you feel the urge but only eat when you're hungry.

3
RELATIONSHIPS: RELAX – WE'RE ALL DYSFUNCTIONAL

I've always gone into relationships with my fingers crossed – it might have been a better idea to go in with my legs crossed, but hindsight is a wonderful thing. Secrecy in relationships, like fear, is a lonely and cancerous path. One day in the nineties, a friend gave me a book about commitment-phobic men. I read it avidly and all I got out of it was that I was a commitment-phobic man. In my parents' day, a woman who was over thirty and single was usually either a widow or had bad posture. In the noughts it is more likely to be because she's divorced or she chose to never marry. Of course, throughout history there have always been women who were 'different' – the bohemians, the Isadora Duncans, the upper-class heiresses who knew no rules – but in the noughts there are many more relationship, professional and personal choices. A fifty-year-old woman today is nothing like a fifty-year-old woman a generation ago – she even looks different.

FAMILIES

Everyone thinks they were brought up in a dysfunctional family. The truth is that most families are dysfunctional, most have some level of violence, even if it's only screaming, arguing or a few whacks disguised as discipline. Some have sexual abuse and all have bad taste in wallpaper and appalling toothpaste etiquette. I believe that the nuclear family doesn't work for a lot of people and is not in the best interests of sanity, happiness and the even distribution of compliments. The family should be re-extended to what it was in the past – there's less pressure on everyone that way. Children need access to other caring adults apart from parents – they need to have great relationships with adult relatives, friends, teachers, et cetera. Giving the job of bringing up children to just one or two people is ludicrous and drives everyone nuts – it takes a committed community to do the job. My parents always used to joke that they couldn't believe how low the child mortality rate was.

EARLY INFLUENCES

The first boy I fell in love with was in my class at school. We were both five. The nature of my relationship with the opposite sex was one of total disinterest until I met Marcel. I wanted him because he was beautiful and sweet. At the tender age of five I was fantasising about this round-faced cherub with olive skin, dressed in a black uniform and blazer that reached his knees. I knew I wanted to marry him even though I had no idea what that meant. God knows what I was fantasising about – I had zero information on the subject of boys/sex/love. Who would think

a five-year-old would need such data? Nevertheless, I sat on my pink candlewick bedspread surrounded by dolls, just being in love. For hours.

Our family villa had four bedrooms, all with big sash windows, a wide, high hallway and a large sitting room that no one ever went into. That room was for special guests and full of valuable ornaments, polished brocade furniture, embossed wallpaper and flowery carpets. Out the back was a yard with tree huts, flowers, vegetables, chickens and fruit trees. All summer we picked passion fruit, peaches, apples, oranges, lemons and plums. My siblings and I lay next to the asparagus garden and ate the tender shoots as soon as they were long enough. We always got into trouble for doing it but couldn't stop ourselves. Sometimes I sat under the drooping pepper tree with my biscuits and milk and dreamt about Marcel. Most of the time I sat under the pepper tree and screamed. It is a little-known fact that I invented Primal Scream so that I wouldn't kill my mother. I didn't get a penny for it. Years later in California, Arthur Janov took credit for encouraging people to get in touch with primary experiences – the biggest waste of time ever invented, after organised religion. If the primary experience was crap the first time, what makes you think it won't be crap the second time? The trick is, you have to scream the first time. If I hadn't got it out then, I'd be in the cuckoo's nest now.

But back to Marcel. He didn't want me and neither did any other boy. When I smiled at him he looked at me blankly. When I gave him my sandwiches wrapped in luncheon paper he ate them without a word of thanks. When I sang little songs for him he laughed. He and his friends made me sit on the boys'

seats under the huge flowering tree by the basketball court on my own because I had a boy's name. The girls' seats were on the other side of the court. The nuns didn't have to keep us separated at that age – we did it naturally. Not only a physical rejection of my girl appeal but a rejection of my identity – my name.

'You have to sit on the boys' seats because you've got a boy's name.'

'I do not. It's a girl's name.'

The clouds boiled black over my head as I sat very straight, hardening in the playground of my life. They all wanted Vanessa, who was Grace Kelly in miniature and a typical girlie-girl. I knew how they felt – I too was charmed by Vanessa and carried her school bag for her until I finally got a life. In the get-a-life department I didn't do well initially, but I caught up fast. Something had to be done about the fact that nobody liked me, that I felt and looked like an alien, and that I wasn't Vanessa. Who would be my friend in these circumstances except other losers? And how was I going to get a husband out of this?

'Sticks and stones will break your bones,' said the mother, looking up from her book and latest baby, 'but names will never hurt you.' This is a lie children are told to cut down on future psychiatry bills. I was a zero in the fitting-in department and like all children, desperately wanted to be a fly on the wall – not king of the flies, just a fly among others, but it was never going to happen with a stigmata like Peta. The names cut deeper than any beating could have and they galvanised me into action. By the time I had sat on that bench a few more times and felt the full force of social exclusion, I started seriously looking around for a new persona. I could see that I would never be as pretty,

blonde, ladylike and indifferent as Vanessa. I decided instead to be smarter, funnier and more staunch. Once I had achieved that they could all kiss my bum. It worked, eventually. Could it be there was a God after all? Being funny worked wonders – it made me slightly more popular, took the edge off my unhappiness at being ugly and unloved by Marcel, and it covered up the fact that I had an unusual name which was unforgivable in 1954 New Zealand. Would the list never end?

Time passed. Marcel became 'Marcel Who?' In my teens a medical, sexual and social revolution occurred – the invention of the pill. The invention of the birth control pill happened ten years after the introduction of television. TV and Pond's beauty cream had, up until then, been the chief forms of birth control. Women slapped buckets of thick face cream on their faces before going to bed to keep their husbands off them. Families who had previously talked to each other, sung around the piano, or read in the evenings were relieved of that burden by the box. Soon afterwards, another social revolution hit – feminism. You can imagine, we were reeling.

In my early twenties, everybody was reading Germaine Greer's *The Female Eunuch*. I went to hear her talk at the university and was desperate to be just like this Amazon queen. Greer was beautiful, statuesque and brainy. She was also raunchy, slept with rock singers and derided the institution of marriage. By this time I suspected marriage was for the birds anyway – not because I knew what I was talking about but because I was a natural subversive. Germaine said the formal, sanctioned, privileged and symbiotic nature of the marriage contract was not to women's advantage. I didn't think the nuclear family worked anyway and

couldn't see what possible advantageous deal marriage held for me – aside from the chance to make a new dress. And there was the ravishing, bawdy, funny Germaine up on the stage, biliously raging at the middle-class myth of love and marriage. She said get real and get a life; we said okay and kept dancing. It was also a great advantage to men to embrace feminism because they were more likely to get laid. They couldn't believe their luck that liberated girls didn't have to be talked into sex.

As a young woman, like anyone else with a brain, I was in revolt against the assumed conformities, the bland hypocrisies and comfortable conceits of society. As hippies and refugees from the middle-class my friends and I thought only the present held meaning. Not only did Catholicism not mean anything anymore, but marriage was now seen by me as slavery at worst and very uncool at best. Who needed to tie themselves to one person? Who needed a piece of paper anyway? We saw ourselves as heroes and revolutionaries. There was a fantastic sense of belonging and community – us against them. We felt very powerful and utterly convinced that we could change the world. In fact the world did change. Things like healthy organic food, loose hippy fashion (which has now come back around twice), having an intellectual life, care for the environment, meditation, et cetera – which are a normal part of life now – were initiated by the hippy generation. In the nineties the tedious new agers were acting like they only just heard of chilling out – they probably had. My friends and I were so chilled out we sometimes didn't move for three days. We were walking cucumber patches – cool as.

MILLS & BOON

One day when I was in my forties I decided to write a Mills & Boon romance. How hard could it be? I had never had the motivation to get past the bad writing and actually finish reading one, but I thought I could write one. They seemed so innocent – a predictable story in which all they do is kiss. The starter pack suggested I read some recent releases, so my friends and I went out and bought three romances to get a gist of the style. We read them to each other, screamed a lot, laughed a lot, and discovered the most amazing thing: the reason they sell millions of copies to all those home executives is S-E-X. Yes siree. Mills & Boon is basically soft porn. We nearly went blind reading them – by page fifteen the hero was 'probing the heroine's depths with experienced fingers'. I won't repeat what they were doing by page fifty. Initially, I thought that no one could possibly relate to anyone in these stories. I mean how many rich, handsome, masculine sheep station owners can there be? The answer is, who cares? What's so great about real life? The station owners behave like no man has ever behaved towards these readers. It is socially sanctioned female pornography, I tell you. You can buy it in the supermarket, just like toilet paper. Contrary to a reader's husband, the hero in the book has a fabulous body, is a sexual paragon, polite, romantic, and completely and utterly besotted with the heroine.

EDWARD DE BONO ON COMMUNICATION

I like Edward de Bono and I would like to talk about thinking. I am fascinated by his concept of going beyond analysis, ideas

and the search for truth in the old Socratic way, and pushing forward to something more creative and constructive. He talks about parallel thinking, being more concerned with what can be than what is, accepting possibilities without judging, accepting both sides of a contradiction, then finding a lateral, creative way forward. Everybody hates change and we often assume that it is an innate, genetic part of human nature. What if we just think the way we do and resolve problems the way we do because we are brought up with a philosophy which is not designed to deal with change? Take arguments, for example. I like arguing to a certain extent. I'm very black and white – right and wrong, win or lose, yes or no. I think aggressive to-ing and fro-ing and verbal conflict is constructive and I think you need a clash to get at the truth. But arguing adversarially is a massively impotent and bleak way of going about things. De Bono likes looking at different approaches and doesn't see why we can't maybe mix the two ways of doing things. It's much better to use your intelligence and be creative and constructive. It's all in the mind. There is no right or wrong – there are many solutions. If I feel I am right about something, it doesn't necessarily make the other person wrong. 'Truth' is a con. We humans are usually bigger on form than on content.

MARRIAGE & FAMILY

Married women are now a minority. Women now live so differently compared to the way their mothers did that it is almost like a new social order. Women may live in an unmarried state with their partners, be single, be openly gay, or live with

other women in rather sophisticated shared households. They want to be free, but not necessarily alone. For many years I lived in a shared household – it was like grown-up flatting. A beautiful house in the best area, a house-keeper, the newspaper delivered daily, a gardener, and a bathroom each.

Modern marriage was originally a property relationship that passed the ownership of women and all their chattels from father to husband. In this era we are experiencing a revolution in marriage and family life, but not because of a lack of respect for the institution. In fact, those who do it have a greater sense of personal obligation, love and mutual respect. Experts say we still take marriage terribly seriously and only split up after a prolonged and quite agonising appraisal of the situation. The overwhelming reason for divorce is infidelity; after that comes a partner's behaviour. Marriage no longer organises social life the way it used to and it will never do so again. The revolution in marriage is occurring because society can no longer dictate personal choices and women can now look after themselves. Also, the link between marriage and child rearing is weakening. In the old days, women married for protection, financial security, social position and political, business and religious alliances. It is only in the last 200 years that people have entertained the concept of choosing their own partner based on love and we now have the expectation of mutual love and intimacy. The problem with the invention of marriage for love was that soon people saw no reason to stay married if they weren't in love any more. Women's lack of choice was one of the main reasons marriage was so stable.

For an educated, middle-class woman, marriage is no longer

the most secure way to invest in her economic future. In my chapter on work we will meet Leslie Bennett, who wrote *The Feminine Mistake*. She suggests it is an extremely high-risk choice to give up your financial self-sufficiency and rely on a man to support you. Marriage no longer provides the only place where women can raise children. Yep. Marriage has changed irrevocably, which doesn't mean it's doomed – it means it has to morph to stay relevant. There is no way people in future will stay married forever, so we have to open the whole thing up to make room for single parents, extended families, fused divorced families, unwed couples, and gay couples. To a large extent we are already doing it – in Australasia, between 2003 and 2004, one in ten people changed their family type. A lot of people under thirty-five left partners and moved into a new living arrangement. Eleven per cent had their first child. Young people change their situations more often than older people and children adjust to all sorts of changes due to family fluxes. It appears we are a constantly moving population. It also seems we are having fewer children and predictions are that by 2012, DINKS (double-income-no-kids) will overtake couples with children as the main New Zealand family type. This is not as bad as Germany, where it's predicted 30 per cent of women will not have kids.

So we're still doing it, but we're doing it differently – the way we live within marriage is changing. Architects and social scientists predict that by 2015 most new houses will have two master bedrooms – one for each partner. This is not only to save your sex life. It is because of complicated work schedules, women making more household decisions, maybe earning more,

and just the need to get a good night's sleep. Men and women still want to be together, but not completely stuck together. They want more independence within the relationship, separate accounts, secret accounts, even separate social lives. Basically, in the past people married for money or beauty, now they are looking for loyalty and kindness. Personally, I would marry someone who is good at housework, excellent at doing dishes and a whiz with cocktails.

Does marriage make us happier? Yes, but only a little and only in the first blush of love. After that, people go back to their pre-marital level of happiness. The bottom line is, if you were happy single, you will probably be happy double, and happy people tend to have stable relationships.

FRIENDSHIP

Everything you always thought women talked about when they're together is true. We talk about sex and men. Here's a conversation I had with two girlfriends last year in a crowded bar in Paris.

'Hi'

'Hey'

'Hi'

Me: 'I'll have a Kir. Are you two having Bordeaux-as-per-usual-God-forbid-you-should-change-your-ways?'

Lucy: 'Shall I tell you what happened on my date last night?'

Me: 'The boring dentist with homely looks and bags of money? Let me guess. Was he a boring, rich dentist, none of which turn you on?'

Lucy: 'Well yes.' All eyes roll. 'But he was nice. What do I do if he calls again?'

Me and Cynthia in unison: 'Say no.'

Lucy: 'But just friendship.'

Cynthia: 'No!'

Me: 'So how's your sex life Cynthia?'

Cynthia: 'Great but I want to talk about orgasms.'

Me: 'We've only been here five minutes.'

Cynthia: 'Look, I'm sorry if this is too much information, but I don't seem to be able to do it while having sex but can do it any other time.'

Lucy: 'Teach him how to do it, what position you have to be in, et cetera. I have to be on top otherwise there's no connection between the you-know-what and my clitoris.'

Cynthia: 'Oh, okay. What about the G-spot type orgasms?'

Me: 'No such thing as far as I'm concerned. I have devoted years of selfless research to this one and if I don't have a G-spot or can't have a vaginal orgasm then they don't exist.'

A conversation then followed where it turned out no one actually knew where the G-spot was supposed to be.

Cynthia: 'Is it possible that all women are different and some people have G-spots and some don't?'

Me: 'Yes I would be prepared to look at that possibility. All fancy anatomical peculiarities aside, when did you have your first orgasm?'

Lucy: 'When I was young, swimming – swimming used to make me come and it wasn't until I grew up and had orgasms during sex that I realised it was the same feeling.'

Me: 'I was sitting on the couch and without touching anything,

it happened. Then, of course, I couldn't stop.'

Cynthia: 'I became very good at sliding up and down poles at gymnastics.' Everyone screams. 'OK so what about clitoral ejaculation?'

Me and Lucy: 'Heard of it but don't think we've done it.'

Lucy: 'What about brain sex?'

Cynthia and me: 'Brain sex?'

Lucy: 'Yeah you know, in your dreams. You just wake up and without having touched anything you're in the middle of an orgasm?'

Cynthia and me: 'Oh yes – often.'

Me: 'Much as we love having sex with men, do we all agree you have better DIY orgasms?'

Cynthia and Lucy: 'Yes.'

I stand up to go. As I do so I notice two perfectly good-looking, friendly men sitting next to us. We were so busy blabbing on about the sex we had had, the men who had got away, and what we would do to the next man we met, we didn't see them.

In among our conversations about sex and men, we women intersperse other information. It would be quite common to talk about sex, art, how to make plum chutney, if the phone doesn't ring that'll always be him, work issues and bras and politics all in one chat session. Believe it or not, even the most undomestic goddesses exchange recipes. Don't get me started on my friend Gwendoline's mother's steak pie – that rave went on for twenty minutes, mostly centred around the difference between English and French methods of making pastry; to kidney or not to kidney; the fact that she once made this pastry with lard left over from the roast for the boys in a single men's hostel.

We need friendships because we are a tribe and the tribe protects us from danger. We need to gather round in times of richness and in times of paucity. Female friendships replace family – they usually last longer than relationships with men. We need our girlfriends for support when that bastard employer or husband finally decides to make us redundant. A real girlfriend will ask important questions like, is he bi-polar, what was he wearing, tell me about the body language, does he have rashes, why did you let him live? This information allows friends to pass judgement. A male friend would just say, get over it. Teenage girls need a lot of friends because no other human being can communicate with them. There's no worrying or guilt when you're with the girls – it's natural and uncomplicated. No pressure, no joke is too stupid, no one ever says 'You can't do it' or 'You're looking tired', no idea is too outlandish. You can do without just about everything except food, water and friends.

Women have very intense friendships which sometimes explode, never to be retrieved. You may put up with bad behaviour for months, sometimes you put up with it for years – maybe thirty years – then one day, just like that, you've had enough. The reasons for 'having enough' are varied – women betray each other, lie, are malicious, jealous and competitive. The most interesting thing is that women's friendships can end very abruptly, with one friend never knowing why. The friend just stops talking and never talks again. We never do this with lovers when we want to end a relationship – we scream, we cry, we tell them exactly why and how they have failed us then we threaten to kill ourselves, or worse. I don't think men dump their men friends. I think it is a female thing. Male friendships seem

to centre around doing something together, whereas female ones are talk orientated and don't need topics to be introduced. You pick up the phone and immediately say, 'I think you should definitely get the green one.' Men don't get the small stuff – they would go mad talking about a pie for twenty minutes. They call a spade a spade and think it really is a spade. How can you be sure? Maybe it's a shovel or a trowel or a hoe and we haven't even talked about colour yet. Men look at the big picture. Why? You might miss the 37,000 small pictures on the way. We do poignant; they do straightforward.

MOTHERHOOD

Being childless, I am an expert on motherhood. This joke was written for me: 'There are two kinds of people in the world: those who have children and those who don't. And those who don't, don't know that there are two kinds of people in the world.' Writer Rachel Cusk said 'motherhood is a career in conformity from which no amount of subterfuge can liberate the soul without violence ...'

Fortunately, some women still do have children, but like relationships, motherhood is not as we knew it. Maybe motherhood has never been what we thought it was? Many of my friends, although they adore their kids and turned out to like motherhood in the end, told me they failed to understand why their own mothers participated in the conspiracy to gloss over what childbirth and motherhood was really like. Why didn't you tell us how hard it was, they asked? Because we didn't want to put you off, their mothers replied. In her book *Mommies*

Who Drink: Sex, Drugs and Other Distant Memories of an Ordinary Mom, American author Brett Paesel tells it how it is and not how everyone pretends it is. Her funny, outrageous book caused an uproar in the US, with one lascivious chapter even being banned in Oregon. Paesel basically boozed her way through the shock of having toddlers and then wrote a book about it. How do you balance motherhood, drinking and having sex? She explores the common bond that either unites women in friendship, or polarises them in wildly opposing camps. Every Friday, Brett and a group of her closest friends meet at a local bar. Here, they address the issues they face as they brave the new world of motherhood. The secret question on their minds at playground is 'what time of the day is too early to start drinking?'

Some new mothers suffer from post-natal depression but Paesel explains that if you have been free for thirty-eight years then suddenly have to stay home with a small person who is completely dependent and screams all the time, have had a C-section, are bloated, feel helpless, and don't know anything about children, it seems unlikely you wouldn't be depressed. It seems like a normal reaction. Maybe even sensible. To make herself feel better she dreams of finding books that would help her. They have titles like, 'What Parenting Experts Do Not Want You to Know About the Secret Benefits of Cocaine' and 'Smoking: the Road Back to Sanity and a Good Figure'. What really saves Brett is not alcohol but good friends and a sense of humour. At the bar they discuss really important motherhood issues like their weirdest sexual fantasies, smoking dope with your husband while your mother-in-law babysits, and how to schedule a hangover so it doesn't interfere with the children's

play dates. Brett becomes a celebrity at her kid's daycare centre when her son tells his teacher he saw Mummy sitting on Daddy's head early one morning.

Mothers have a tough time of it. Everyone – the state, media, school, sisters-in-law, and supermarket – judges them on whether they're good or bad. They are judged on what they feed their children, how much television they watch, how many times they say 'fuck' in front of them, the hideous names they saddle them with for life, how they dress them, and the extra-curricular activities they force them into. Now it's fashionable to make motherhood glamorous rather than admired, so we have yummy mummies, slummy mummies and celebrity mummies.

Another mysterious fad is the admiration of celebrity mummies who 'get their figure back' after childbirth in five minutes. What's wrong with looking like a mother? You are not a nubile young woman anymore – you've had a baby and that is something to be proud of. Why do woman want to look like they're not mothers? It's normal to miss the body you had before, but it's not normal to want it back exactly as it was.

MOTHER'S DAY

Hail to the gentle, tender army – our mothers. On Mother's Day I interviewed the mothers in my family to enquire upon their most memorable Mother's Day culinary experiences. The responses varied from 'too exhausted to remember' to 'burnt toast and cold weak tea'. All of them said the most important thing for them was not gifts or food, but kind and thoughtful

actions to show all their hard slog was appreciated. Most of them also expressed distaste for the commercialisation of their special day. The woman who instigated the original official observance of Mother's Day in 1910 objected bitterly to this too, saying she had wanted it to be a day of sentiment, not profit.

If I were a mother I would want a really smashing English breakfast of kedgeree, poached trout, crab legs, kippers, fried black pudding, stewed fruit, porridge with honey, cream and whisky, and more whisky on the side. At lunch I should like to be served roly-poly pudding with lashings of whipped cream. I wouldn't need any other food – just multiple servings of what must surely be the ultimate comfort-mummy food. I would want to do nothing, absolutely nothing, for the rest of the day. Everybody should do everything for me – dress me, brush my hair, drive me to the seaside and sing me to sleep.

GAY GAY GAY

There are lots of stereotypes around gay relationships. What do lesbians take with them on the second date? The furniture. What do gay guys take on the second date? What second date? However, some of these jokes are based on reality, simply because that's how men and women behave. In general, gay men are more appearance obsessed and promiscuous than gay women; lesbians are into sexual fidelity and their relationships last longer. Meeting lesbian partners online is becoming more and more popular and is huge overseas, particularly London. The online lesbian community are in solidarity and the sites feel comfortable and cosy rather than a bit scary. The main reason

straight relationships last as long as they may is because of the woman – she forgives bad behaviour, she compromises, and she sees long-term benefits of maintaining the relationship. Gay men say they manage 'openness' better than straight men; gay women are not interested in sharing at all. Touch my woman and I'll break your kneecaps. Research shows that the main reasons for lesbian break-ups are money problems and infidelity. Women don't like that – it is the main reason for straight break-ups too.

Lily

Lily, an attractive forty-year-old lawyer, was married for ten years, and has three teenage children. Since her divorce, she has been in three relationships, all of them lesbian. She is happily in love with her girlfriend. I asked Lily if she thought gay relationships were different from straight ones and, if so, in what way. She opened her eyes wide and answered.

'They are completely different. They are more profound, more intense and more intimate. A woman has the ability to know you better than a man can, cuts straight to the chase, and cares to know you very deeply. Men and women are socialised into having very clear roles, just accept that they are very different, and hence don't necessarily ever understand each other beyond a very simplistic level. The result often leads to them having separate lives and so they become strangers and they are more likely to give up on the relationship. Or, at the expense of their

own happiness and fulfilment, they stay together for all sorts of reasons like money, children, career, social status, et cetera. I think that's why heterosexual women have such intimate friendships – because they feel men are not good companions.

Lesbian relationships are more likely to be deep and meaningful and it is less likely lesbians would ever accept a superficial level of existence. From my own experience, a lesbian relationship requires each partner to actually be present on both an emotional and psychological level. A deeper and more open level of communication is required and, although this can be quite scary at times, it leads to a much more loving and trusting relationship. This obviously has a positive impact on one's sex life!'

'At your age, did your mother manage relationships the way you do?'

'Absolutely not. Mainly because my mother has never done any work on herself. I think that until she is prepared to confront herself and what happens in her life she can never improve her own (heterosexual) relationship. When I look at my mother and her partner I feel sad for her as their relationship appears very empty and unsatisfying and her behaviour confirms this. For me, on the other hand, I have always tried to improve myself and have no problem visiting my therapist on a semi-regular basis to talk things out and get feedback, and I honestly believe that has a direct positive impact on all of my relationships. Let's face it, there are issues all of us would rather not talk about with our friends and my therapist is able to tell me that I am

sane and whole. I learn a lot about myself by doing this.'

'When did you realise you were gay?'

'Long ago – as a child. Well . . . you always feel you're different, but when you grow up in a middle-class, fairly conservative environment you learn very quickly to mask that difference and go with the status quo. I didn't just become lesbian overnight. I was socially constructed to be heterosexual, to get married and have babies. My father would always start a conversation with, "When you get married . . ." After a few secret liaisons with women it just seemed easier to play the heterosexual role. Not to mention how unusual it was to be queer in those days. In contrast, my own children think homosexual relationships are just as normal as straight ones, and so I'm fairly sure that if one of them were gay, it wouldn't worry them.'

'How do gay women meet?'

'Well, the same way straight ones meet men! However, there are fewer of us, so it is probably more difficult. Our gaydars sharpen up over time and generally we can spot each other – by body language or a particular style or look . . . It's very acute – a tiny eyebrow movement is often all that's needed for a woman to know another woman is gay. We meet in ordinary social circumstances.'

'What's the secret to a happy relationship?'

'Trust, openness, and an ability to surrender oneself. If you are lucky enough to get this right then your sex life can be so much more intimate then you've ever imagined.'

WISDOM GAINED

- Secrecy in relationships, like fear, is a lonely and cancerous path.
- It's never too early in the day to drink if your kid has just vomited on you.
- If you are a happy single you will probably be a happy double and happy people tend to have stable relationships.

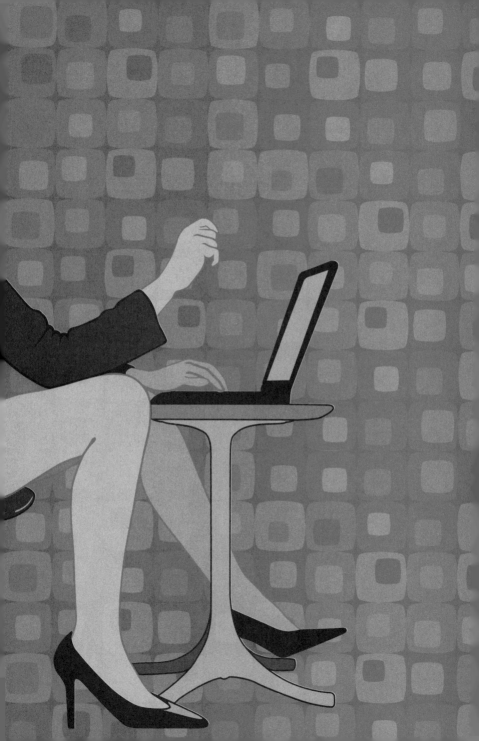

4
WORK: IS IT A PERSONALITY DISORDER?

They say if you do a job you love, you will never have to work a day in your life. I say it is more likely that most people work for money and that job satisfaction is an optional extra. Some people work all their lives in jobs they dislike because needs must. A few lucky ones get it right and do what they love right from the start. In my father's day, you had a profession for life and got a watch at the end of it. These days people change careers three to five times in a working lifetime and often change from a job for which they were highly trained to one of the imagination and self-expression – they follow their hearts. I think my case is typical of many in my generation – I have changed careers four times, each time because I no longer loved the previous one. Because I don't have a family to support, the likelihood of having to do a job I disliked was slim. Even so, it took me a long time to find the perfect job, which I now feel I should have been doing

from the start. Here's my theory: the jobs you are doing as an adult should be associated with what you were good at at school and to be successful you have to know what motivates you.

If you were good at performing arts, English, French and composition – don't become a nurse. Train to become a writer and television presenter right from the start, don't fall into it when you're forty-five. This is a good example of time wasting and delayed development. The tricky part is sometimes you have to be a nurse, a counsellor and a chef to find out that you are a writer and an entertainer. The upside is, by the time you're forty-five, you don't need to train, you just drop into your new life. You've spent a lifetime gaining experience, confidence, trying out tragic fashion combinations, falling for the wrong men and becoming opinionated – you're ready for your real life.

When I was in my early forties I went to a public speaking course to help with my work as a counsellor. The first thing the leader said was, 'Hello', the second was, 'You are in the wrong career – you are an entertainer.' What rubbish, I thought. A few years later, the executive producer of what was then called the lifestyle division of TVNZ called me and proved that my missionary complex could be put to better use.

My advice is 'diversify' – it's very trendy. We are often betrayed, let down and used by employers. When this happens to me and I am lying on the floor in shock, the advice of most of my male friends is, drop it, flick it, move on, and get over yourself. The advice of my female friends is, those bastards, don't let them get away with it, but don't make too much of a fuss. My own method of dealing with employer treachery is, Don't Fuck With Me. So far it's worked. Most employers don't expect you to stick up for

yourself and most employees don't do it. Work dishonesty for me is dealt with in the employment courts, in purple prose and a willingness to indulge my inner James Bond. I also have a very good lawyer who I've never paid a penny in my life. The Don't Fuck With Me system of employment negotiation is directly inherited from my fighting Irish mother, who didn't take any crapola from teachers, Protestants, grocers or priests. She was a small, good-looking woman. She wore a combat outfit that was very stylish usually; it distracted the unsuspecting head teacher, or whoever, from the true nature of what they were about to experience. If she meted out tough justice at home, it was nothing compared to what anyone else who treated her children unfairly got.

EARLY INFLUENCES

In my childhood, the confrontation between the mother and the nuns was a formality more than anything else; a scene oft repeated through the years was played out. The prosecution (the nuns) made it clear that I was skating on thin ice and being a brazen hussy was the least of it. The defence (the mother) denied the accusations on principle, regardless of what they were, flashed her eyes and cited our impeccable family background. The prosecution then threatened the 'E' word. The scandal of being expelled was on a par with getting pregnant or having sex with a weta. The 'E' word was always whispered with the whites of the eyes showing. It was lucky the mother always took our sides. She was going to need the practice. When one of my brothers refused to cut his long hair or play what

he called dickhead, violent football at secondary school, he was suspended. The mother was down there in a shot in her best outfit, eventuating in my brother being the first brilliant senior student at St Peter's College to be excused from rugby and allowed to keep his pony tail. In spite of the brothers, he grew up to be a wonderful person. He still hasn't cut his hair and he's now fifty-seven. Technically this is called non-recovery.

When we're young, most of us work madly to achieve fame and fortune, support our families and achieve. At my age of influence, I started to meet hippies who were into free love, peace and sharing, not being bourgeois, capitalist losers. This was a new concept for me and although a very radical one it made sense. My friends and I talked for hours about Alan Ginsburg, who told us to drop acid to understand the meaning of the universe; Jerry Ruben, who said don't trust anyone over thirty; and Henry Miller, who said don't save it man, give it away. As a young woman, doing the shift work of a nurse suited me. I liked the freedom and flexibility, having lost the concept of weekends. However, the whole idea of turning up anywhere, five days a week, fifty weeks a year and wearing stiff white clothes from another planet was starting to get seriously on my alternative nerves. Whose life was it anyway? I smoked another joint, ate some mung beans, and put it out of my mind for three whole years until I graduated.

HOW TO GET WORK

Basically, the person who has the most confidence, in spite of the fact that they may have the least qualifications, is usually the

person who gets the job. You may be a fully paid-up feminist, but there's no reason why you should not smile nicely and employ a few feminine wiles. Please God I never have to do another job interview in my life, but in the dark days when I did, this system rarely failed. The job interview is a form of legally sanctioned torture that: one, shows what you are made of; two, exposes the fraud you really are; and three, allows judgements to be made based on the way you are dressed, your tone of voice and the shape of your body. None of these torture techniques work if you are confident and get the upper hand first. Employers need you as much as you need them. Never forget to picture them in their knickers.

ESSENTIAL THINGS IN JOB HUNTING

1. Don't go out on the razz the night before a job interview.
2. Check that you have everything you need for the interview – CV, covering letter, laptop, portfolios, photos, menus, et cetera. Be sure that your CV is up to date, not completely full of lies and not too long. Correct spelling mistakes and don't put kisses or lipstick smudges on it.
3. Dress properly. This is not the moment to express your inner goddess. Wear something appropriate to the job you are going for. Iron your clothes. Don't wear a violently short skirt. Wear new shoes. Get your hair done. If it's an accounting job, wear a suit; if it's a chef job, wear neat but casual clothes; if it's in fashion, wear something that suits the style of the fashion house.
4. Leave lots of time to get there and turn up on time.

5. Stand up straight and put your shoulders back. Look at your torturers when they speak to you – lack of eye contact means you are nervous or sneaky or shy.
6. Make polite conversation and look alert and interested. Smile if you can manage it. Try to remember what is written in your CV so that when the torturers say, 'There seems to be a gap of six months here', you can smoothly say, 'Yes – that's when I was researching my new book/menu/look.'
7. Prepare a few marginally intelligent questions to ask.
8. By the end of the interview, they should be thanking God you lowered yourself to meet with them, over-qualified as you are.

ONCE YOU HAVE THE JOB

1. Read the contract carefully before you sign it then burn it because it doesn't hold up most of the time anyway. Most contracts can be got out of.
2. Don't sleep with the boss. If he/she fires you, seduce them, then dump them.
3. People who work extra or very long hours are not more productive than those who work normal hours and leave when they're supposed to. Stay late or go the extra mile if there's a purpose to it, but never make it a habit. Don't be chronically late – it's a boring and transparent way of controlling people when you feel powerless.
4. Do the job as well as you possibly can initially. Leave sick days, drunken lunches and naughtiness in the linen cupboard for much later.

5. If you're working in a hospital, don't ask every doctor if he's single.

ADVICE I NEVER TOOK ON HOW TO STAY SANE

1. Don't take work home or work all weekend.
2. Say no occasionally – they'll live without you and you'll manage without the money.
3. Eat properly – not standing up and not junk food.
4. Don't talk shop – it's boring and an invalid form of conversation.
5. Wear high heels and lipstick whenever possible. This may be inappropriate in the operating theatre or potato field, however.
6. Switch the mobile off at night, in restaurants and while making love.
7. Don't choose work over friends. Friendships need nurturing – your friends will leave you if you choose work over them too often.
8. If you're not enjoying your job, find another that's better suited to your true talents.

SELF-EMPLOYMENT

The great thing about the loosening up of the workplace is that it is never too late to change career. If you've always been a lawyer and dreamed of being a ski instructor, do it. There comes a time when you just have to let go the security blanket, your fears and your straightness and leap. Once you've done it you

will realise that you survive. It's still scary sometimes but at least you're free – you can get up when you want, take a siesta when you want, write when you're inspired, work like mad for a few months, then take it easy. For the self-employed, holidays have no relevance because you don't need a break or a change – your life is full of change and you're doing what you want. Retirement holds no interest because you're not brutalised by a lifetime of obedience, obligation and boredom. I can't recommend self-employment highly enough, but it's not for the faint-hearted – you have to have a tough skin and be able to outstare bank managers, family, significant others and dogs. If you ignore naysayers, they'll go away. It doesn't matter if there are already ninety-nine caterers in your town – you will do it better. Sort the money, get a loan, get an investor, make a plan, stick to it, give it a name, keep the lipstick touched up and keep smiling. When people let you down, flick them and move on like a velvet grader. Working independently is not so much about making money, as being free and happy.

Periodically, I'll call my bank for a financial forecast, am depressed for a day, then smile bravely through the panic. At these moments I am sometimes heard to say, 'That's it, I can't take this artist's life, I can't take the insecurity, if it wasn't for money my life would be heaven on earth, I'm going back to a real job where there are no surprises.' A day and a few gins later I say, 'It's all worth it just to be free. I'm not dead or in prison yet, nature has mercifully removed the fear of pregnancy, security comes from within, I must continue for the sake of the people who don't get to make their living by drinking and eating.'

Billie

Billie is a specialist head-hunter for advertising, media, design and public relations companies. She has been in the business on and off for twenty-five years and places both men and women. Billie is forthright, intelligent, beautiful, loves boxing and cooking, and she endeavours to live by Buddhist principles. She had a lot to say about Generation Y women (early twenties to early thirties) and their attitude to work; in fact, I couldn't shut her up. I asked her what sort of world she works in.

'It is fast moving, dynamic and intense – it's the quick or the dead. My clients are high achievers, intelligent, highly qualified, motivated and competitive. As a result I have to be very responsive and on my toes. If their lives are stressful and over-loaded, so is mine sometimes. I have to be available outside normal working hours because many of my clients work long hours and I also have a number of overseas clients. In the field of advertising and public relations, it's not about how long you have been doing it, but how effective you are. I try to achieve a good 'cultural fit' between my clients and the candidates – the right person for the right company. Women are born multi-taskers and they thrive in the industry because of their ability to manage many different projects at once.'

'Is it really true that women multi-task better than men? Research is now saying it's not necessarily so.'

'In my experience it is absolutely true and it is well known in the field, where women have to liaise with many

different people/departments and manage a number of different projects. This results in the need to retain a lot of information. Plus, they have to have superb people skills. Women do these things particularly well, which is not to say men don't, but women seem to be able to manage that with excellent attention to detail.'

'Is there a high turnover in this business?'

'There is a natural flow of people moving from one job to another – mainly to further develop their skills – and in a fast-moving industry, people grow fast.'

'Do young women have a different attitude to work than the one we were brought up with?'

'God yes – don't get me started. I am going to sound like my mother here – it just isn't like it used to be! Here's an example. The other day I placed a girl in a very good entry-level job. She was young, attractive, tertiary educated and well brought up. After only one day in the job she called me up and said she had seen how hard the other account executives worked and didn't think she wanted to work that hard. I told her to go home because she wouldn't survive in the industry with that attitude. The problem is that there is almost no unemployment, there is a real shortage of skilled people and these girls have entered the work force with a huge choice of job options. They haven't experienced tough times (as yet). They expect to have a fabulous life, wear fabulous clothes and earn fabulous money straight out of university. A lot of them don't appear to have the same work ethic and hunger we did when we were starting out. But the ones who do have

the work ethic are brilliant – sadly, there are not enough of them. So many of them want to be managing director without putting in any of the hard yards. They think a tertiary qualification is enough. Pleeeease!'

'Are working conditions different from how they were twenty or thirty years ago?'

'Very different and you know what it is? Technology. Technological advances mean that you are never free, you can send information instantly by email – you don't even have to wait for a fax. A courier would be too slow. This means you are always on call; your professional life has been extended into your private life. We need to turn off our phones and stop checking emails every five minutes.'

'Are women getting the top jobs?'

'Yes, but we still need more of them moving into management.'

'What about balancing family and work life?'

'This is still quite hard. Most women have to arrange their own day care but more and more businesses are becoming flexible about hours. This is the only way to go because flexibility creates loyalty and job satisfaction. Happy women stay longer.'

'What's the future looking like?'

'Actually very good because most women are resilient and flexible. If they lose their job or get sick of it, they are usually flexible enough to accept change and upskill, if that is what is needed. Look at you – nurse, counsellor, chef, writer and broadcaster. I have had several career

moves also – nursing, hospitality, fashion – sometimes going backwards and forwards between them. This is very typical of how women work these days.'

NIETZSCHE OR THE MORTGAGE?

As you get older, you start asking yourself why you're working so hard, what's the purpose and, in severe cases, what's the meaning of life anyway? That question and its answer lead to madness. And what's worse, I'm only going to die anyway at the end of all this. Why don't I just sit in a bar all day drinking gin, wearing beautiful black clothes, reading Nietzsche and living off the dole? I find this a sensible solution. Unfortunately, I have a mortgage to pay, Issey Miyake and Marni to buy, and business class travel to rationalise. This sends Nietzsche out the window (the gin stays). It's a shame we (and women are the worst offenders) think life has to mean something – that we have to have choices, that we want to keep achieving. I think it's a sign of 'over-civilisation'. In middle age, men's dream fulfilment starts going downhill. They are moving towards retirement and are slowing down, but women seem to do the opposite – we get a second wind and fly, leaving our men behind.

Katrina

Katrina Winn is the blue-eyed, blonde tornado behind the online magazine Womenz. She has four children and has just remarried. When I interviewed her, she couldn't talk fast enough to get out everything she had to say –

her brain seems to work faster than her mouth. She gets halfway through an idea and you can see another one forming already. She's the sort of woman who would walk up to you and tell you to stop sitting around moaning, pull your shoulders back, stick your chest out and move forward. Katrina has always run women's networks and worked from home. She recently hit on the idea of starting up her online magazine. Needless to say, her plans are to conquer the universe. Mission: to inspire, inform, encourage, excite, connect and unite women. Motto: be the best you can be.

She runs huge Women's Night Out events where hundreds of women network, entertain, communicate, rave and inspire. Katrina doesn't appear to have a specific target market – anyone and everyone from all professions and walks of life are welcome – the more the merrier. She loves rising-from-the-ashes, transforming, chance-encounter stories like that of singers Pearl, who I saw perform at a Women's Night Out. Pearl is two New Zealand women who, when they and everyone else least expected it, turned their passion into thriving music careers. They were introduced to each other by a life coach, ditched their corporate jobs and flew into singing, song writing and performing. Industry experts told them they were too old to start and succeed. They did it anyway, without the experts, and they successfully sell their music online. They started in 2003 and have already opened for Eric Clapton, Elton John, The Feelers, Jimmy Barnes and Th' Dudes. *No Ordinary Day*, their critically acclaimed debut

album, was released in 2006.

I didn't have to ask Katrina questions – I just turned her on and off she went.

'I believe women can do anything if they stick together and support each other. Younger and older women should be getting together a lot more than they do to learn and exchange ideas. Life is very stressful for women who work and have families – you are never free of the guilt that you are doing neither job properly. At least 30 per cent of working women are on Prozac. The health of a nation is determined by the health of the family so government and work places have to support women more and provide viable choices. Employers say they prefer older workers but if you're older, just try to get a job. In the workplace there is sometimes friction between younger and older women in terms of attitude. We are not in competition with each other – we need to talk, understand and cooperate.

Young women now are educated to have high expectations, both of the money they will earn and how their lives will be. They wouldn't do what we had to do – they just wouldn't do it. They expect to have balance in their lives and insist on taking time off for their child's school concert, to have a massage, to look after their health, and to nourish their relationships with family and their partners. What happened to us was we were so stressed and guilty we quite often dropped the ball and lost the partner. Women need time to connect with other women and not always be rushing around.

For women to be happy and productive employers have

to embrace flexitime and in-house childcare facilities – this is one of the principal solutions. It can be achieved but there has to be trust between employers and employees. We have to remove guilt and stress from women's working lives. This is the way of the future – more choices. Many women will be working from home on contract, which is what I have always done. It's not that easy being interrupted by kids all the time but women really really want to be with their children and guide them when they are young because they are our future. In terms of 'getting to the top' women are already doing that – the one remaining thing they have to get more of a handle on is removing emotion from the job. You can still be gentle and feminine with all the natural advantages we have AND borrow from the positive masculine ways of operating. Men don't take things personally and we have to stop doing that. We work for our children but I think we should spend all the money before we die. Our children will have many more opportunities for making money than we did – they'll be fine.'

BACKLASH

In my mother's day, it was unusual for a married woman to keep working once she started having children. These days most mothers work, but there is a new generation of professional women who are choosing to stay at home with their children and have their husbands support them. This, according to Leslie Bennetts who wrote *The Feminine Mistake*, is dangerous. 'Husbands

are unreliable. They run off with other women and die young. They are struck down by debilitating and expensive illnesses, turn to drink, lose their jobs and squander investments.'

Bennetts has two children and dedicated her book to her babysitter. If you are a highly trained, successful worker, you would be mad to give up that self-sufficiency and tie yourself to a man to raise his children. Just do a bit of simple adding and you will notice the odds are stacked against you. Okay, so it might work out, but the likelihood is that it won't. It's better to lock the kids in the car and go to the casino – the odds would be marginally higher.

As young feminists we were told we could have it all – career, children, great sexy husband, happiness. Then some of our daughters came along, turned their backs on their expensive educations and promises of professional achievement, and said, actually no, we're staying home with the Treasures thanks. This business of fighting like mad to 'become equal' and financially independent then throwing it all away is most fashionable at the moment – tales of feminine surrender (the opt-out revolution) are now celebrated by influential New York writers. Before I have even finished writing this sentence, I know my sister will be on the blower saying, 'What makes you think being a full-time mother IS NOT WORK?' I do think it's work, but I just have to agree with Bennetts by seeing it as high-risk behaviour – acting as if nothing could possibly go wrong. What if the husband falls over? It is perilously difficult to get back into your old career. It goes back to diversifying – cover many bases then when catastrophe strikes, you won't be too weakened.

The only reason I know this is because I am fifty-eight and

saw what happened to families of my childhood when they lost the breadwinner. My friends and I read *The Feminine Mystique* and *The Female Eunuch* and said, 'This will never happen to us. We will never put ourselves in a position where we can't look after ourselves.' Young professional women in their thirties today who had strong, independent parents – especially mothers – assume they are safe and they can revert to old-fashioned lifestyles. In a way, it's kind of Sod's Law – you will do the opposite of your mother. I forbade my mother to open her mouth in the presence of childhood officials because her ability to stand up for herself was so embarrassing. Then I grew up and turned out exactly the same. However, I didn't stretch it further than that – as a young woman I refused husbands and children, and then couldn't stop. I'm still waiting to grow up and be ready for a family. This is as much a form of non-recovery as my brother with the long hair. But not as bad as my cousin, who got engaged five times to five different men then backed off. On one occasion, my uncle even had to go down to the post office and retrieve the wedding invitations.

RETIREMENT

According to the authors of *Avoid Retirement and Stay Alive*, retirement is a crap idea for losers with no place in contemporary society and it will probably kill you. Stop dreaming of the time when you can lie around drinking flat whites all day and start rocking. Most people stop working because they can't stand the stress anymore. They dream of chasing younger men, trout fishing, or just lying on the floor breathing. What happens when

you stop is you do all these things and it's great, you recover from the stress, then you get itchy feet and want to work again. Some people stop working because they have made the big bucks and can afford it – it's a sign of success. Retirement was invented to get rid of an oversupply of labour but times have changed and we will now need older workers. Also, stopping work early is bad for your health – we are programmed to be mentally and physically active.

The solution is to keep working but do less of it, meaning employers need to be flexible and think outside the square. Of course, people whose bodies are broken by hard physical work all their lives do want to retire, but they would be better off doing something different and part-time, like quality assurance, mentoring or driving a taxi.

THE FUTURE

Internationally, New Zealand is considered the sixth most effective country at making the world a better and safer place, the 'coolest' travel destination in the world, and one of the three least corrupt nations on the planet. The recent census results showed that the most common occupation was sales assistants at 93,940, and that there were 9270 hairdressers and 9084 lawyers. My question is, if there are 9270 hairdressers and 9084 lawyers, why don't the lawyers have better hairdos?

According to Daniel Pink ,who wrote *A Whole New Mind*, the future will soon see artistic and emotional skills overtake left-brain, numeric, logical and analytical prowess as being the most valuable work skill. In order to thrive people will have to develop

right-brain skills. Good news for women in the workplace because we naturally tell stories, play and work co-operatively rather than competitively. In the future, you will be employed, not only for your technical qualifications and experience but also for your attitude, values, ability to look and feel good and make fellow employees feel that way too. Tomorrow belongs to the dreamers and poets, artists and storytellers, soothers and empathisers. Three major global forces are driving the need for right-brain skills: abundance, Asia and automation. The new abundance is spectacular and widespread. Whereas before it was enough to sell a product that did the job, now it has to be stylish, have aesthetic appeal and a story attached to it. Skills that will be needed for the future are design, story, symphony (the big picture), empathy, play and meaning – if you develop these you will do well.

Allan and Barbara Pease who wrote the annoyingly titled book, *Easy Peasy People Skills*, say the strong, silent man is an endangered species. Communication in the workplace is now key and if you (man or woman) can't get your message across you will be left behind. Male and female brains were 'hard-wired' in primitive, prehistoric times when a man needed spatial skills and physical strength and a woman needed nurturing and people-reading skills.

In the workplace, it is true that women have more to prove than men but they have more options. There is still a pay gap between the sexes and according to research, it will be eighty years before we catch up. However, predictions are that there will be more female than male millionaires in the same time span. In New Zealand, there have recently been two female

prime ministers and the deputy prime minister of Australia is a woman. These days, women at the top are not considered unusual or remarkable and people can barely understand why Americans make such a big fuss about Hillary Clinton. After all, New Zealand was the first country in the world to give women the vote.

Most people I spoke to while writing this book said they felt it was important to keep peaking in life. Never settle on the first peak. There are many different peaks – professional, personal, spiritual, physical. They felt it was important to keep dreaming and changing and challenging yourself. Nobody mentioned money. Nobody said the more money they made, the happier they got. Nobody said they were happier as a successful barrister than they were as a poor student.

WISDOM GAINED

- Why am I working so hard, what's the purpose and what's the meaning of life anyway? Both asking these questions and finding their answers lead to madness. Don't bother.
- The compulsive pursuit of money and possessions is a personality disorder.
- The day I burnt the bridge of salaried employment and took the risk of self-employment was one of the most liberating days of my life. If you're not stepping into the void, then you're not serious.

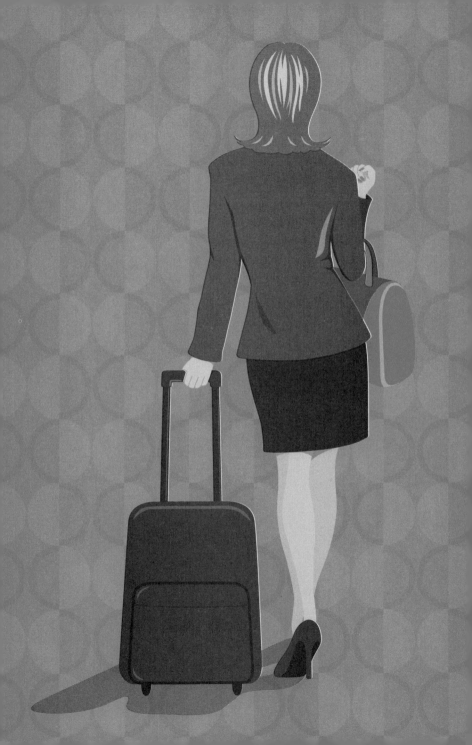

5
TRAVEL: UNDER THE INFLUENCE OF THE NOMAD

A million years ago when cavemen went for a walk, they returned and told the others about it. Then they started recording their travel stories on cave walls. Pretty soon humans were blogging their travels for people reluctant to leave their armchairs. John Gardner said that there are only two plots in all of literature. You go on a journey or a stranger comes to town. People in the eighteenth century travelled very little compared to today, when you can't get folk to stay home. Back then you travelled to go to church, transport produce and buy supplies, or to visit neighbours and family. People who lived in rural areas went to town once or twice a year. It was really only government officials, merchants and dealers who travelled for business or pleasure. To travel for pleasure was a conceit of the upper classes. When I was filming in Bolivia, the peasants couldn't understand the concept of holidays or travel. They couldn't see

the point; they thought it was wasteful and indulgent.

Travelling is like being in love – you're under the influence. The normal rules don't apply – you're more open, more tolerant, more reckless. You have no past and no future because no one knows you. You can reinvent yourself. Travel cracks you open and so pushes you over all the walls and low horizons that habits and defensiveness set up. The best way of discovering things is to get lost, a technique I have cleverly taken advantage of many times. Oliver Cromwell said a person never goes so far as when he doesn't know where he is going. Wanderlust, which I think is a great word, is something I suspect travel writers are born with. (Incidentally, the God-given talents you are born with are the jobs you should be doing as an adult. If you have any doubt as to your true calling, go back to your school reports and see what you were good at. I was good at English, French and music, so what did I do with that? I became a nurse.) The lust part of wanderlust has more to do with surrender than conquest, and the wander part is less to do with countries than about stretching one's boundaries and understanding of what's 'normal'.

The way you experience a country is also coloured by the mode of transport you use, the guidebook you carry, where you stay, the weather, what you eat and the psychological baggage you carry with you – your hopes, fears, prejudices and plans. Proust said that the real voyage of discovery consists not in seeing new places but in seeing with new eyes. The visitor and guest each see their respective countries in a benevolent light of warmth and beauty. Travel spins us around in two ways at once: it shows us the sights and values and issues that we might ordinarily ignore; but it also, and more profoundly, shows us all the parts

of ourselves that might otherwise grow rusty. In travelling to a truly foreign place, we inevitably travel to moods and states of mind and hidden inward passages that we'd otherwise seldom have cause to visit. And of course, as a travel writer you never need the services of a shrink. You spend so much time on your own that you work it all out eventually.

EARLY TRAVELS

My first travel experiences were in the station wagon on the way to our house at the beach. The forty-five minute drive actually took about two hours due to the fact that the mother kept throwing her children out of the car or threatening to drive them all to the police station and leave them there. We drove past rolling, green countryside and dense bush. It was usually either raining or blowing a gale. Scene: six children with nothing in common but three thousand freckles, yelling, pushing, accusing and baiting each other. My strict policy was to ignore my sisters and brothers in general, but in a car, what can you do?

'Harvey! Stop the car.'
'No don't stop Dad.'
'Stop the car.'
'I can't stop here Ann, it's too dangerous.'
'Stop the car NOW!'
Screech of tires. The mother out and opening all the doors.
'Now get out and walk home – I've had enough.'
The children all falling out of the car on to the side of road.
'Mum, we'll never do it again. We promise we'll be good.'

Crying and wailing, younger clinging to elder.

'Nope. I said walk, so start walking.'

'Dear, don't you think...'

'Dad save us, save us. We promise to cross our hearts and hope to die without sin that we'll stop fighting forever.'

Exchange of looks between parents, who by this stage are having trouble keeping their faces straight.

'What do you think dear?' the mother would inquire.

'Let them in. One last chance.'

Smiles and abject gratitude all round. Silence for five minutes, subdued chatter for ten, and then recommencement of the carnival. This could be why I never talk to people on public transport. I'm always afraid I might say, 'If you touch my lollies one more time I'm going to tell Mum then scratch you.' In fact, once, under extreme stress, I did say something like that to a poor man on a business class flight out of Bolivia. I was so traumatised from my ten-day trip, ill and lacking in sleep, that when this obese man next to me said in a Texas drawl, 'Ah hope you don't mand honey but ah may snore', I turned on him with flaming eyes, 'Not in my lifetime. Disturb me and I'll have a grande mal all over you.' This is called inappropriate airline behaviour.

AIRPORTS

An inevitable part of travelling is airports and all behaviour in them is necessarily inappropriate. For a lot of people, getting on a plane is like being in hospital – the stress and worry makes you undergo a personality change. Either your passage through

these mausoleums goes all right, or it all goes wrong. Actually, I don't think I've ever had a good time in an airport. I've either been vomiting, fighting unconsciousness or dementia, weeping, angry, bored, or verging on medically unfit due to swollen legs from standing in a queue for an hour. As a child, I was often put on a plane to visit my mother's family in Australia. I vomited all the way over and all the way back, my feet and calves doubled in size and I frequently left the aircraft in a wheelchair. How did I turn into a travel writer? The most useful thing you could ever have in an airport would be a urethral catheter because you can't fit your baggage through a toilet door and international airports have deliberately set it up so that if you do say, 'bugger it', and leave your baggage unattended for more than thirty seconds, they detonate it.

As with all connecting flights, timing is of the essence, so airline staff deliberately do things to make you crazy, like obliging you to wait twenty minutes to alight from the plane in London because they have misplaced the stairs. You then wait half an hour for a 'frequent' shuttle between terminals. The people standing next to you are speaking a guttural, alien, Swedish sort of language that you listen to intently, trying to identify. Eventually you realise the language is English, from some dark, primeval hole of a place in the far north of Lancashire.

Whenever I see couples tearfully osmosing with each other at airports I always want to laugh. Heathrow in particular reminds me of one memorable goodbye from my then boyfriend. We were sitting on the floor next to the point of no return where they have garrotting wires to separate people. The last, last, last call came and he threw himself on my legs weeping and begged

me not to go. Ever since, I've always felt that other men have been particularly undemonstrative in this area. If they're not going to kill themselves when you leave, maybe you shouldn't have been there in the first place.

Thanks to the 'frequent' shuttle you are now late for the flight to Los Angeles. You are told to carry your suitcases directly to the plane yourself – through passport control and security where, as is only correct, the security werewolves decide to search everything in your possession. 'Please hurry. I'm late and it's not my fault. Why are you doing this to me.' Panicky eyes, breathless demeanour. Their slow dark eyes register. We must under no circumstances bow to this person, we must not speed up, no one must be shown preference. 'Excuse me I'm late, please do my bags ahead of these people who have all the time in the world.' Slow dark eyes in expressionless faces. 'Oh no, we can't do things out of order.' 'Will you buy me another ticket when I miss my plane?' Silence. Searching. You grab the bags and run through a city of waiting lounges. 'Are you running late, love?' 'No, I'm doing my fast walk and I use luggage for weights.'

I don't understand why more people are not alcoholics. Prescription drugs don't seem adequate somehow. Now you are on the plane, that torture chamber of bad pressure, bad food and bad company. I'm always amazed at how few psychopaths and chainsaw massacres there are on planes. By the time you get to your seat you have been deliberately driven to the point of dementia, then you're asked to sit still and enjoy your venous system blocking up for ten hours. Everyone quietly does. Personally, I think the man who hit the headlines for defecating on his airline meal was making a reasonable statement. We who

do nothing are suffering from Battered Travellers' Syndrome. We need help. We need to be taught – there is a choice, we are lovable and we can just say no. It's all about self-esteem and triumphing over passivity.

At 5.00 a.m. you touch down. It's a clear, crisp dawn in the beautiful land you call home. This land you truly love. After Paris and Los Angeles the air seems sweet, almost alpine. The air is not this clean even in the south of France. You walk into a pretty, ordered, light-filled house; the front and back doors open to let in the early air. Your room is full of fresh flowers and champagne. Pressed linen graces the large bed. On the table is a fax from a French friend: 'We miss you already and the only thing we have to look forward to is your return in the springtime with the swallows.' I ask you.

SHOES

It has been said that women who collect shoes are either symbolically searching for enlightenment or are frustrated travellers. Sometimes it's more about possession than use – lots of women continue buying shoes even though they actually only wear a few of the many they own. You don't buy because you need – you buy because of your private fantasies about how this enchanting shoe will change your life. If you had this beautiful shoe, your life would be different. Shoes, travel and me are a psychopathology that defies explanation. Shoes have sex in my suitcase and multiply in the dark all on their own. Because a good shoe is so special, we never throw it away, even if it's falling apart. I will repair and repair a favourite shoe till the cobbler tells

me to get counselling. Symbolically, when I throw the shoe away, I throw away the journey it is associated with.

ANYTHING BUT A TRAIN OR A PLANE

Train travel provides a unique opportunity to eat revolting food and meet harmless lunatics while sitting doing nothing. This, as everyone knows, is why a person becomes a travel writer. I have learned not to allow people to talk to me on planes, not because I am anal retentive, but because I have never had an interesting conversation on a plane, ever. The stories are always the same, it's usually a man (compulsive sharers) and he has been undone by some slattern he was married to for twenty years. He never notices that you are either comatose or bleeding from the ears.

I would prefer to travel by candle-lit, horse-drawn carriage with four young slaves to look after my womanly needs and another four to fold and iron my clothes by lying on them. I would prefer to be long and alabaster of leg with stars in my raven locks, have a nature so sweet and dulcet that the sun came out merely at the mention of my name and wear nothing but gold satin gowns cut on the cross to reveal my curvaceous but firm body. But you see, there I am: five foot four, always carrying a ridiculous amount of luggage sans assistance; covered in freckles, and with hair so red an Irish pilot suggested I could be used as a landing light for planes. For a sociable loner I don't do too badly – only a few tears, lots of bursting into laughter, many days of hibernation, a small handful of temper tantrums, and unlimited nosiness. This is the character of the traveller. I'm always amazed at travel writers who are nasty and lacking in

graciousness. How do they get people to talk to them? How do they get into people's homes? Who would feed the person who is a hand-biter? And how come they sell millions of books?

WHY DO WE TRAVEL?

Bruce Chatwin called it horreur du domicile, this need to be nomadic that is both a compulsion to wander and a compulsion to return. All human beings have the wandering characteristic genetically inherited from vegetarian primates; just as they have an emotional need for a base or port, which comes from carnivores. But a nomad is not a person who wanders aimlessly from place to place; au contraire, she is a person who follows prescribed paths, someone who is following a calling, be it professional, spiritual, or pastoral. A wanderer is usually poor because luxury hampers mobility. You can't have an ornate house, gold taps, social commitments, over-indulgence AND freedom, movement and an understanding of other cultures and climes. An insatiable lust for gold has ruined many a nomadic tribe.

Pascal said that all man's unhappiness stemmed from a single cause – his inability to remain quietly in a room. We seem to need change as we need the air we breathe, for without it our brains and bodies rot. Encephalographs of travellers' brains show that change stimulates the brain rhythms, bringing a sense of wellbeing and a purpose in life. I know that if I stay in one place for too long I get tired, irritable and apathetic, and yet as soon as I voyage I feel stimulated, alive, open and much more tolerant than normal. Chatwin said that travelling doesn't only

broaden the mind, it makes the mind. Deprived of the danger of movement we invent artificial enemies, psychosomatic illnesses, tax collectors and worst of all, ourselves. Adrenalin is our travel allowance. Drugs are for people who have forgotten how to walk.

It has been said that people become travel writers because they wish to have sex with strangers. There are other reasons. We travel initially to lose ourselves and we travel next to find ourselves. People sometimes ask me why I have always travelled so much and what I am running away from. To be a travel writer, home has to be something portable that you carry around inside you. You need a very stable, resilient character and it is absolutely not true that you need a good sense of direction. Picturesque as it sounds, not many people actually have the constitution for adventure, excitement and romance as a lifestyle – it's something you do when you're young; it's not normally continued into middle age. Unless it becomes pathological, as it has in my case. In general, if you can't cure yourself of pathology, it's best to give in to it and call it a job. For example, if you can't stop collecting, open a junk shop; if you can't stop giving people advice, get a degree and call yourself a psychologist; if you're addicted to culture and can't afford to travel the world to experience it, make them all come to you and call it an arts festival.

GASTRONOMIC TRAVEL

The best way to access a culture is through its cuisine. Eating and drinking make you feel good and it is the finest way for a host to express a welcome and show respect for their guest.

Most important decisions are made over food. All important events in our lives are smoothed by food and drink – weddings, birthdays and funerals. The first thing you do for a visitor is cook for them or take them out to eat. Appetite, cooking and romance are history's great motivators – they preserve and propagate the species, provoke wars and songs, and help keep society together. From birth to death, food, love and wellbeing go hand in hand and at times the boundaries between them evaporate completely. A cook transmits a very intense personal energy during the time he or she is cooking and food has the ability to transport us back to our very essence. When one prepares food with energy and passion, those very qualities are transferred to the people who eat the food.

Gastronomic travel writing is a romantic subject which has to do with recalling a world that has vanished. Behind every recipe is a story of local traditions and daily life in villages and towns. Recipes are about ancestral memories and looking back and holding on to old cultures – they are profoundly about identity. The bible recalls in Exodus the wistful longings of the Jews for the foods they had left behind in Egypt. Traditional dishes are important because they are a link with the past, a celebration of roots, and a symbol of continuity. They are that part of a culture which survives the longest, kept up even when clothing, music and language have been abandoned. Cooking in a place like Morocco, for example, is passed down through the genes and the fingertips. Like love, it has the capacity for change and for passing on new experience from one generation to another.

In his book *The Philosophy of Travel*, George Santayana wrote 'we need sometimes to escape into open solitudes, into aimlessness,

into the moral holiday of running some pure hazard, in order to sharpen the edge of life, to taste hardship, and to be compelled to work desperately for a moment at no matter what.' I can tell you, walking around a medina in Morocco in high heels is hardship – don't think I don't suffer for my art. Even my intestines have suffered for the sake of art. It was in the middle of the medina (old city) at Rabat, on a day trip with friends that I got that 'lonely feeling' – like grief but purely physical. No one can help you, no one can stop you, nothing can reverse it, and Moroccan law stipulates that you will be kilometres from a toilet when it happens. Bombay bottom, Deli belly, Rabat rumbles, Moroccan mambo – the dance everyone warned me I would eventually have to do. Panic stricken, I ran around in circles asking for a pharmacy or a toilet, whichever came first. I found a pharmacy, bought the pills to stop the lonely feeling, and ran up to the roof of the pharmacy building to the toilet. Can I share with you how wonderful it is to already be sick and have to use a fetid Arab toilet? Not to mention the multi-tasking skills required in controlling one's sphincter while getting a grip on the olfactory assault. You would block your nose if you could (well you would block everything if you could) but you need many other hands for keeping your skirt out of the sludge while you squat, hanging the basket somewhere, finding and opening the packet of wet wipes, doing the deed and then cleaning up by sluicing with the bucket and tap on the wall. Like being a nurse in a hell full of colostomy patients. To recover I bought anything I could that smelled nice – dried rosebuds, henna from a henna mountain, saffron threads and picked pink and white flowers from the oleander trees.

Another good reason to become a travel writer, aside from the fantasy of sex with strangers, is shopping. Food markets are valuable because they show you the differences between cultures, but craft shops generally only show you the ignoble shadows of your character. I am not a bargainer by nature but my photographer in Morocco was. She was a Rottweiler, rationalising her behaviour by saying that haggling is a local custom. She sometimes wasn't doing it because she needed the item; she needed the adrenaline rush of seeming to beat a cunning salesman at his own game. I have a rather capricious attitude to shopping. I can be incredibly disciplined and say no to Moroccan rugs, Provençal pottery and Irish jumpers, but I can't get past heavy food books or shoes.

The great joy of travel writing is simply the luxury of leaving all your beliefs and certainties at home and seeing everything you thought you knew in a different light and from a different angle. A good traveller always gives back. It's very handy if you have some sort of God-given talent like dancing, drawing or tight rope walking because then people don't feel you've just walked into their lives, sucked the soul out of them and sailed off to make money from their stories. In my travels people give me songs and recipes and love and I give them back songs and recipes and love. But also you carry values and beliefs and news to places you go, and in some parts of the world you're a walking newspaper or movie, taking people out of the closed limits of their lives. In a small village in Portugal you become the ears and eyes of the people you meet. A travel writer imports and exports dreams – hopefully with tenderness and generosity. For example, I tell people about my recipe for slow roasted tomato

sauce or goat cheese soufflé. They get down on the floor and show me how to make couscous from scratch with semolina and water. Vietnamese women showed me how to grill a rice paddy mouse, thus sharing a treasured speciality. I sing them a love song about how I see life through rose tinted glasses. And so it goes . . .

TRAVEL CHECKLIST

1. Always carry unreasonable amounts of tampons and condoms with you – if you don't need them, someone else will. Don't wear sanitary pads – lions, leopards and hyenas will drag you out of your bed and eat you. You don't have to bleed monthly. Nothing bad will happen to your system if you don't. You can get your doctor to temporarily stop your periods with hormone pills. If you're fifty or over ask your doctor to stop them altogether.
2. Always carry diarrhoea pills and wet wipes – it's too boring to try and find a chemist and usually too late, if you know what I mean.
3. Leave all your preconceptions behind.
4. Take a notebook and write in it – it attracts people to you and you will never be lonely.
5. Pack earplugs, a sleep mask and sleeping pills for desperate moments. Although killing someone who snores is not really murder anyway.
6. Pack ONE suitcase. Take half the stuff out. Lock the suitcase.

TRAVEL: UNDER THE INFLUENCE OF THE NOMAD

TRAVEL TIPS

1. If the person next to you on the plane has a throbbing shoe, is sweating and looks happy to see you – that *is* a gun in his pants. Call your mother and say goodbye.
2. Forbid anyone who has verbal diarrhoea or is into sharing their innermost feelings to come anywhere near you. Otherwise, talk to everyone – that's why you're travelling.
3. Steam iron your clothes by hanging them in the shower and turning the shower on to very hot.
4. Reheat pizzas and cook toast on the iron.
5. Bidets are not for washing your feet or anything else – they are for keeping champagne cool.
6. Start eating the food of your guest country the minute you get there. If taxi drivers invite you home to their mother's for dinner, go.
7. If you're single, get a local lover. The fastest way to learn a language is in bed.
8. Be careful with pedestrian crossings in other countries – they are there as a guide for cars to target you more effectively.

Diana

Diana Creighton has been in the music business, importing, and property. She currently jumps on any train, boat or plane she can get away on. Stunningly attractive and cultured, a funny and incisive conversationalist, Diana's brains and inquisitiveness are fuelled by wanderlust and her endless openness. I asked her why she travels so much

and how it makes her feel.

'Eight schools – in England, Khartoum on the banks of the Nile, Singapore and Germany – all before ten years of age. What chance did I have of ever staying put? It's in my blood, and Aries love change. There's nothing better than getting on a flight clutching two credit cards and off you go, complete with that spacey, slightly disconnected feeling. If I am away for more than a few weeks I do have to make contact with friends and relations otherwise I start to feel just too disconnected and rootless.'

'On what criteria do you chose your destinations?'

'I love ethnic dress – northern Vietnam is the best – hand-woven, cobalt-coloured material, embroidered with garish cross stitch, set off by black silk velvet wrapped carefully up each leg. So few places are left now that haven't traded in their gorgeous traditional garb for a huge plastic tee shirt with a giant number on the chest and black shiny long shorts. The look's completed with rubber jandals, which have even invaded northern Vietnam. I'm on the trail of tradition in life and food, unless it's the Greek Islands, where it is just food, retsina, sunshine, swimming and the absence of any cars. Being in places that have a community which promenades in the cooler evenings, sits on the doorsteps or eats in the squares does it for me. A bit of culture also helps the mix, provided it hasn't been rebuilt as they thought it should look, which I encountered a lot on the Silk Route in Northern China. If the weather turns, shopping is good, but then the holiday can change into nail-biting, will-the-credit-card-be-rejected horror, and

debt upon return.'

'Is travel important and why?'

'God yes – it's a bit like those who read or those who don't. People who don't travel – how could you bear to be around anyone who isn't able to draw any comparisons between language, dress or scenery? I have an old boyfriend whose travel was limited to the US and Australia and of course he is crazily in love with New Zealand. Where is the comparison?'

'Is your attitude to travel and adventure different from what your mother's would have been?'

'My mother was married to a British Army officer, so she was often transported by big old noisy planes or else similar ships so it probably didn't seem very romantic or exciting. She was married and that is definitely a travel limitation, as is any consideration for loved ones. I don't think my mother even indulged in the thought, "Where would I like to go". That is a single person's mind set.'

'What has been your most outrageous travel behaviour?'

'Perhaps only the very obvious one of a puff of this and that when I was young. I was more likely to be found eating the local food and searching out the wines, with an eye for the lads, than bothering with rather dull criminal activities.'

'Do you travel alone or with others?'

'I do travel alone – no problem – just get the book out quickly when you get on the plane or feign sleep and no one has the courage to talk to you. Have been known to

utter a few banal words when the plane is taxiing in and I am safe. Holidaying I prefer with a friend, though you have to run a few casual tests before setting off with someone. Do they go "off"? – that is, get a fit of the sulks and want to go home or otherwise display disgusting behaviour like taking food from the buffet breakfast to eat later in the day.'

'Where is travel at these days and what do you think the future holds?'

'Carbon miles – now that's scary. I now have to feel guilty about travel. I just have to hope that they find something other than oil to fly airplanes on or else, as old age grips, maybe it'll be cruises. Do they use less of the world's resources? Though I have told my friends that I can't possibly cruise until I am eighty or I need to be wheeled out at the ports of call. Cruises seem a bit like asking to be shot when you get a sensible hairdo or shoes.'

GREAT WOMEN TRAVELLERS

Women were unable to travel alone in the Victorian period for many reasons. It was considered immoral and only a few brave ones ventured into the unknown. It was difficult to travel because of the complicated and restrictive clothing and also because of the physical and sexual danger. If your feet are bound you can't walk; if you're corseted, you can hardly breathe. Why would you be outside the house without a husband, escort or chaperone? Prominent women travellers of the Victorian time period were intrepid women like Harriet Martineau, Isabella

Bird, Gertrude Bell and Mary Henrietta Kingsley. It may be a joke to say you travel to have sex with strangers, but it's not that far from the truth – the thrill of travel is similar to sex and even similar words are used to describe it – adventure, exploits, awakening, discovery. In French, to call a woman une aventurière has distinct sexual connotations of risky behaviour. Even today I have to tell people in Vietnam that my dead husband is nearby because they can't understand that I would travel alone. When they did start travelling, Victorian women sometimes used official projects like study or art viewing as their motives, when what they actually wanted were amorous adventures.

Even though women are much freer these days, we still travel differently and see the world differently to men. Women travel writers are much more intimate and personal in their writing, while their male counterparts don't let too much out about their inner life. Women are always aware of their bodies and the undeniable fear of unwanted attention or rape. Of course, men get mugged and killed on the road, but women have the added worry of sexual vulnerability. Victorian women often dressed as men, especially when travelling in the desert. They were upper-class women of independent means; white, highly educated and often without domestic ties. Even today, non-white, working class, female travel writers are under-represented. Here are some of history's great women travellers.

LADY MARY WORTLEY MONTAGU (1689–1762)

She was a satirist and poet. When her husband was appointed ambassador to Constantinople, she created a scandal by following him, unchaperoned. She loved Turkey and dressed

in Turkish clothes. Maybe because she was bitten by the travel bug, Lady Montagu eventually left her husband and spent many years travelling in Europe with various lovers.

MARY WOLLSTONECRAFT (1759–1797)

She wrote about social and political injustices and criticised the church, government and penal system. She travelled a lot in Europe and her writing was very modern in the personal way she recorded her journeys. She died giving birth to her second daughter Mary, who married the poet Shelley and wrote Frankenstein.

ISABELLE EBERHARDT (1877–1904)

Isabelle's story is very interesting and it ended badly. She was Swiss and travelled through North Africa dressed as a man, having converted to Islam. She was called Si Mahmoud and wrote about her interior journey and love dramas with dusky gentlemen. Rejected by both European society for converting to Islam and Arab society for posing as a man, she ended up drug addicted, homeless and begging for food. She was only twenty-eight when she died in a flood in Algeria.

EDITH WHARTON (1862–1937)

Although Edith was an aristocrat she was a very good writer, especially of fiction. She also wrote travel stories of great sensitivity and insight. She travelled a lot with Henry James and the world seemed to sparkle around them.

ISAK DINESEN (1885–1962)

Isak was the pen name of Karen Blixon who wrote *Out of Africa*, described sometimes as the best travel book ever written. She had a coffee farm in Africa and wrote powerfully of her travels on the African continent.

FREYA STARK (1893–1993)

She was a southern Arabian expert, especially in dialects and she travelled extensively to Turkey, China, Afghanistan and Nepal. A beautiful writer, she was named a Dame of the British Empire and died at the age of one hundred.

MARGARET MEAD (1901–1978)

Margaret was a famous anthropologist and a philosopher – she knew how to wait quietly but actively and to learn what she had to learn about the folk she was observing. She studied and wrote about South Pacific adolescent sexuality and behaviour.

M.F.K. FISHER (1908–1992)

Mary Frances is my favourite food/travel writer. She wrote a lot about her beloved France, especially Dijon, but also about America, her home. She was witty, worldly, beautiful and probably the best-ever gastronomic travel writer in English.

ETHICAL TRAVEL

'If you are coming to help me, you are wasting your time but, if you are coming because your liberation is bound up with mine, then let us work together.' There are a growing

number of conscientious consumers and responsible travel companies who are donating financial resources, time, talent and economic patronage to protect and positively impact the cultures and environments they visit. This voluntary movement is becoming known as travellers' philanthropy or altruistic travel. It helps to support community development, biodiversity, conservation and other environmental, socio-cultural and economic improvements, including providing jobs, educational and professional training opportunities, healthcare and environmental guidance. Outfits like Exquisite Safaris have a philanthropic mission which is to include a visit to a humanitarian outreach project into every private, luxury, guided, safari tour and expedition they sell. The resulting personal introductions create cross-cultural friendships that generate trust, respect, and generous donations that have funded grassroots humanitarian projects worldwide.

Cape York Turtle Rescue operates trips of two, three and five nights out of Camp Chivaree, thirty minutes' drive from Mapoon Aboriginal community on Cape York's northwest coast, from July to October. Ethical travellers can meet the researchers, watch documentaries, and find out about the private life of turtles and help save them from extinction.

You can volunteer through Meaningfultravel at a Buddhist orphanage in Chiang Mai, Thailand. The little charges have been left in the care of the Buddhist nuns due to parental death, neglect, poverty or incarceration. What they need more than anything, after food and shelter, is love, feeling cherished and being played with. You go for as long as you can and return when you can. People who have done it say it changed their lives.

country to get places. I have been sexually attacked many times but never raped. Unbelievably, I didn't get into serious trouble till one fine summer's day, hitching from Washington State to Vancouver. My older, worried friends begged me to get a bus and later said I looked like a lamb going to slaughter – slight summer dress, sandals and carry-bag. Absolutely no protection whatsoever. That I survived this trip was pure luck and I never hitchhiked again. I got into a van with a young man. The back of the van was entirely carpeted from floor to ceiling, with nothing in it but a bed. There was a gun on the dashboard, the driver was an army man and he insisted I look at a book he had – it featured deformed and mutilated people. The doors had been automatically locked. Every vein in my body ran cold and I understood that this was it – my luck had finally run out. We drove for miles; he was taking it slowly and priming himself for what was to come. I asked many times to be let out to no avail. Eventually the van ran low on gas and had to pull into a station. He locked the doors when he got out to pay but forgot to do so when he got back in again. As he was pulling out on to the highway I opened the door, threw myself out of the moving van, rolled on to the grass verge then ran. By the time he was able to turn back, I was in the care of the gas station owners.

SAFETY SUGGESTIONS

Don't allow this list to put you off. In general, women find travel liberating rather than dangerous.

1. Travel with a man or a native of the country when possible – the safety difference is extraordinary. Walking down a

street in Marrakesh on your own invites harassment, both commercial and sexual. With a man or a Moroccan, it ceases instantly.
2. Some hotels, car rental agencies, airlines and travel agencies have developed marketing programs aimed at women travellers. Hotels are now accommodating women's rooms with special security features and allowing women to rent or request a bodyguard to accompany them on morning jogs or city trips. Use these services.
3. Always have a cellphone on roaming and know the local number to call for help.
4. Dress appropriately – don't wear tight revealing clothes in Muslim countries. You can look pretty, but to wear sexually provocative clothing is inviting sexual harassment.
5. Be aware of yourself and your surroundings. Don't walk home late at night on your own. Make sure no one is following you as you enter the hotel, apartment building, camp ground, et cetera.
6. If you are attacked, try and stay calm. I have been attacked on towpaths, streets, foyers, parks and in my home. I always got out of it eventually by talking and negotiating. Never be afraid to disturb the peace and scream your head off.
7. Don't live in fear – just take reasonable precautions.

ADVENTURE TRAVEL

In 2002 I was very excited about going to film an adventure travel show in Bolivia. I'm not an adventure travel kind of girl but I reasoned, how bad could it be? Never in my most delirious

understand adventure tourism at all – they don't understand leisure and travel. For them, life is about survival and family and religion. The peasant women don't wear knickers and they squat on the ground to pee, surrounded and hidden by their colourful, voluminous skirts. I don't get close enough to find out what toddlers do. They stare at my red hair, not in admiration but in amazement.

I found Potassi a hard, bleak, unattractive town in spite of the remnants of ornate churches and colonial architecture. Its ignoble history – its gigantic silver mines etched in blood and unimaginable cruelty – seem to have polluted its soul. Any footage of me sleeping is fake – I slept three hours in ten days. Bad enough that they talked me into no make-up, but no one mentioned the chronic altitude sickness and that I'd see none of the national product, cocaine, to keep me attentive, or that I'd eat nothing but 250 kinds of potato. No that's not fair – I ate a rather good meal of quinoa soup, lama steaks and chips. Speaking of potatoes, we found a really wonderful market where I bought lots of different kinds of spuds, including dried ones which looked like large chick-peas. This market was full of veggies and fruit and unimaginably graphic carcasses of meat with the fur still on, hanging from hooks. Women carried bloody carcasses wrapped in colourful blankets through the market on their backs. They were shy and often covered their faces when they saw us filming.

Our hotel was zero stars with no heating and it got colder and colder. We practically had to chop our right hands off to get hot water bottles out of the staff and because we had no sleeping bags we had to hire them to add to inadequate bedding. I half

slept. I was rigid, fully dressed and wondering why I was doing this. What makes other people think hardship is enjoyable? Where was my mother? Why was there no God?

The people in Potassi are stoned on local hootch and coca leaves all day. It's the only way they stay sane and tolerate their hard lives. A lot of the men have barrel chests and hacking coughs. The gentle Bolivians are passive in relation to foreigners – they're neither interested nor uninterested. For example, no one would ever hassle you or try to sell you anything. They are deeply religious, mixing Catholicism and Inca paganism. The purpose of their lives is to work and produce – there is no hope of much more in a mining town. The mines, with their savage bloodstained openings, are low and claustrophobic, dark and mysterious. I felt sad and shocked for the miners. To make myself, rather than them, feel better I exchanged saliva secretions with a group of stoned miners who passed their 'herb-filled' cigarette around. I drank the hootch.

Strangely enough I didn't find chewing coca leaves and the alkaline lime stuff you chew with it too disagreeable – the rest of the group found it repulsive. I'd do anything to stop the altitude sickness, which is only worse once we reached the highest goddamn city in the world. I was so out of breath I could barely walk to the restaurant where doing a round of the conga nearly threw me into ventricular shutdown. We have wine, hootch, coca leaves and chocolates for our production meetings.

Our lodge that night was the Laguna Verde – a vile hoghole of a pigdog slum. Absolutely no amenities, putrid toilets, not one heater or wood fire in the entire place and it was twenty-five below zero. Just as well we were accustomed to sleeping

in our clothes, because I was sure the sheets were dirty. The cooks in the little kitchen were lovely young women with thick ebony hair that hung down to their hips. They wore jaunty straw hats. Dinner in the freezing dining room was ordinary but not inedible. This is the upside of intrepid touring and bad conditions – everyone is in the same boat. We got drunk and told stories and laughed our heads off every night to kill the cold. I now know I could volunteer for the Foreign Legion – it would be a piece of cake. I would be the one who could lie under snow with no food or water for three days, waiting for the enemy.

In the morning the driver was walking around with icicles in his hair, which is, I assume, how he slept. I woke up feeling like three kinds of shit after sharing a room with six others. The Swiss seriously lost their sense of humour – actually I think they were the only ones who behaved normally. It was those of us who persisted in laughing and telling jokes in bed at night and being brave who had behaviour problems. It was five days since I'd washed anything – hair, clothes or body. Surprising how undisgusting it felt – lucky it was so cold. We visited hot pools and stifled orgasms as we delicately put our frozen feet in the water. The beautiful scenery was breathtaking – cool blues and pinks and mad vegetation.

Back in Uyuni I took a shower for the first time in almost a week. I felt like Lady Macbeth – unable to stop washing and scrubbing. Afterwards I felt bleached and euphoric. But the pain was not over. We endured a twelve-hour, overnight bus ride from hell, all delusions of sleeping put aside. No heating. Freezing. Overcrowded. Bolivians sat stoically on the floor – fun

fun fun. We certainly lived like the people – with adventure travel there's no skidding over the surfaces, no observing through Prada sunglasses, no shirking from the reality of the culture. In that sense, the journey was unforgettable because it was so intense and put us right up against the wall. If I complained they just smiled and said, this is how we've lived all our lives and we're happy. Our ancestors are in those mountains and this is our place.

We arrived back in La Paz practically hallucinating from tiredness. If I hadn't known it was the last day of the trip I would have lost it – I would definitely have bitten someone. The witches market was my kind of scene – who wouldn't want a lama foetus if they could get one? I absolutely believe in little charms because you never know when a bit of magic will come in handy in life. We all need magic. That's how Bolivians rise above their everyday lives – with potions and advice and looking out for each other. When I got dressed up in the traditional Bolivian outfit, the hands of the woman helping me were soft and gentle and she spoke like a little bell. We enjoyed a last night dinner in a groovy restaurant where the food was good for a change. All was forgiven. We exchanged tearful goodbyes and promises to keep in touch. We were genuinely sad to be leaving the lovely Bolivians. I felt that I'd only touched the surface and that I need to retrace the journey in a luxury caravan carrying 200 pairs of lacy knickers for the ladies and a well-equipped kitchen.

TRAVEL: UNDER THE INFLUENCE OF THE NOMAD

WISDOM GAINED

- It doesn't matter where you are going or for how long – you only need one suitcase.
- Try and be an ethical traveller – drop the luxury hotels and get on down with the people.
- Be fearless but not reckless.
- At every occasion, including desert and jungle travel, it is appropriate to wear lipstick.

6
HEALTH, HORMONES & BEAUTY: NATURE IS YOUR ENEMY

According to epidemiologists, a woman who reaches the age of fifty free of cancer and heart disease can expect to live to ninety-two. Experts keep telling us we have to exercise more. Is it just me? Shopping isn't enough? Sex isn't enough? Singing in the choir isn't enough? Ironing isn't enough? We now know that too much exercise is extremely bad for you. It takes away from more important activities like eating, cooking, drinking and flirting. It leads to anorexia, death, or worse, encourages competition with inanimate machines and fosters self-righteousness. And who needs to lose two hours from their day getting to a gym, changing, pumping, reaffirming that everyone else and their dog looks better than you, showering, getting back? And who needs to sweat – aren't power surges bad enough? And who needs to pay for this torture? Structured exercise is like structured religion – it's all so joyless and guilty-making unless you are a

genuinely sporty type and enjoy it anyway. The terrifying term 'no pain no gain' was lifted from the Catholic priest's handbook – only suffering will bring redemption. You are being asked to actually turn against your own body.

The thing with exercise is to make it incidental – don't take the lift or the escalator – walk up all stairs; walk or bicycle to work if you can; don't take the car if the restaurant is within walking distance; if you're near a beach – don't sit on it, take your shoes off and walk on it; if you're in the water – don't float like a dolphin, walk in it; go for a walk in the evening or in the morning. The thing that really puts me off is the ugly, unflattering outfit you have to wear for exercise – only triathletes look good in spandex. So wear what you feel like wearing – comfortable but stylish shoes, a skirt if you want, and dark glasses so no one knows who the nutcase is, walking purposefully around the neighbourhood in Marni pants.

The true secret to staying young, beautiful and healthy forever is boringly simple – diet. Fruit and vegetables, fruit and vegetables, fruit and vegetables. The risk of heart disease and cancer, especially of the colon and the breast, can be cut by as much as 40 per cent if you eat lots of fruit and veggies. This small change in your lifestyle reaps big rewards. It's also a good idea to drink one or two glasses of red wine daily (white wine is best for removing stains and disinfecting); eat at least two squares of dark chocolate a day; drink as much coffee as you like; have as much sex as you can; and eat lots of fish for your brain.

Women's magazines scream out at us from every second page that eternal youth is within our grasp. It isn't called eternal youth – it's called skin care and has pseudoscientific names

like cellular-active-youth-complex, but it means eternal youth. They say when a woman buys a tiny pot of $450 La Prairie, she is not buying face cream, she is buying hope. Collagen, elastin, Botafirm and liposomes are the big players but I happen to know that Elizabeth Arden capsules do not prevent wrinkles because guess what? I have a mirror. The advertising works on you subliminally. You find yourself buying expensive face creams against your will merely by walking across the ground floor of any department store. Personally, I can't get from the front door to the escalator without thinking – but what if they do work, what if Ralph Nader is wrong and Estée Lauder is right? For months afterwards, having spent the equivalent of some small African republic's GDP on a pot of eternal youth and a bottle of perfume, I walk around wondering why my friends are not gasping at my rejuvenated, dramatically improved skin texture.

It used to be just creams, now it is invasive surgical procedures involving needles ('This needle is very very fine, Peta.' So why does it feel like a bread knife?), electric shocks, burning, cutting, filling and tucking. Chunks of female flesh are being thrown out wholesale. Nowadays you don't just get 'work' done when you're falling apart and even your goddamn knees are going south; now you consider 'preventative' cosmetic procedures. Hollywood actresses are losing work because they are so botoxed, they can no longer show emotion. In my experience, everything is fine until you're forty-five, then it quickly becomes reality TV – you look in the mirror and ask, how did this happen? I'm only twenty-seven.

We now live in a frighteningly youth-oriented society. I was an idiot when I was young and passably pretty – who

convinced us we all want to revisit that? Part of it is that our life expectancy has increased and a teenage girl today can expect to live to eighty-three. The last time a girl stops wanting to be older and more grown up is when she turns twenty. From then on in we become younger – thirty is twenty, fifty is forty, and so on. And the thing is, it's not just physical – we are supposed to act younger than we are, seem younger, perform younger. People are supposed to say, isn't she amazing – still out there, still achieving, still having adventures, still having love affairs with younger men. I go into this younger man/older woman thing in more detail in my chapter on sex, but from my observations, younger men make the first moves on older women; it's not usually the other way around.

HORMONES

I have PMT and I'm carrying a gun. As Germaine Greer noted, you're only young once but you can be immature forever. Listen to me carefully on the hormone story because it is crucial. Your girl hormones, oestrogen and progesterone and even testosterone, decrease production drastically as you age. You stop menstruating. The average age for this to happen is between forty-five and fifty-five, at which stage you are supposed to be slowing down anyway. But what if you are a modern woman and are not only still in full work mode at this age, but are also starting a new career (in my case two simultaneously), having new adventures and demanding more rather than less of the body? Travel, constantly changing beds (not as exciting as it sounds), memorising pieces to camera, learning new skills like

writing and staying in a room on your own for hours, trying to keep up your personal appearance, trying to understand why you eat and drink less than you did when you were in your thirties but are heavier. Through all this we suffer disjointed sleeps, night sweats, power surges, dry skin, dry vaginas, dry horrors, irritability, weeping, depression, lack of concentration and losing whatever looks nature had been kind enough to throw at us.

By the year 2000, millions of women had discovered the joys of hormone replacement therapy (HRT). It was discovered that if you wanted to feel like a human being again, all you had to do was artificially replace the leaching hormones. So we did and were very relieved to get rid of soaked bed sheets, have more youthful skin, re-access our inner sweetness of mood and best of all, be protected from the dreaded killer triplets: heart disease, breast cancer and osteoporosis. Then disaster struck. In 2002 a study by the American Women's Health Initiative showed that women on HRT not only were not protected from heart disease and breast cancer, but in some cases, actually at greater risk. This was a flawed study and the information was false. Fortunately, I had good advice from professional friends who assured me the research was faulty and that there was no need to suffer if I didn't want to. I happen to be in a business – television presenting – where appearances count to a certain extent, but even if I weren't, vanity and outrage at the unfairness of it would have driven me to fight ageing.

There's nothing to be gained from being natural, trusting nature and letting it take its course. NATURE IS YOUR ENEMY – she wants to get rid of you as soon as your first blush of youth

is over. She bends over backwards to make our female bones brittle, drives us insane by withdrawing essential hormones, makes our skin look like a snake's and prevents us from sleeping properly. As soon as we're not needed anymore to reproduce and attract breeding partners, she takes away our looks, our strength and our relevance. Nature couldn't give a stuff about us, so we have to look after ourselves. The only reason we live to ninety is because of medical advances; the only reason we can see is because of glasses; and the only reason we don't starve is because the state looks after us. Old age goes on for a long time – best to be as fit and healthy as possible. Obviously, nature wins in the end but you should go down disgracefully.

My friend Dr Gail Ratcliffe, the eminent psychologist, told me she had many mid-life women coming to her complaining of depression. These women had never been depressed before and nothing in their lives had changed or seemed sufficiently negative to warrant their unhappiness. It dawned on her that they didn't need medication, they needed hormone replacement. As soon as she referred them to their doctors for HRT their depression lifted and they never had to go anywhere near Prozac. If you feel nothing and menopause doesn't bother you – great – do nothing. Continue your happy life. But if you feel that nature is doing you in, that you're over the hill, unsexy, an insomniac and you find you want to rip the bus driver's throat out, chances are, your girl hormones are awry. It's easy and safe to fix. Take the pill, rub the cream in, eat the tofu, go holistic, go herbal, go homeopathic, howl at the moon, do whatever you feel comfortable with. You do not have to feel or look terrible. Nature will not look after you. If you can't have sex with someone, have

it with yourself – it keeps you young and happy. Use it or lose it. We don't have the lives some of our mothers had – into our fifties, sixties, seventies and even eighties we now still have and want to keep many balls up in the air.

Almost half of all menopausal women report that their sex lives suffer – sex drive, frequency and comfort level. It could be that they are sick of their boring old husbands, but the main problem seems to be vaginal dryness and atrophy (narrowing or shrinking) caused by low oestrogen. This makes for painful sex. The astonishing thing is, none of this suffering is necessary – 75 per cent of women surveyed did not know that therapies are available to relieve vaginal dryness. My doctor says the best one is Ovestin cream. This is a prescription drug but there are also many you can buy over the counter. The vaginal walls become thin and fragile and can be built up and strengthened by these treatments, which makes sex more comfortable and enjoyable.

In the interest of research, I got myself injected with testosterone. The real reason I did it was to be more focused and stronger. The result was explosive and at no point did I feel focused or strong. Even the small amount I was given had the most extraordinary effect and I realised what it was like to be a man. I could not stop thinking about sex – morning, noon and night. I looked longingly at bus drivers, power poles and schoolboys – anything would have done. A donkey would have done. It was incredibly distracting. I found it hard to concentrate and work and couldn't wait to get back to my normal oestrogen-flooded girl self.

PMT & MENOPAUSE SAFETY LIST

1. If you feel like going shopping for shoes, look at your safety checklist first:
 - Is it a week before my period?
 - How old am I?
 - Am I having hot flushes?
 - Look in your wardrobe and count how many shoes you have.
2. If you are feeling too relaxed when someone insults you by asking if you should be driving, check that the three pills you took in the morning were the thyroid not the Prozac pills.
3. If you think any of the following is a good look then you need to review the hormone situation: animal skin print; lime glasses; a shaved head (Sinead O'Connor is the only exception in the entire universe); white boots; exposed breasts (especially old ones) in a turquoise top; sun hat with pom-poms around it.
4. Scissors are for sewing. If you feel like picking them up and hacking at your hair during hormone crises, look at your safety checklist, which should have your hairdresser's phone number on it.
5. Hide all chocolates because you will be unable to have one – you will have to eat the entire box.
6. If you suspect your behaviour is sandpapery, paranoid or you are leaving teeth marks on post office tellers, ask a trusted friend to give you a reality check. Don't ask your boyfriend because he is sure to say, yes, you're a raving bloody maniac.

Note: Just because you are paranoid, does not mean people aren't following you or staring at you. If you are even remotely different, people will stare at you with their mouths open.
7. Remember the boning knives are for cutting steak only. If you find yourself looking longingly at the knife then maniacally at your significant other's carotid artery, stand back from both and breathe out. Anyone can breathe in – the real trick is in breathing out.

THE POINT IN BEING CURVY

Small waist, big hips equals big brain – there's proof. It's always been thought that most men are attracted to curvy women like Nigella Lawson and Scarlett Johansson, but lately they've been trained to think ironing boards and stick insects like Paris Hilton and Keira Knightley are womanly. But curvy women live longer and it is now also thought that they are brighter and produce more intelligent children. They do this because they have higher levels of omega-3 fatty acids on the hips and thighs, which are essential for the growth of the brain during pregnancy. The essential thing is to have a small waist – fat around the waist is not suited to brain growth; it just makes you diabetic and gives you heart disease. It also doesn't apply to teenage mothers, whose children rate poorly in cognitive tests because teenage girls haven't yet matured into their proper, womanly shape. Having research that shows women with hourglass figures are not only sexy but also smart and at a biological advantage over their slim sisters is most interesting. No one really knows why

men are hard-wired to find big hips and a small waist desirable, but one theory is that a small waist means the woman is still fertile and will have a long life. I don't think men in bars are thinking of that though.

THE BEAUTY MYTH

If you think being rich, poor, white, black, Jewish, Catholic or one-legged is stopping you from being happy, try being beautiful. It's the most depressing thing of all. You can change just about everything – your mind, your job, your clothes, your friends, an ugly face . . . but you can't return beauty to your creator. Beauty, although apparently a gift, can become a demand and invites judgement. Modern conceptions of women's beauty impact on employment, culture, religion, sexuality, eating disorders and cosmetic surgery. Take the tragically beautiful life of models. The lonely life of catwalk strutting makes them feel like clothes horses stripped of their autonomy and happiness. Surveys have found that, in spite of being icons of beauty and glamour, models have poorer mental health and lower life satisfaction than women in other careers. Why is it so depressing to be pretty? Because you are objectified, judged and owned by the public and media. Many models feel their lives are out of control and their bodies are the only aspect of their lives they have any power over, which makes them obsessive and anxious. They spend their days compulsively dieting, exercising and sometimes purging.

However, hideous research has shown that if two equally qualified people apply for a job and both do very good interviews, the good-looking one will get it. No? If appearance doesn't

count, why do we dress up for job interviews? Beautiful people, in general, have more successful careers than ugly people – even in jobs where beauty is not required. But are we making a mistake by favouring good-looking people?

According to the godfather of the scientific study of beauty, Dr Randy Thornhill of the University of New Mexico, perfect symmetry is hard for a developing embryo to maintain. The embryo that manages it obviously has good genes (and good luck), which is why health and beauty seem to be linked. Other signs of beauty like hair and skin show the state of the woman's health and even, apparently, her intelligence. In terms of general intelligence, symmetrical people do very well. Faces tell the story too. In experiments, beautiful people were given an intelligence test then their photos were shown to other people, who more or less correctly guessed the results. So maybe we're not making a mistake by favouring the fair.

It is easier to guess the intelligence of children and middle-aged adults by their faces than it is teenagers and elderly people. You would think face reading for teenagers would be important in terms of mate selection, but so too is trickery – evolution and hormones are working overtime to cover up faults. People like Brad Pitt and Angelina Jolie are rich and successful, to a large extent, as a result of their beauty. All things being equal, it might actually be a good idea to give the better-looking person the job because they may bring in more revenue. Good-looking political candidates do better than their more ordinary sisters. There is a feedback loop between biology and social environment that gives to those who have beauty and takes from those who do not. Beauty is a sign you cannot fake – it signifies good health, brains

and good genes. It makes sense to have beautiful friends because they have brains and will be helpful and it makes sense to choose good-looking mates because they will breed well. Even being slightly good-looking is an advantage. These advantages stack up to the point where the really beautiful just get life handed to them on a silver platter, and still they're not happy.

HOW TO SLEEP

In England they call it TATT – tired all the time – mothers who wake up tired, businesswomen who commute for work and never sleep properly, burning the candle at both ends, unable to let go . . . a nation of sleep walkers. Sure signs of stress-related sleeplessness are sweating, getting up to the toilet several times during the night, over-eating and blood pressure problems. The trouble with compromising your sleep hours is not simply that you are tired, bad-tempered or diabolically humourless for that day or that year; the real problem is long-term damage like obesity, diabetes, cancer, stroke, heart disease, high blood pressure and depression. These days we sleep less than our parents did, and that includes children – a third of the population is sleep deprived and one in four has chronic insomnia. No wonder we torture animals.

Most sleeplessness is due to over-stimulation and an inability to relax and turn off. The over-stimulation starts from the violent way we wake up with a loud alarm ringing and it continues all day with cellphones, computers, telephones, always thinking, always keeping too many balls up in the air. It has long been proven that people who work late at the office and do killer

hours, are not more productive than people who work normal hours efficiently then stop. There are all sorts of obvious tricks to getting a good night's sleep, like having a hot bath, going to bed and getting up at the same time every day (as if), not drinking in the evening (as if), making sure the bedroom is dark and quiet. But the real solution is learning how to slow down brain activity with meditation and relaxation exercises.

The power nap is also a good trick. No woman ever gets enough sleep at night – men snoring all over you, power surges, crying babies, stress, worry, travel, leaving the front door open. Telling women they should be getting eight hours sleep a night is a joke to most of us. To save your life, health, beauty and sanity, go all Mediterranean and take siestas. The human circadian clock is set to want a brief nap in the early afternoon. Naps are good for the heart, the blood pressure and wellbeing. Here's how you do it – just lying down and relaxing doesn't count. You have to lose consciousness, but not for too long. More than half an hour just leaves you groggy because you have sunk too deep and have to fight your way back out of unconsciousness. Brainwaves slow down considerably as you get drowsy. It's in that sleepy window of time, right before falling asleep, that the drop in blood pressure occurs, not during the nap itself. Of course, any sleep is good for you so it doesn't matter if you end up sleeping for a couple of hours, but in terms of a siesta, it must be brief to get the increased alertness at waking. Young children and sleep-deprived adults normally go into a deep state of sleep very quickly in the afternoon. That post-lunch drop in energy is there for a reason – take off your stilettos, lie down, and close your eyes.

Phyllida

Phyllida Cotton-Barker is my GP. She has referred me to various torturers such as X-ray and ultrasound technicians, gynaecologists and skin specialists, and without fail they have always looked at the referral slip, smiled and said something extremely complimentary about her. Phyllida is tall, slim, good-looking in that fair Irish way, has sparkling blue eyes and is happily married with three children. While having a drink at my local, I saw her running and decided to ask her a few questions.

'Do we really need to exercise?'

'Yes we do and here's why. The human body is a hunter/gatherer; it's adapted to movement. We were made to eat a little and work hard during the day. We live much longer than we were designed to, so to age well we have to remain physically active – the machine is made to move and if you look after the chassis it will serve you.'

'What if you hate it and believe your body is designed for sitting in front of the TV?'

'Set it up so there's a possibility of enjoying exercise. Do something you like, do it with friends and 'protect' time for exercise. Also, take advantage of incidental exercise like walking rather than driving to work. There are many choices now for recreation and exercise. It is an investment in the future and just part of looking after your health and beauty.'

'What do you do to maintain good looks and health?'

'I don't smoke. Smoking enormously increases the risks

of a raft of diseases and also degrades the skin, which of course affects your looks. I eat and drink moderately but still have lots of fun. Don't stand next to teenagers. Be careful of the sun – I advise standing in it for ten minutes, half-dressed, each day. Actually, the official story is twenty minutes, arms and legs exposed to maintain healthy vitamin D levels. Simplify your life and figure out what is important to you. Look inwards to find out what you think is beautiful, not outwards. And look, you're as good as you get today – that's the truth of it. You should look good for your age and it's never too late to change habits.'

'It really annoys me when I see women who break all the rules, don't look after themselves, drink, eat rubbish and still look great.'

'Show me one over forty. You do pay for it eventually.'

'What are your thoughts on cosmetic surgery?'

'I have no objection to it in moderation, if that's really what you want. You can think about the starving children in Africa and wonder why you are spending money on your appearance or you can do it and contribute to helping others in another way – anything can be justified. You really have to think why you wish to alter your appearance or look younger – you have to balance it with societal expectations. Do you want cosmetic surgery because you need to be noticed maybe? I mean, what's wrong with growing old? We somehow see ageing as a weakness and cover it up. I suspect there will be a backlash against plastic surgery and a middle ground will be found.'

'What about taking hormones for the various passages

in our lives like menstruation, fertility or menopause?'

'It's up to the individual woman but yes, with expert advice, if she is able to make a well-informed choice, do what is necessary. This is the twenty-first century and we're lucky we have the option of HRT to support us if we want it.'

'Are you seeing different problems in women's health from when you first started practising?'

'Yes – more sexually transmitted infections, more fertility problems, mostly associated with women starting to have babies too late. More alcohol problems. The upside is, women are much more open now and manage their mental health more positively. They will talk about things instead of bearing it. Also doctors are now more approachable.'

'What advice do you give women to stay sexy, healthy and happy for the future?'

'Women have much more choice these days so make good lifestyle choices, get good advice and fill your life with possibilities and adventures. Keep doing things to stimulate yourself and keep moving. Your weight and blood pressure don't necessarily increase with age. I also like alternative remedies if they are proven to work and be safe. The drive for the future is coming from pharmaceuticals so it is a women's responsibility to be aware of that when they make their choices.'

HOW TO LOOK YOUR BEST

The first thing you do is throw out all non-essential numbers: age, weight and height. Let the doctors worry about them – that's what you pay them for. If you are a woman of a certain age, the correct reply to the question, 'How old are you?' is 'Age only matters if you're a cheese.' In terms of the cosmetic industry, there is an increasingly important market of women over fifty who don't think they're fifty, don't look fifty and don't feel they've even approached the hill. These women have more money than their daughters and wish to age gracefully and disgracefully, taking advantage of every trick in the book. They are cashed-up, wised-up and ready to rock. They are confident, will not be condescended to and love to see role models they can relate to. Think of all the advertisements that feature beautiful older women with lines and necks and curves – who knew a neck would become an issue? I never even saw my neck until I was forty-five then suddenly it was stuff world peace, it's all about the neck. The interesting thing is they don't want to look like they did when they were thirty; they want to be considered attractive at over fifty.

My mother, who was beautiful (another thing for which I have yet to forgive her), had a beautician from Elizabeth Arden come to our home when I was twelve to give me a course on how to look after my skin. From that day on, I have never experienced a day without face cream. Whether it made any difference or not is debatable, considering all the sun I soaked up, but God only knows what the damage would be like if I hadn't slathered it on. Face cream does not prevent ageing. It covers your skin so that less natural moisture escapes and it also helps to protect from

pollution, sunshine and dirt. Putting it on at night forces you to wash your face when all you want to do is crash. We don't use face packs and scrub our skin enough. When I am in France and Morocco I always go to a hammam or bathhouse. They range from grass-roots to very posh establishments. The effect on your skin of having it scrubbed hard is extraordinary. No cream comes close to the soft skin you are left with.

In the hammam, the North African women use black soap, which is actually dark red, and a rough scrubbing glove. They fill several buckets with differing temperatures of water and pour it all over to wash the soap away. Then they grab clumps of henna and rub that all over you. This is then brusquely washed off by matter-of-fact hands. The bath ladies are voluptuous mountains of flesh utterly comfortable in their own bodies and with yours. Coming from an Anglo culture I always find it curious to be handled all over, and believe me, they don't shirk from cleaning *any* crevice. In the process of being turned and every inch of you got at, you fall gently against their bodies – it's like being a child – they take you over. On go the abrasive gloves – I don't use the word 'abrasive' lightly – and off comes your skin in black rolls. This scrub goes on for quite a long time, then another soap washing and deluge follows. Finally, vigorous hair washing and a deluge poured straight onto the head. The whole family goes to the hammam – little toddlers and very old ladies calmly sit there being massaged and swamped in buckets of water.

You can make your own face packs at home. The secret to good skin is in what you eat, specifically vegetables, fruit and lots of water. If you don't like putting vegetables inside your body, you can slap them on the outside. To tighten pores and prevent

wrinkles on normal skin, you throw half a cup of cabbage in the blender with enough water to make it into a paste, plaster it all over your face then wash it off when it has dried. Smells ghastly. Otherwise, you can smear a beaten egg over your skin. This won't harden so do it over the washbasin, leave it on for five minutes, then wash it off. Smeared blended apple skin is also a good cleanser. For oily skin, paste blended cucumber on your face, let it dry, and then wash it off. To moisturise dry skin, mash a very ripe banana with a teaspoon of honey, slap it over, rinse off when dry. For pimples and blackheads, you can make an abrasive paste of baking powder and water and rub it in circular movements into the skin then wash off. Believe it or not, lemon juice not only whitens and tightens the skin but moisturises it with its oil, so rub lemon juice all over your face and leave it overnight. In the morning, your skin will be soft and glowing.

THE GOLDEN DOOR

'Jane, my stomach's so empty, I can hear the water sloshing around in it as I walk.'

'Don't be stupid. That's your water bottle.'

'I'm desperate for a G&T.'

'Peta. Release yourself. Move your mind towards the pretty wild flowers.'

It's 6.30 in the morning. I'm in the kind of shock a plane must feel in reverse thrust. I am half-blind due to semi-consciousness and am supposed to notice a wild flower. And if you had just done a bush walk at dawn and already consumed half your

body weight in water, you too would mistake your body for a mobile water tank.

Jane Hunter of Hunter's Wines and myself, inactive television presenter and food writer, took it into our heads to jump on a plane to Queensland and place ourselves in the hands of The Golden Door Health Retreat. Somehow, we had injected the word 'luxury' into the equation, a fantasy which never eventuated. The Golden Door is not for dilettantes and debutantes. It is a true, holistic health retreat. You go there to improve the quality of your life, so every part of your being is rejuvenated and kick-started – from the body to the mind to the spirit. It's not about lying around and being pampered, although you can do that if you so choose. No one forces you to participate; you can just drape yourself on the edge of the pool all day, dragging yourself off for a massage and a cup of wheat grass every so often.

Upon arrival, three interesting things happen. First, you check into your chalet and notice a distinct lack of TV, radio, cooking utensils, bickies, gin and mixers. Jane and I glanced at each other in panic. Then you are pinched and measured, encouraged to touch an area in the general direction of your toes and asked to pedal the exercycle to nowhere for three hours until your heartbeat can be felt exploding in your eyebrows. This takes three minutes in real time. A green dot on your nametag means you can walk to food but that's about it, a blue dot means you are pretty fit, and a pink one means you are a triathlete. Then you have a communal detox dinner comprising vegetables and fruit, mostly raw and fantastic in their variety and quality. No meat, no fat, no sugar, very little salt, and lots of guess what? Water or herbal tea.

If you're like Jane and me and most of the fifty people who visit the Golden Door for the week, you are a person who works hard, is a bit lazy on the exercise front, ingests toxins of the alcohol, coffee, tea, fat, sugar genre and knows that you should meditate but never quite gets around to it. There are lots of pampering, massaging, wrapping in algae and mud, facials and aromatherapy. And there are lots of games, dance and music, bird watching and water therapy – all designed to secretly exercise you in between belly laughs. Water therapy is not to be confused with the ingestion of the Pacific Ocean-like quantities of water you are encouraged to drink daily. If you have the sense God gave gravel, you stop drinking at dinner time or you do the toilet tango all night.

Excuse me while I go to the toilet.

On the second day the alcohol, tobacco and coffee freaks have headaches and feel sick from the lack of poison. Jane and I were seriously missing olive oil. Jane kept calling her family and telling them what she was eating. I could hear the incredulous gasps emanating from the cellphone. We are asleep at 9.00 p.m., exhausted, happy and feeling every part of our bodies in the kindest possible way. By day two we are already transformed. At 5.30 a.m. on the dot, I can hear Jane rising in the other room, making her green tea and contemplating the dawn. I am awake, feeling wonderful and looking forward to Tai Chi. At 6.30 a.m. we are all (mostly) on the lawn near the giant fig tree, warming up with group shoulder massages and bum pummelling. Learning Tai Chi was the shining star of my stay at The Golden Door. The slow, disciplined movements are a beautiful thing and 'looking back at the moon' while facing

the rising sun and listening to the birdies is the most joyous, heartening experience. And then you do the bush walk. And then you have porridge, muesli, fruit and yoghurt for breakfast. All this you have achieved before 8.00 a.m. and it feels fine. The fruit platters are sumptuous, voluptuous displays of papaya, strawberries, bananas, pineapple, passion fruit, grapes, watermelon, green melon, yellow and green kiwifruit.

Jane took lots of tennis lessons, swearing her coach was the best she's ever had. The pinks dots threw themselves into things – I would only walk past with my eyes raised to heaven. While Jane snuck off to the pool I did the visualisation class and all I could bring up was steak and béarnaise sauce. I never eat steak and béarnaise sauce and now I'm obsessed with it. I was attracted to yoga, meditation, stretch and accessing my inner African at the drumming session. This would best be described as deconstructed anarchy. Who would have known so many people would have so many ideas of what the word rhythm means? We reached drumming fever pitch, considered throwing all our clothes off, remembered we weren't African tribespeople after all and common sense prevailed. I also really liked the lectures on nutrition, food for life, stress management, personal action plans and women's health.

By the third day, the meals increased in variety. Now we were getting Mexican beans with guacamole, corn, roasted beetroot with balsamic and orange dressing, sushi rolls, pasta, vegetable soups, fish with sauces and a smashing mango and mint sorbet with berry coulis. And then there's the cooking demonstration where chef David Hunter taught us fat-free recipes like sea bass on Asian noodle salad with wilted greens; fettuccini with

lemon scented button mushrooms and avocado pesto (I know what you're thinking but try it – it's fantastic); and my personal favourite, ocean trout spring rolls with sweet chilli sauce. He has put out a recipe book of beautiful food designed to be flavourful, healthy and simple to prepare. Such things as their famous Golden Door muesli, fruit loaf, red pepper sauce, poached snapper with coriander, lime and mango salsa and a variety of mixed fruit ice creams.

'You get it out girl. Go ahead and blow your nose. Good girl'.

I'm crying, my nose is running by the bucketful and I am possibly in the most pain I've ever been, not counting when my heart was broken in 1976. This is one of the massage rooms at The Golden Door and the woman who is holding the key to my release is the Maori warrior queen, Ipu. She's cleverly disguised as a trigger point therapist but really she's a magic woman. You feel her personal power as soon as she opens the door and trust me, her fingers are like pistols breaking down the concrete I call a neck. I haven't had any pain since. Jane, who had just had a facial, was radiant and blooming in the next room.

You may wonder why I was exhausted at the end of every day. Well it was because of the noodle circuit where the trainer exhorts you to put the polystyrene noodle between your legs and try to run under water and yells encouraging things like 'No tongue Sharon. I said no tongue'. And then there was the pilates and the water polo and the tribal dance. The staff are highly qualified, funny, tender and accepting. There's none of the manic hysterics of gym instructors here – just competent instructions, always given with a smile and a quiet word in your

ear if you're doing it wrong ('Peta, I said put your left leg around *your* right ear, not the ear of the person next to you.'). In fact the staff are so nice to you, some people weep, others ask their favourite masseur to marry them and even rock-hard cynics such as Jane and I can't find fault. People love coming here so much – a staggering 35 per cent are returnees. About 75 percent of the guests are females, 25 per cent males and 1 per cent decide when they get there (just kidding).

The last thing that happens before you leave, holding onto the instructor's shins and begging to be allowed to stay forever, is the re-pinching and re-measuring. Jane did very well on this one and I am pleased to report I did lose a few centimetres here and there – some from my waist, zero from my ankles. I was devastated about the ankle situation but when it came to toe touching time, I was a champion, a freak of nature, practically double-jointed.

'I feel fantastic Jane. How do you feel?'

'Very good. No back pain. Did all sorts of things I didn't think I could do. What do you think is the first thing we will do on arrival in the real world?'

'Go to the toilet and then drink gin.'

ON DEATH & DYING

Elizabeth Kubler-Ross, a Swiss-born psychiatrist, wrote the ultimate book on death and dying. She believed that guilt is perhaps the most painful companion of death. She identified the five stages of grief in terminal illness – denial, anger, bargaining, depression and acceptance. The five stages have

since been adopted by many as applying to the survivors of a loved one's death as well. In my experience of this topic, it's the being ill and in pain part that's tricky, not the dying bit. Almost everyone I have talked to who died and came back, didn't want to come back at the time. They describe it as a wonderful, peaceful, almost hallucinatory experience, where they were being seductively beckoned to the other side by a light and relatives already there or a friendly smiling person. They were angry at being brought back by their children saying, we need you Mummy, or the doctor resuscitating them, or a lifeguard saving them. As a nurse, I watched a lot of people die and they are rarely conscious at the end – just floating and forgetting and moving away. Scientists tell us this travelling down a warm tunnel, experiencing blinding light, feeling high and euphoric at the end is just the brain being flooded with chemicals like serotonin and endorphins. Many doctors believe these are hallucinations connected to the physical process of death and not afterlife previews. Human beings are unbelievably intelligent in comparison to other animals, so why we can't make dying easier is a mystery to me.

Most of the women I have admired in my life have 'aged like the butcher's wife', as Simone Signoret once said of herself. They dress beautifully and have normally aged faces, untouched by knives and fillers. These women project a calm, true sense of themselves. They continue to live extraordinary lives, while not denying their losses and their vulnerability. You can deny your age a little bit, but by violently denying your age, you are denying a part of yourself. You are not going to become your fulfilled self, your most fabulous self, if you are ashamed of

the most ordinary and inevitable of human conditions – that we all get older. I think it's fine to do a little cosmetic surgery, but not too much. I worry that our culture places a higher premium on looks than on character, especially for women. But I also worry that women have changed the conversation around this issue so much that feminist rhetoric is used to justify our maniacal pursuit of youthful beauty – 'It makes me feel better about myself', 'It's my body, my choice.' This rhetoric clouds the truth – that we 'feel better about ourselves' because the world will perceive us as youthful and therefore viable. Surgically staving off the inevitable makes us radically unprepared for our own deaths. The ageing process eases us toward our certain end, forcing us to place value on our inner journey rather than on our outer selves. Without this process, we will be far more frightened than our predecessors when called upon to go to the big restaurant in the sky.

WISDOM GAINED

- You're only young once but you can be immature forever.
- Experts keep telling us we have to exercise more – they're right.
- Wrinkles merely indicate where smiles have been – look after your body and it will look after you.

7
MUSIC & SINGING: A CRY FROM THE HEART

What is music for? We swim in music like fish swim in water and our hunger for it seems to have no limits. Neuroscientists tell us that although we don't need music to survive, there must be some evolutionary advantage or it wouldn't have persisted. One advantage could be that music and singing make you amorous by releasing the 'love hormone' oxytocin, and this can lead to baby making. However, no one has ever proved that every adaptation needs to be functional – especially if it is decorative or mood enhancing.

The essential elements of music itself are pitch, rhythm, tempo, contour, timbre, dynamics – loudness and softness. From these we build the higher order components of metre, key, melody and harmony. Singing is an unusual and potentially flawed form of communication because the singer gets to say their piece without being interrupted (hopefully), something

that never happens in conversation. Singing a song is like going to the shrink – it's the only time you get to bang on without being interrupted. The songs of famous singers are not loved by everyone – some people can't stand them. They can arouse a disagreeable emotional state, make you depressed and irritated, or you may disagree with the sentiments.

Whether someone responds to a song or not depends on what they can get out of it, rather than what is there for all the world to see. Music provides instant access to emotional states in a way no other form of communication can, and the weird thing is, we can hear the same song over and over again and never get sick of it. You can't do that in conversation. If we were to repeat things over and over people would fall off their chairs with boredom. The doctors who discovered some performers lose weight during a performance would be interested to know that blood pressure readings and measurements of the electrical conductivity of the skin show that we are physically affected by music and the same song can affect different people in different ways.

There are very mysterious things which happen around music. Conductors don't communicate only by humming the tune for example – they gesticulate, grunt, howl and weep. Children with Williams Syndrome can sing beautifully or play several thousands of pieces of music but can't add two and three together or tie their shoelaces. Why do some people have perfect pitch? There are people who you can ask to sing a high C and they do it unerringly. There is a type of synaesthesia (sort of crossed brain wires) where the affected person tastes words but even more fascinating, there is the form where they hear words as music. It is overwhelming for them and these people

usually end up reclusive, simply to get some peace from the noise. There is a form of profound amnesia, notably one suffered by an English musician, where he can only remember things for a matter of seconds. He knows he has it and keeps a notebook which says the same thing over and over again – I am awake. Despite this unimaginable horror, he is still able to do two things – love his wife and play music. He can still sight read, play the organ and conduct – testament to the fragility and complexity of the human mind.

The relationship between singer, songwriter and audience is complex without our really knowing it. Communication is a multi-layered thing, and it is often not so much what we say but how we say it. Victor Hugo wrote the shortest letter in the world to his publisher: '?' It meant how is my book doing, is it selling and is it selling well? Many thoughts, emotions, maybe conversations, maybe scribblings had gone on before reducing all to one question mark. His publisher understood immediately and wrote back: '!' This told Hugo all he needed to know about *Les Misérables*. Imagine if a song was written called: '.' There is nothing there but a Zen landscape of information reduced to the beauty of silence. What's left out can be very moving. The singer Jacques Brel was expert at pauses, leaving out the last obvious word of a sentence or using an exaggerated, drawn-out pronunciation. A true artist, as opposed to someone who is just opening their mouth, is one who knows instinctively how to judge the space and feel the correct length of the silence. This is a very powerful thing.

The true mystery of communication in song is this: how is it possible that we manage to leave a lot out, sing in a foreign

language, have no personal experience of the topic at hand but still be profoundly moved? For example, you can sing an Irish song to French people about a girl who walked into a pub and heard her lover saying the same sweet nothings that he had said to her to a strange girl on his knee, and everyone in the room understands how that feels, although that exact thing may not have happened to them. A great singer is able to control her listeners because she not only thinks of herself but also of what the audience have in their heads and hearts. It is never enough to entertain; there is always a complicity – the act, like love, requires two parties, the giver and the receiver. One doesn't work without the other. A live performance raises itself above the mundane when the audience graciously give of themselves and can only result in profound satisfaction when this happens. They must be attentive and give in to the seduction actively.

CHILDHOOD INFLUENCES

By a miracle of fate, from a family with no melodic talent whatever, I was blest with one saving grace – innate musical ability. I sang for hours in my cot as a baby, sang to my dolls, hummed in church, played the piano and recorder for friends and relatives and sang and danced all around the swimming pool, inevitably falling in at least twice during a 'recital'. Music unchained my heart and harmonised my little life. It was an ecstasy that I could tap into at will in the unhappiness and confusion of childhood. Aged eight I commenced piano lessons in the music room at Holy Cross Convent. This wonderful room was part of the convent where the nuns lived, rather than part of the school. It was polished,

calm, full of flowers, had a grand piano and always seemed to have a summer, sea-perfumed breeze blowing in through the window. Like most children I participated in music and singing competitions, the most nerve-wracking experience invented by the church after fasting. My Irish friends loved singing and taught me all the maudlin songs like 'The Black Velvet Band', 'I'll Take You Home Again Kathleen' and 'If You Ever Go Across The Sea To Ireland'. The sadder the better. If I could get them all crying it was a sign of success. Sometimes I even wept myself. I stood up whenever I was asked to sing and like a good girl performed to order, my long black hair tied up in a ponytail with green ribbons, hazel eyes flashing. Nobody seemed to notice my terrible ankles or freckles or nose. This is how I got addicted to performing. These suburban stages are where the television presenter was born. Never underestimate the talents you were born with – they're all you've got.

Later, at St Mary's College, once again the music school was the most beautiful part – a separate house on the grounds that was a realm of culture, order and happiness. I loved being in there because somehow you became a human being, the nuns gave you tea and biscuits and you met extraordinary people and famous opera singers. Anyone in New Zealand with any talent had been taught by Sister Mary Leo and they all came back exuding Chanel No. 5 and minor constellation quality – Mina Foley, Kiri Te Kanawa, Malvina Major. Unlike the classroom, you actually learned something and made progress there. Some people said that Sister Leo was a hard taskmaster, but I couldn't think what they were talking about. I had been brought up by women who were all very strict and uncompromising so to me it

wasn't behaviour out of the ordinary, in fact, like the rampaging sisters at primary school, Sister Leo was just another fascinating character in my life. If any adult had asked my opinion on anything at all, I would have been shocked at the permissiveness of it. In those days you didn't have conversations with your elders – the answer was yes or no. It wasn't negotiable; they were in charge; we were afraid of them. It was like benign fascism – you weren't happy but you weren't necessarily unhappy either.

Sister Leo always used to say, anyone can be taught to sing, and I watched her do it over and over again, so never think just because you sound like a gravel truck on steroids, you are beyond help. You may never sing like someone born with a voice but you will sing and you will be happy and you will share this ecstasy with others. If you have always harboured a fantasy to sing – pick up the phone and organise some lessons right now. I know it sounds goofy, but choir singing is inexplicably satisfying and produces serotonin like crazy. Singing increases immunity, reduces depression, improves cognitive function and mood and increases wellbeing. According to research from the University of Ontario, choral singing can help stop the voice from ageing, help people cope with chronic pain, lower stress levels and improve lung function. Singing and music give you physical pleasure and lead to dancing which leads to sex – you can't lose.

Fiona

Fiona Ferens is the most generous singer I have ever met. She will sing anytime she's asked to and in spite of her

glorious soprano voice, makes everyone feel that they too could sing just like her. We've all tried but the thing that's really hard to imitate is her beauty and perfect figure. Fiona has developed a substantial repertoire of operatic, sacred and concert music. She performs all over the country, appearing nationally on television and radio and she also teaches. I asked her why she sang and made music and how it made her feel.

'I have absolutely no idea why I simply have to sing and have to make music. I have done so since I was a wee tot and can remember as a pre-schooler singing to any visitors who came to our house. As a child I loved going to church because there was music and singing to look forward to, which definitely made up for the boring bits in between. I was a complete parrot and could memorise lyrics in no time flat. Push the correct button and I sang at the slightest opportunity.

'Music elevates me. There are some people who say the giving of a stunning performance, 'tripping' on the endorphins of sensuality and creativity, the physical 'high', plus the adoration of the audience, feels better than any orgasm. Me, I'm not going to comment on that, because you'll print it! As a classical musician the experience post and during performance can be varied, depending on the number and type of instruments you're performing with, how demanding or straightforward your part is and of course, how well you've conveyed the heart of the music from your heart to the audience. To sing classical music is a complete mental multi-tasking job, always a challenge but

when you really feel you've achieved a good performance and you hold the audience in the proverbial palm of your hand, it really is absolutely amazing.'

'How does listening to music make you feel?'

'Music has the power to stop you in your tracks. Time stops, your heart thankfully somehow manages to beat on, while the rest of you is kidnapped to a sphere you didn't know existed. This is true for any kind of music. That's how I feel when a piece of music I'm listening to really grabs me. Music I can't stand seems like noise. In general I like most music. Why are songs repeated on the popular radio stations? Why are certain operatic arias everybody's favourites? These are the pieces with the magic X factor. Music has this power to stop us, make us listen. Perhaps we could infuse politicians' and warlords' brains with it, compulsory symphonies for all!'

'Is singing and music important in our lives?'

'Singing and music are both terribly important in our lives. In this electronic age we are surrounded by them both unknowingly and knowingly, a huge amount of the time. I'm sure singing started because basically the instrument, your voice, was there. You didn't need to fashion it out of a bit of wood or ivory. It expressed what you needed it to, whether it was an emotion or a simple way of remembering a story that could be passed on from generation to generation, tribe to tribe or village to village. It was communal, a great addition to occasions where there was food and/or formality or just plain good times. Nothing has changed today. Music is in the background

or foreground of everything – it can make or break an occasion and is especially useful in the advertising industry. Supermarkets play certain types and certain speeds of music depending on the time of day and the season.

'I heard the same LONG reel of music twice when I was in hospital in labour with my second son. I wanted to scream "turn it off!" but didn't have the energy. It was the overture to the opera *The Magic Flute* and because earlier in my pregnancy I had played the lead female role in this opera, I felt I should be leaping off the labour bed and putting my stage make-up and costume on! Singing and music are things you can share. They can keep you company, can be shared by family and friends, can get rid of and express pent up emotions, can help you change to a better mood or mental place, can powerfully lift you out of everyday drudgery and engage all your senses. In other words nothing has changed since man first began to sing and make music.'

'What has been your most criminal singing behaviour?'

'Mmm . . . probably to perform a gig where I hadn't warmed up and where the pianist and other singers and I hadn't rehearsed. Believe me a smile can go a long way! Usually I'm anal about preparing for anything, no matter how small a function. I was singing one night at a regular gig and realised that my new strapless dress was halfway down my boobs! I casually pulled it up and carried on! Luckily I was wearing a bra.'

OPERA

Opera singing, as we all know, is an acquired taste. Fortunately I grew up with opera so bypassed the stage of feeling that it is a very artificial way to sing. Nobody is born singing in this elaborate fashion – one has to learn it. Opera sounds as it does because it began in the seventeenth century, in the baroque era, when trilling and twisting was the mood of the time and even architecture was very elaborate. Italian composers of the time wanted to bring this style to their dramas and plays so had people sing rather than talk. These singing plays quickly evolved into top-end evening entertainment comprising recitatives or simple, monotone and arias or grand melodies in which the performer could show off their brilliance, training and vocal range. The aria reflects the emotion of the recitative – these are the dramatic, heart-stopping songs we wait for in an opera – like in *La Traviata, The Marriage of Figaro, Don Giovanni, The Magic Flute, Madame Butterfly* and *Carmen*. I burst into tears at all the sad arias and always hope that the heroine doesn't poison herself, die of tuberculosis or get knifed. I always want to run up to the stage and warn her. The powerful combination of voice and drama is why opera has endured as an art form to this day.

By the eighteenth century, opera style had divided into opera seria or serious, tragic stuff, and opera buffa or light, witty performances, the forerunner of operettas like *The Mikado*. If you want to get into opera, don't start with heavy, inaccessible composers like Wagner – go for Mozart or Verdi and try to see it live, that way the arias and story make more sense. If you listen to opera at home, buy CDs of anything sung by Maria Callas. Her voice pours into you like molten lava. Opera was

written to be seen and originally in the seventeenth century, the audience talked, flirted, drank and ate all the way through it. They only really paid attention when a big aria started and if they really liked it they would demand an encore there and then. To appreciate opera you have to be open-minded, cool and fearless. Forget the fuddy-duddy, snobby, old-fashioned image and experience it as one of the true, live, powerful pleasures left in this world of recorded music.

I love the ostentatious, flamboyant side of opera – the sets, costumes, no microphones and getting dressed up myself to attend. There's no such thing as over-dressing for the opera – why do people go in jeans and tawdry, moth-eaten furs when they can get a thrill from beautiful, glamorous clothes laden down with jewellery? It doesn't have to cost a fortune – borrow, beg or visit the second-hand designer shops. There's no reason why you shouldn't turn up in a vintage kimono for *Madame Butterfly*. You can't have too much make-up on for the opera either – get out those false eyelashes, hairpieces and nail polish. To make a real evening of it, organise a dinner or party afterwards.

Note: Don't sing along at the opera and only wear extravagant clothes at a live performance – the supermarket is neither the time nor the place. You won't look exotic and eccentric – you will look like you're on day leave from a rest home.

SAD SONGS

I'm a sucker for a sad song, as are most women. Songs of disappointed love, national longing and political betrayal arouse a particular bittersweet pleasure but I don't really know why. I

wasn't born or brought up in misery but I feel the songs. They don't make me sad – the feeling is one of pleasure because the melodies are often in a minor key and very beautiful. In songs of unbelievable beauty and desperation such as 'Ne Me Quitte Pas' – 'If You Go Away', one only need hear that phrase and a mood, memories and feelings install themselves in one's consciousness and physical body. Sad songs should be poetic, should make you dream, should produce a gut reaction.

The upside of being half-Irish is you never have to explain why you like sad songs. Positivity and always looking on the bright side of life is a tyrannical curse many women suffer from, developed to counteract natural inherited pessimism. The virtues of negativity are manifest and denying it is bad for your health – pessimism is a learned, guaranteed formula for avoiding disappointment. We lie through our teeth about everything from ham sandwiches to love. A big smile is rarely seen in childhood photographs – it is something developed and learned with maturity and experience.

Some women wake up depressed every morning, which is a result of low endorphin levels. Endorphins are naturally occurring neurotransmitters in the brain and are at their lowest levels in the early morning, postpartum and in Alzheimers sufferers. This is why you sometimes wake up feeling black, women get postpartum depression and Alzheimers patients are often grumpy and angry. Endorphins are at their highest levels after hard physical exercise, during sex and after eating certain foods such as pure chocolate. All this to say that in our copying of the American Dream mentality and relentless positive thinking, we are no longer permitted to indulge in healthy, underrated

pastimes such as the vapours, morbidity, melancholia and plain ordinary sadness. No one wants to listen to us moaning about our problems – this is why we need sad songs.

EDITH PIAF

French singer Edith Piaf said, 'I am the lover, my song must be sad, it must be a cry from the heart, it is my life.' Her songs talked of reckless passion, excessive declarations of fidelity and a sort of morose self-pity that if all else failed, at least the lovers would be happy in heaven if not in this miserable valley of tears. She sang of betrayal, sex, fun, drugs and deception. It was said that to listen to her sing in person was like having someone confess to you and you alone, and people often wept during her performances. When you find out the personal stories of sad singers and songwriters the tradition is imbued with another layer of sadness, further enriching your journey of following their poignant melodies. Piaf paid dearly for her fame, showing the whole world her distress and solitude, pouring her tormented soul and deepest, darkest emotions into her performances to the point where she almost literally died on stage, but not quite. She lost consciousness, fell over, couldn't finish shows, cut songs out of her repertoire that were too hard, but didn't actually die. In fact, towards the end, when she could only stand up with a shot of heroin backstage, some people went to her performances out of a ghoulish fascination, to see whether she would make it or not. At her death in 1963 she was only in her mid-forties but she looked like a twisted, tiny, deformed old woman with a ghastly bloated face.

Note: Piaf songs are very emotional and cathartic to sing but absolutely worth it because they make everyone else cry.

JACQUES BREL

The Belgian singer Jacques Brel had a presence on stage that was utterly breathtaking. In one song he talks of women who are so good at eating you alive, their teeth hurt. He saw women either as faithless bitches or angels of tenderness. He made his songs into paintings, insisting the audience experience something very intense. They had to participate emotionally and suffer with him, struggle for breath, almost inhale his sweat. He was terrifyingly lucid, psychologically black and spoke of absolute despair. What people got with Brel's songs was eroticism, rebellion, laughter but, most of all, a sense of belonging. Brel sang every song as if it was his last and was completely exhausted after a concert. In a one-and-a-half hour show he could lose 800 grams in body weight and his suit was soaked. His audience were marginally less exhausted.

My favourite Brel song is 'Voir Un Ami Pleurer' – 'To See a Friend Cry'. The tune is deceptively simple and unbearably moving. For Brel, this song was the summing up of all pain. How many times have we watched a friend weep knowing with our every fiber that it is a lonely occupation; no one has yet invented a way to take away pain. He sings this song in a voice of infinite sadness, leaving the last line open for the listener to search their own heart. Like Piaf before him, his relatively young death from cancer unleashed a huge, cathartic and profound public mourning.

Note: It's quite dangerous to sing like Brel – it can result in sudden weight loss, illness, unhappiness, and a dislike of being bourgeois.

FADO

In the Portuguese taverns of Alfama and Bairro Alto in Lisbon, where you can hear the best fado, there is complete silence before and during the song. The silence is only broken after the last, wrenching moment by deafening applause. Amália Rodrigues was the greatest fadista of all – the Piaf of Portugal, the Callas of fado, the queen of anguish. The first time I heard a recording of her I knew she had that thing so few singers have – the voice to alter your life forever. The most profound and imprisoning voice imaginable – deep, wrenching and achingly beautiful. She maintained spectacular control of the music as she swooped from phrase to phrase, bringing words up from her deepest darkest soul and wrenching the very arteries out of your heart. She made me think of Om Kalsoum, the great Egyptian singer. Fado is sung with two guitars – one Spanish and the other Portuguese. It is not just an accompaniment – they are in an intimate conversation with each other and the standard of musicianship is very high. It is heartbreakingly beautiful, melodic and often in a minor key. The singer is usually dressed in black and stands in one place with little movement. The topics of fado are sailors lost at sea, prostitution, immigration, starvation, poverty and unrequited love.

The Portuguese sing fado or sad songs because it suits their nature. They have a baffling, national fondness for being sad

and there is a strong connection between the melting sadness of the fado and the amorous, sentimental fatalism of Portuguese people. The fado has been described as a lament interrupted by sobs. The word comes from the Latin 'fatum', meaning fate, and its fundamental tragic theme is the unattainable in life and love. The most common form that this national characteristic takes is 'saudade', which means nostalgia. This term doesn't exist in other languages but can be described as a unique and constant desire for something that does not and probably cannot exist, for something other than the present, a turning towards the past or towards the future; not an active discontent or poignant sadness, but an indolent dreaming wistfulness. The corollary to saudade is fatalism and superstition, the belief that things are beyond our control and that the forces that do control them must be respected.

Note: If you wish to become a fado singer, first get a sailor boyfriend, second go to Lisbon, and third buy a whole bunch of black clothes.

FLAMENCO

Flamenco is the outward expression of Andalusian society and family and originally was a mélange of Moorish, Gypsy, Indian and Spanish folk music. This was the ancient singing of marginalised people, outcasts, victims of fate – hidden, macho, harsh, secret music. If fado singers are specialists in sadness and beauty, flamenco singers are specialists in pain and passion. Their themes are bitter romance, hate, death, mothers, jealousy, prison, murder, alienation, betrayal. The similarity flamenco

shares with fado is fatalism, powerlessness, oppression and an inability to do anything about life's pain. In Andalusia the graveyard is called tierra de la verdad, or place of truth. One is buried and that's the end; all life is an illusion because it finishes; death eats into life and as soon as the intoxication of youth is over, death begins to sap the taste for pleasure.

The first live flamenco singing I ever heard was in La Carbonaria bar in Seville. A middle-aged, stocky man in dark pants and white shirt walked on to the stage and sat down. The guitarist walked on and sat quietly next to him. He placed his hands on his knees, threw his head back and sang with what the Spanish call duende – muse, angel, demon, hypnotic energy. Like fado singers, the flamenco singer must have an emotional exchange with the audience and every so often this man stood up and begged the noisy audience to be quiet and respect the song. The singer must establish contact with his inner self and be driven by a ferocious sincerity which he turns radically inward. In fact, when you watch flamenco singers for the first time, you are spying on something intensely intimate. He started his songs with moaning, called the ayeo, and he rubbed his hands together in a sort of soft clap. Gradually he launched into a harsh, very ornamented singing, intimately connected with the guitar. As with fado, the guitarist and singer appear to be in a conversation, watching each other and no one else.

Paco Peña is one of the great contemporary flamenco guitarists. This man's voice is strong and of course there is no amplification so it has to carry around a very big room. This singing seems to come up from the very soul of the performer and is extremely guttural and oriental sounding. You can clearly

hear Indian and Arab influences in the Moorish wailing. The singer appears to be in physical pain, gasping, crying out, stamping and holding their arms out as if begging to be relieved of an unbearable burden. Sometimes, after a huge exertion, the audience would olé and clap in the middle of the song, as in opera when the soprano hits the high note flawlessly. Flamenco musicians disappear into their spiritual essence as if their conscious selves are being overridden. The sombreness of flamenco song contrasts markedly with the flashiness of the dance. More than any other music I have listened to, flamenco made me feel as if I was an integral part of it; that I had a role, that I was drawn in and my heart was beating with it. At the end of a song the singer was exhausted and covered in sweat and the audience clapped wildly.

Note: If you have a tendency to fall in love with swarthy flamenco singers, just stick to the clapping.

SEAN-NOS

The sean-nos singing of Ireland is an early seventeenth century tradition of unaccompanied songs, probably originating from French Provençal troubadour songs of the thirteenth and fourteenth centuries. Most of what is still sung today originates in the eighteenth century and they are laments or love stories. As with songs of lament in all cultures, there is a very strong connection between the singer and the audience. Often the audience know the background story and there is a common awareness of place; they respond as if the singer is talking to them by making short comments, showing encouragement and

approval, maybe singing along with the last line, and sometimes even grabbing the singer's hand to hold or squeeze it while they sing. In Ireland I often saw old people weeping over a song, especially songs that told stories of executed local heroes or national betrayal. The singer's delivery is aloof and almost trance-like, unlike other sad song traditions such as fado, which is very engaged and passionate. Sean-nos have an aristocratic, literary background of formality and social constraint, whereas fado and flamenco come from city slums and are fusions of various styles. The expressiveness doesn't come from emotive vibrato or dramatic demonstrations, but from subtle, restrained delivery, letting the beauty of the music speak for itself.

The really defining thing about sean-nos is the complex, pretty ornamentation or variation in the melody. The singer turns and rolls around a single note, called melismatic ornamentation, or does the 'shakes', which is like a trembling or vibrating sound. Another technique varies intervals between certain notes of a melody and slides up to a note. Edith Piaf also used this a lot in her singing. When done with restraint, it is unbelievably erotic. The Irish say that songs are like people – you have to get to know them, you can't just sing a song, you have to put your personality into it, you may only be able to sing a song really well after a few years.

It's always a pleasure to find myself in a pub in Cork – pumping, frenetic, friendly and full of good food. Half an hour into a singing session and you start thinking, 'Christ, it's always the mudder. Either she's dyin' or she's dead or her heart's been broken by some slut of a daughter who would rather be out at the disco than at home "batin" the buther.' Irish mothers suffer

most dreadfully in song and they only give their sons up after a long struggle. In the country, if a man isn't married he will still be at home running the farm. Even if there's no farm he doesn't move into his own place, he stays at the 'home place' where, it doesn't take too much imagination to figure out, there'd be no business with women (who would only be there to take him away from the mudder anyway). There would be no question of deserting the mudder.

Note: Please remember that people don't take their clothes off at wakes any more but if you feel like standing in a corner with your face to the wall and sobbing a wee lament, everyone will think that's grand.

KARAOKE

There is absolutely no excuse for karaoke – it is God's way of telling you that you've drunk too much. The accompanying music is ghastly and usually off key, with a boring, unbending beat. Everyone who sings it undergoes a transformation where they are convinced, because of the artificial reverberation, that they can sing. They can't. On the other hand, when my friends drag out the ukuleles, I love it. I know it sounds desperate but it's such fun and don't you find it interesting that the more some folk drink, the more they think they can sing? But my ukulele players, who are accomplished jazz musicians, would be the last people to discourage anyone from participating just because they sound like an emptying drain.

Note: Karaoke leads to delusional behaviour and loss of face.

Moana

Moana Maniapoto told me she has been singing all her life in her family – she can't remember a time when she wasn't singing. That's how it is in Maori families. Her father had a guitar and sang with his brothers at the marae and her pakeha mother came from a musical family where the grandmother played the piano for garden parties. They had garage parties which were always happy occasions, full of singing. While Moana was getting her law degree she sang in bands to make money, but when she graduated she decided to keep singing as it just seemed too sad a life to be a lawyer. She has no regrets and is now one of New Zealand's most prominent singers and a household name. Her music is a fusion of traditional elements and rock/pop. She also happens to be very beautiful. I asked her how she felt when she sang.

'It is a completely magical experience because you create your own cosmos or vortex for the period of the song and that's how you make your connection with the audience. You don't get up on a stage and sing without a certain amount of ego and liking of attention, but I still get stage fright occasionally, where I walk on to a stage and have no idea what the words are. But something happens with the audience and the minute I open my mouth it all comes back.'

'Is a practice session different from a live show?'

'Yes and no. They are two different things. You can't ever get up on a stage and think there will be no connection

with the audience, which is why I never close my eyes when I'm singing. I don't understand singers who close their eyes — to me it's a way of cutting people out. Singing is a mood alterer — it always brings me up, never down. I love sad songs but they don't make me sad. However, audiences often cry when the band does a sad song.'

'You write your own songs. What do you write about?'

'Anything I am passionate about — politics, history, women, land, death, spiritual stuff. A song for summer would have a reggae feel, a sad song might be more classical. Sometimes we sing unaccompanied with a little reverb in the sound system. Reverberation is often used to cover up a weak voice, but when it's used ever so slightly in unaccompanied singing, it is very beautiful.'

'In flamenco music there is often dancing. Does a performance change when you have dancers on stage?'

'Oh yes. When my dancers come on, the energy level immediately amps right up because traditional Maori dancing is very masculine and earthy and primal. But we've also performed with Michael Parmenter and with ballerinas in Russia. The fabulous thing about music and singing is that it crosses borders and you can communicate easily with people all over the world. It doesn't matter what language you are singing in, you can always connect emotionally — nobody needs to understand the words.'

MUSIC AND SINGING: A CRY FROM THE HEART

WISDOM GAINED

- Everyone can sing – just find a teacher.
- You can never be too ostentatious or too flamboyant with music.
- No one has yet invented a way to take away pain – but singing comes close. Music turns grief into beauty.

8
SEX & LOVE: WHY IT MAKES US BLIND

We were told by the nuns if we indulged in sexual congress and then got run over by a car still in a state of mortal sin, we would go straight to hell, where the air is pungent with the aroma of roasting sluts. Call me old-fashioned but I miss those colourful days when sex was dirty and the air was clean. Remember when nice girls didn't have sex but nice boys did? If you were a girl who had sex you were a slag, if you were a boy, you were a real man. My question is this, if none of us girls were putting out, who were these boys sleeping with? Ever thought of that? Here's what I think happened. According to my friend John, his first sexual experience went like this: it was dark, wet and scary. The worst part was he was completely alone.

We Anglo-Saxons now know sex exists – we just don't have a handle on the fact that it usually involves another person and that person has to be consenting. I was very interested to hear

the latest gossip on the tennis court when I was about fifteen – according to the boys I was rather hot in the old sackeroochi. Hot would be an understatement. I was a virgin and was pretty sure all this activity hadn't happened in my sleep. Actually, I was still getting over the fact that my mother had given birth to her last child only the year before at the age of forty-four – the most embarrassing event in the history of the world. It was worse than being pregnant myself.

What was really terrifying for Catholic girls was that we knew perfectly well we could get pregnant just by thinking about it. We had incontrovertible proof in the Virgin Mary. She conceived a baby all on her own and continued to be a virgin for the rest of her life. By the time we found out that this was just a reincarnation of a pagan myth, our pelvises had already fused. Krishna's mother Devaki was a virgin, so were Adonis' mother Myrrh and Dionysus' mother Semele. Hello?

One day at school my best friend offered devastating intelligence she had gathered.

'I found out how you get pregnant,' she said, leaning back on the umpire stand at the tennis court.

'How?'

'Well, the woman and the man are in bed together and he sticks his thing into her thing. He puts a seed in . . .'

'NO! I don't believe it.' Ashen faced, standing up very straight in my blue uniform.

I forgot this – or blocked it out – and went about my childhood in the old way. But it was too late. I had been polluted by the information and what's more, my body had seriously started to change. The body didn't seem to be going up anymore.

I had the awful feeling that childhood innocence and lack of responsibility were haemorrhaging out of my life irreversibly. I decided the best course of action was to adopt the wild dog policy – ignore it and it'll go away. My best friend's mother was an actress and had earned my undying admiration by whipping off her corset in a play and throwing it at her stage husband, screaming, 'Don't touch me you bastard, your fingers are still wet from another woman.' I wasn't exactly sure what that meant but I knew it was shocking. My friend came back a week later with new intelligence.

'Guess what?'

'Go away. I don't want to know.' I put my hands over my ears.

'No wait. Listen. It's not as bad as we thought. Apparently it can happen in your sleep and you never feel a thing. But also, apparently once you've done it it can become addictive.'

'Thank God,' I gasped with relief. I ignored the addictive part, so unlikely it seemed.

Some rugby jock gave me my first 'passionate' kiss, an experience that reminded me of eating snails from the garden as a toddler. We stood in darkness outside the front door. The trees rustled, as did the blinds the parents peered through.

'Well thanks for bringing me home,' I said, 'normally by this time Mum has got the police looking all over the neighbourhood for me.'

'Aren't you going to invite me in for coffee or something?'

'Are you out of your mind? If I let you in the mother would have you for breakfast.'

Suddenly he planted an open mouth on my lips.

'What are you doing?' I asked, stepping back, wiping my mouth with the back of my hand.

'That's what you're meant to do. You're supposed to put your tongue in my mouth too, I think.'

'Don't be ridiculous.'

He grabbed me and tried again.

'Look, just relax.'

'Relax! There's a snail in my mouth and I should relax?'

In 1964, to get pregnant was to have your life ruined. Shop soiled, second-hand goods. Your entire extended family was brought into disrepute, you yourself would probably go to hell or worse, but far more serious than any of these, YOU COULD KISS GOODBYE TO EVER GETTING A HUSBAND. By the time we got around to having sex for the first time, our bodies went into spasm and shook from the deep psychic trauma. That was the first reaction. The second reaction was, Is that it? That non-event is what I have been saving myself for? The third, delayed reaction after a bit of practice was, Ooooo this is delicious. Needless to say, the concept of the orgasm was unheard of. Nobody talked about it; nobody knew it existed. We found out from the sealed section of a women's magazine. I'm sure some women knew about orgasms but we thought we had invented them. However, unlike many other girls, we did know what we looked like inside thanks to biology class. We knew what a cervix was, but the clitoris was left off the diagrams.

I went straight from the arms of nuns to the arms of nursing school matrons. When it was time for birth control in my late teens, I took myself off to the doctor (not the family doctor, obviously), explained that I wished to be disencumbered of my

pregnancy liability, and asked what he could do about it. Doctors didn't talk about sex, emotional problems or thick ankles in those days. Neither did anybody else. You didn't confide in your parents, there were no psychologists, psychiatrists were only used for psychopaths and schizophrenics, and priests were hopeless because they just gave you more and more Hail Marys to say. The doctor was horrified by my request and told me the pill was for married women who had already proved their fertility to the state, not wanton eighteen-year-olds. So I invented the myth of an irregular, harrowing period. To another, younger doctor I recounted my menstrual trials. He prescribed a new hormone drug to control matters – the pill.

The whole business had started to irritate me anyway. Boys didn't have to go through this. They didn't have to be examined by total strangers, they didn't have to fear pregnancy or muck around taking pills, they didn't have to behave like a lady. I had always wanted to be a boy, realising quite early on how many more advantages boys had intellectually, socially and physically. It was expected that they should think for themselves, be assertive and take what was their due. It was nothing flagrant but they seemed freer, less burdened than girls. In the get-a-life department, being a boy would definitely have made things easier.

LOVE & SEX IN FOREIGN LANDS

Being a registered nurse made me an expert in everything so when I moved to Canada I got a job as a drug and alcohol counsellor with a youth program. Noticing a huge hole in the

market I decided to initiate sex education classes.

'Who wants to know more about sex?' I asked the clients, as they were respectfully called. Everyone was lying or loitering all over my office, in a united dance of teenage ennui.

'We know it all,' the boys said grinning.

'In your dreams,' the girls said pityingly.

'I bet you don't know a thing about basic anatomy, the reproductive system or relationship management,' I said. They put their stupid faces on.

The teenage delinquent world is very macho and I knew no adult had ever suggested the concept of responsibility, choice or indeed that there was a difference between love and sex. I was treading on slippery ground here as I wasn't actually sure about the difference between love and sex myself, but I went on the principle that if I gave them the party line I too might learn something.

'Go and get me lots of those big sheets of paper next door and lay them on the floor,' I said, grabbing crayons. We all lay on the floor.

'Okay now write down every word you know for sex.'

Screaming, yelling and laughing for fifteen minutes. This experiment resulted in an 80 per cent increase in my sex vocabulary.

'Turn the papers over and write down every word you can think of for vagina and penis.' Industrious silence.

'Eew, gross,' shouted the girls when they saw what the boys had written. 'The words we wrote for penis are much nicer.'

I realised they were educating me rather than the other way round. The boys and girls were genuinely fascinated by the

ins and outs, so to speak, of the reproductive system and the hydraulics of sexual intercourse.

'What the hell's that?'

'A uterus.'

'A what?'

They gasped when I told them about the clitoris and that women could basically have orgasms indefinitely, the only thing stopping them being exhaustion. Men on the other hand were to be pitied as they could only have one or two usually, then die. This was 1976.

Another book that every person in the world seemed to be reading that year was *Fear of Flying*. Many people think Erica Jong invented sex. She wrote about all the terrible, outrageous things women said to each other about sex, men and relationships in a way no one else had before. She told all the sordid secrets, fears and truths about women's lives in a hilarious, ribald way with no concerns about political correctness. Like Germaine Greer, she behaved as a man and told the whole world about it. It was the sort of book that made you scream aloud while you were reading it.

I admired Erica Jong and eventually met her at a reading she was giving to promote her book. I had to see what she looked like. I had to see what a woman who had screwed everyone except the doorman looked like. At the reading, I saw a rather academic, slightly plump woman, indifferently dressed, with large shaded glasses that hid her eyes and a hairdo that hid her face. She had none of the sex appeal, wit or charisma I was looking for. She signed my copy of her book 'Keep travelling fearlessly – Erica'. Two days later, I saw her interviewed by a respected

male journalist on television. Complete transformation. The glasses were absent, the hair was off the face, slick make-up helped create a stunning smile, and she was actually flirting with this serious man who was visibly beside himself with the titivation of it. I couldn't believe my eyes, but it sure answered my question about the doorman.

Then I became a chef in Paris. Restaurant kitchens are famous for being hotbeds of sexual banter and my years as a chef equipped me for just about any subject of discussion that came up. I learned a lot about how French men see women and formed my own theory on the myth of the Latin lover. We discussed lust as a stress factor, love from the neck up, virility versus good looks, lust as a battle, the connection between lust and a challenge, charisma versus beauty. French men moved in a zone of sexual confidence other men could only hope for, and so did French women.

There could never be a sex survey in an Anglo-Saxon country because there is no sex, but studies in Europe show that men think about sex at least once a day. They're lying. All men think about sex thousands of times a day. The surveys say that women think about sex 20 per cent of the time. What women? It's all we talk about. Another interesting piece of information studies have thrown light on is that everybody is getting more sex than you are, including the dog next door. This explains why men always think that a woman is incredibly sexually active – people just can't believe everybody else's sex life is as boring as their own. This is why I don't believe surveys. But get this – research has shown that the most sexually active people on the planet are Eskimos. They make love about a dozen times a week –

that's more than once a day! And there was a woman in America who could have 130 orgasms an hour. When do these people find time to cook and clean is what I want to know? There's the story of semi-naked black male stripper in London who tried to leap over a woman in a nightclub but landed on her head mid vault. Ever since, because of her injuries, she's been unable to dress herself and is now suing the gentleman. Excuse me if I'm missing something here, but London is full of graceful, beautifully spoken black men and if one landed on me and I was unable to dress myself, I'd go on a pilgrimage to Lourdes in thanks.

Scarlett

Scarlett usually greets you with a 'Hello darling' and a huge, luscious smile. My favourite vision of her is standing in the kitchen surrounded by family and friends, cooking delicious things, drinking wine with everyone yelling and screaming, trying to tell the most outrageous story. Scarlett is a voluptuous, highly educated professional and she's very funny. She lives with her partner and children. I asked her to talk about the sex she's had and the sex she wants to have.

'Becoming a sexually active teenager in the late seventies and early eighties meant I assumed a number of things. Firstly, we were only concerned with not getting pregnant, so we all took the pill like fluoride tablets or cod-liver oil. Sometimes condoms were mentioned but I do not ever remember having sex with a condom until I

was at least thirty! I preach condom use now, of course. It wasn't, however, until I was nearly twenty that I could manage my sexual encounters with some knowledge and power. We all shagged like rabbits in our early teens and it wasn't unusual to have two different lovers a week, but these weren't particularly satisfying encounters and living in a small town made it awkward at times.'

'Why *did* we have so much unsatisfying sex?'

'My first realish boyfriend was an opiate addict and rarely got it up. I was so naïve that I didn't even know he was a junkie until I arrived home to find a heap of marijuana on the kitchen floor – that was the end of him. This experience was very deflating and my self-esteem plummeted – I had envisioned romantic picnics at the lake and sex that would approximate a train crash. The lure of romance and passion kept my hopes of having good sex alive. I discovered you had to make yourself feel sexy and be sexy in order for men to rise to the occasion. Most men just don't have a clue about passion or making women feel sexy – they just want to fuck, especially when they are teenagers.'

'What makes a good lover?'

'This has changed over the years. In my twenties I just wanted passion and romance, not even a relationship. I had one lover who lived in a large house in a beautiful suburb and we met weekly. We would go out for dinner, talk, drink lots of wine, walk, and then shag all night. The excitement of satisfying each other to the point of orgasm and then desisting was a pleasurable game. There wasn't any

inhibition, we knew we weren't going to have a relationship, but we liked each other's minds enough to physically enjoy each other as well. These meetings gave me a sense of pure pleasure, the sex was great and we fully embraced it without thinking about any future domesticity.'

'Is it important to orgasm?'

'Yes, with and without your partner. There's nothing like a good masturbate! Flick through the images of gone lovers. Women who have learnt the art of masturbation younger are more likely to be in charge of their sex lives. The joy of a good vibrator was something I discovered early. Of course you don't have to be hopelessly in love with anyone to have good sex – it can be just fun. Finding that fun is up to you – it's about your own levels of satisfaction and what you want. There are a number of men out there who can fulfill this. There is a certain amount of energy and intent required to find sex that is suited to you at different times in your life. I think we all go through phases of pursuing this. Access to it now seems easier with texting and internet – I missed internet dating by a few years. Internet dating seems more purposeful and honest (and cheaper) than going to a bar and drinking copious amounts of wine in the hope of finding the perfect fuck.

Actually, drinking in bars has led me into some difficult situations – I'm still getting the cum stains out of my favourite leather jacket!'

'How does your mother's attitude to sex differ from yours?'

'My mother doesn't have sex and rarely did in her marriage. She has a weird mind-set about sex, doesn't want to engage sexually, sees it as a chore and hasn't moved beyond this, which I think is sad. I am sure my own daughter is going to have her share of dreadful sexual experiences until she finds what she likes. She still thinks I don't have sex!'

'Where is sex at these days?'

'What sex? Of course I don't have sex any more! I am a mother, I am too tired, I am too lazy and there are always too many people in the house for any privacy. After having children there is a need to work on your sex life and find ways to enjoy each other again. Men continue to get it up but women undergo huge changes. Firstly, there is the childbirth – I am sure my vagina will never look the same again. There are the months of no sleep, demands of breast-feeding and looking after the house. Why on earth would you want to have sex with these demands being placed on you? Nobody tells you about the months of dry vagina syndrome, hormone fluctuation and sheer hatred you feel towards your somewhat unchanged partner. One's attitude towards sex and the frequency and quality changes over one's life. I do live in hope that sex in my forties and fifties will be fabulous and incredibly enjoyable. Even though I am in a relationship with someone I love I very much hope he isn't the only person I fuck for the rest of my life!'

KISSING

The most well-known people to kiss were Romeo and Juliet in 1595, Act 1 Scene 5. If a man's a good kisser and a committed kisser, he's really exchanging the breath of life in the purist, most intimate sense. It is a mingling of souls like the mingling of streams in mythology. To leave this life with your inamorata's kiss on your mouth would be a great gift. How many people have died while in the transports of love – the heart literally stopping in ecstasy? When a woman makes love with a man he is not only every man she has ever known, his kiss holds all the kisses he has ever received and takes from her every kiss she has given, joining them in a ritual love loop. Why do we love kissing so much and why is it such an intimate thing to do? Prostitutes don't do it but lovers do. Of the goddess Ishtar it was said: 'In lips she is sweet; life is in her mouth.' I think it's the kissing that joins the souls, not the fucking, although that does come a close second. A man who loves kissing is a man with generosity, warmth of spirit and a real love of women. A man who loves kissing loves his mother, and if he loves his mother, he'll be a good partner.

THE PSYCHOSIS OF LOVE

We now know that sexual attraction and falling in love are a type of illness – a psychosis, if you like. When a woman meets a man who makes her earth tremble, her front brain tells her to stand back from the commitment-phobic, good-looking, devil-man. However, her middle brain throws black dust over the front brain and says, 'His voice is like velvet, his legs are

long, his eyes are drilling holes into me and I will knee-cap any woman who touches him.' So why does she sometimes go for Mr Wrong when she knows perfectly well what Mr Right looks like? The neural systems and biology of reward that underpin the mysteries of sexual attraction and love have been studied. English scientists gathered together a bunch of lovesick phase one-ers (there are three phases to relationships – phase one being the one where you are blind, deaf and you stop eating) and slid them into an MRI machine. The scans showed that the brains of people in love look the same as those of people addicted to drugs or alcohol. The brain, in effect, makes you think that your beloved is the endless source of pleasure. This trick is necessary for evolution. If the brain didn't trick you into thinking this man was heaven on a stick, you wouldn't mate with him.

Anyone can mate – it's the most primitive system in the brain – even cold-blooded reptiles know they have to reproduce. Humans are more complicated because on top of chemistry there is also personal history, age, your parents, friends, school, television, timing and mystery. But really, the most powerful thing is the arsenal of brain chemicals that concoct the wild magic between two people who can't stop thinking about each other, who spend hours looking into each other's eyes, and who think all faults are adorable. Of all the millions of people in the world, this love drug convinces us that the man or woman in front of us is the only one, the true mate for which we will forsake all others, the ultimate life prize. In my interviews, men told me the reason they bed hop is because they are looking for the prize mate. Strangely enough, this continues to happen even when mating is off the cards.

The secret to seeing another person as a stable, tender mate rather than as a one night stand lies in the passionate limbic system – a part of the brain between the neocortex (the seat of reason and intellect) and the reptilian brain (the house of primitive instinct). The limbic system floods our bodies with heavenly dopamine, norepinephrine and serotonin – we are almost powerless to resist their arousing effect. These wicked, addictive drugs stop us from sleeping and eating, make us euphoric and encourage us to take exceptional risks for the love object. This is the point where you wouldn't notice if they had two heads. The areas of the brain controlling craving, reward, recklessness, obsession and habit all collude in the mischief. If this didn't happen, no one would get together or stay together, which makes me wonder how arranged marriages work.

HOW TO HAVE GOOD SEX

1. Be in love.
2. The less you obsess about orgasms the better. The point is to relax and enjoy yourself. It's much easier to have an orgasm on your own than with a partner. That's life. Sex is very pleasurable without orgasms and having or not having them is not an indication of either good sex or true love. However, once you do start having orgasms with your partner, you'll do it all the time.
3. Don't do anything you don't want to do and do everything you do want to do.
4. If your partner is not making you happy then show him how to.

5. Never ask the dumbest question in the world – was that good for you? If you are nice to your partner, are happy and like him, of course it was good for him. Are you blind?
6. Unless you're seventeen and he is too, never ask, 'Is that it?'
7. All women are beautiful when they are having sex so don't worry about your naked body – men are MUCH less judgemental than you are.
8. Don't ask yourself whether you are liberated or just an easy lay – enjoy it.
9. This is not the time to multi-task. Reading a book while having sex conveys mixed messages.
10. Use a condom.

FAKING IT

You know that saying – women fake orgasms but men fake whole relationships? Well wouldn't you know it, men, who are always copying us, now want to jump on the bandwagon and fake orgasms. Do they have to follow everything we do? We are the fakers and we're very good at it according to men, so leave us alone and think up something of your own. Sex shops are full of all sorts of terrifying tools to help women orgasm because men are supposed to be such hopeless, clueless orgasm bunglers. According to sex shop Ann Summers, 80 per cent of women fail to experience seismic sex (unless, of course, they buy a sex toy). The cruel truth is it is very difficult to achieve an orgasm during sex with a man. When you know someone really well, there's no need to fake – faking is for stage one in a relationship,

when you haven't yet taught the man what to do. Now the boys are saying, how do you know when we've had an orgasm? Why is so much attention paid to women? With a woman, there is no way in a million years of telling, but if a man ejaculates one assumes he has orgasmed.

POST-FEMINIST SEX

Girls today say 'We have brains *and* bodies and it's acceptable to use both.' The way you choose to use them and in what proportion determines where you will end up. Girls now are very switched on and open-minded about using what they have to get what they want. They have more information and maturity than women in generations before theirs, mainly because of the media, which is obsessed with teenagers.

Some people are worried, like Carol Platt Liebau, the woman who wrote *Prude: How the Sex-Obsessed Culture Damages Girls*. Liebau thinks our present culture values looks over intellect and talent. Originally, it looked like sexual emancipation, but media and marketing have skewed it so it looks like girls are unable to separate their self-worth from their sexual power. They are in control, but of what? Girls compete for attention on the basis of how far they will go with boys. Using their sexual power is the fast lane to success. When I was a teenager, girls had sex for attention and love. What girls now say is that beauty and sex appeal may not count forever, but it definitely counts at their age. Teenagers have always been like this, but now they don't apologise for it. Feminism liberated us sexually and we took full advantage of that liberation. This is what the girls have inherited.

SEX & LOVE FOR THE SEASONED WOMAN

Lust is transient. Most normal people and houseplants know this, but some people are slow learners. Women complain that after the age of fifty they become invisible – they are no longer sexual beings in the eyes of men. I am happy to report I have only become partially invisible. In a good light, I am sometimes seen and flirted with, especially by people who know they can't have me – married men, infatuated younger men, gay women and wine makers (don't ask). Sex is like playing bridge. If you don't have a good partner, you'd better have a good hand. When talking about older women lovers, the French (who understand everything about love) say, 'Les meillieurs daubes sont faites dans des plus anciennes marmites' – 'The best stews are cooked in the oldest pots'. I always reply 'Yes, but it is essential to have a young carrot.' The secret of a good stew is in the carrots, which, like life, are sweeter in autumn.

When I was young and pretty with smooth skin and thick black hair, I could never get the man I really wanted – handsome, charming and interested. Most of the time I fell for skinny intellectuals who were cool and I was grateful they even bothered. As I got older, the type of gorgeous men who wouldn't look at me in my youth, were naturally, willingly and enthusiastically attracted to me. I wondered what was going on – for five minutes. Women who stare a gift horse in the mouth have obviously had too many gifts. A woman who has an affair with a younger man immediately starts worrying: What about my pores? What about my lumps? What about the earthquake cleverly disguised as my face? And he says, 'I love everything about your well-seasoned body.' Go figure. When I

asked younger men what they found attractive in older women, I expected them to say personality, financial independence, self-assurance, less expectations, interesting, blah blah blah. But what many of them said was sex appeal, the very thing we feel we are losing! They say older women are better in bed, have fewer inhibitions, are more experienced, and look gorgeous to them.

When women hit middle age and so do their lovers they sometimes discover sexual problems in men. Of course when a man can't get it up, you are very nice and understanding about it but inside you are saying 'FOR GOD'S SAKE! This is all we ask of you and you can't even do that.' I know this is cruel and by admitting it I will never get laid again, but I guess I can always continue to pick on foreigners and younger men. Many people feel Viagra-type drugs are the answer and maybe they are, but I'm not so sure.

A really depressing thing for women is when sex has been regular and it stops. Something happens – partner leaves you, dies, gets ill, loses interest. Or you leave, get ill or lose interest. You have taken sex for granted, assumed you will always have it, always be interested; so when it ends you miss it more than is reasonable, simply because you can't have it. Everyone knows that something you can't have is more desirable. Unfortunately, sexual desire doesn't go away with age, but it does slow down. You are no longer as driven by oestrogen as you were. You can live without sex, especially if your life is full in other areas, but as soon as you meet someone who makes your knees tremble, that oestrogen comes flooding back in joyous waves.

Finding love and sex as you get older is not that much different from when you are younger. It's basically a numbers

game – the more people you meet, the more you are likely to meet someone special. If you never go out, then obviously the chances of the mailman being the one are relatively slim. I have friends who make no effort whatsoever and friends who use dating agencies, go online and socialise a lot. From what I can see, neither system has advantages over the other. It still, to a large extent, comes down to old-fashioned electricity and chance. Rumi said that lovers don't finally meet somewhere; they're in each other all along.

> **WISDOM GAINED**
> - You don't need to have sex to get pregnant – look at the Virgin Mary.
> - We now know sex exists; we just don't have a handle on the fact that it usually involves another person and that person has to be consenting.
> - Lovers don't finally meet somewhere; they're in each other all along.

9
HAPPINESS: HOW TO TELL WHETHER YOU'RE HAPPY OR JUST EASY TO PLEASE

I wept because I had no shoes until I met a man who had no feet. As nauseating as this saying from my mother's book of sanctimonious parables is, most experts agree that happiness is relative. In a way, it doesn't exist – it is only the result of something else.

It is said the recipe for happiness is good health and a bad memory. Happiness is about having people like and admire you, treating others as you would wish to be treated yourself, contributing to society for no other reason than you just want to, and feeling you belong. Happy people lead meaningful lives with purpose. They have good relationships and look beyond the superficial for deep satisfaction. Research has shown that money and the pursuit of it do not deliver the above states. For some reason I noticed this ages ago and have never been attracted to the making of money, men who have money, and have never

had a fear of future financial insecurity. Happiness always comes from within. Happiness comes from how we behave, not what we have. In her book *What Makes Women Happy*, Fay Weldon says women can only be happy for ten minutes at a time so stop expecting so much of yourself. But those ten minutes are so fantastic they tide us over until the next time.

Develop the faux-inscrutable smile – if you look happy and smile bravely through the tears all the time, people will think you're happy all the time. People think happy people have a secret, but they don't – they're often just naturally reckless and poetic. Happy people live in the present, not in the past, with its blows to pride, unrequited love and parents with bad taste, and not in the future with the knight in shining armour and sudden riches.

Happiness has an ugly sister, depression. The World Health Organization has predicted that by 2020 depression is on track to become the second most widespread disease, after heart disease, in the developed world. But happiness also has pretty twin sisters called exuberance and joy. The things that make women happy are found in the other chapters of this book – health, food, frocks, music, relationships, sex, travel, work and men. To be absolutely truthful, in my conversations with women for this book, men came fairly low down the list – they seem to contribute more to unhappiness than happiness. However, it is fatuous nonsense to say you prefer chocolate to sex, because you'd have to eat mountains of chocolate to get anywhere remotely near an orgasm. Women like sex but they don't seem too fussed with what comes with it. Not everyone thinks happiness is a personal thing. The central thesis in Oliver

James' book *Affluenza* is that happiness and mental wellbeing are public health issues. He says happiness is not a matter of personal performance and effort ('I've achieved it' or 'Why have I failed?') but a product of a set of environmental – social, economic and cultural – circumstances. Our highly unequal, competitive and individualistic culture is producing more and more emotional distress.

ANXIETY

Anxiety is like a wild dog – if you ignore it, it will go away, but not always. Our recent increased wealth has come at the cost of emotional wellbeing – rates of distress among women almost doubled between 1982 and 2000. Women have so much on their plates that they often don't realise they are anxious because it comes and goes; is disguised as insomnia, needless worrying, aches and pains; and they've been anxious since they came out of the womb, looked around and thought, this can't be right, so they kind of feel anxiety is normal. My anxiety manifests itself almost entirely in insomnia, so if anything in my life is out of the ordinary (which is 60 per cent of the time), I immediately stop sleeping. Appointment in the morning: don't sleep. Airline travel: don't sleep. Strange bed: don't sleep. Strange man: don't sleep (that could be for other reasons). Strange hotel: don't sleep . . . and on and on and on. Other women suffering from anxiety don't eat so are always slim, other women eat too much so are always plump, yet others always feel their heart is pressing on their chest.

It can be controlled but I'm not very good at it. When a woman was violently raped in her home, which is near my

house, I became phobic and spent my nights in terror. I could hear people breaking into the house, feel them in my bedroom, smell them on top of me. This was compounded by the fact that in my twenties this actually happened to me twice – I woke up to find a man had climbed in my window and was trying to get into my bed. My psychologist friend Gail Ratcliffe assured me that I couldn't live like this. Her solution to a lot of problems in life is: change what you can change and drop the rest. First, she got me to have a locksmith check all doors and windows then got the local coppers to come and give me advice on how to be safe. Finally, she taught me 'thought stopping'. Here's how it works: bring the bad thought into your mind as forcefully as you can then very loudly shout STOP! Do this three times then try and sleep. Every time the bad thought comes into your head do this exercise three times. It worked after just a few nights.

You can control anxiety, pain (especially muscle pain) and mild depression with relaxation exercises. They mostly consist of tensing and relaxing the muscles one by one, throughout your entire body. When I had my restaurant in Paris, I had relentless back pain and I was weeping three times a day. My brothers in Australia told me to buy a book on relaxation exercises – any book. I bought one in the airport. It said the exercises wouldn't work overnight but they would work. I lay down on the restaurant floor under the tables between shifts and did them. They worked almost instantly. If delivery people turned up, I would sign the invoices from the floor.

In my mother's day, when a woman got depressed, she just went to bed for a week and refused to get up. She said she had the flu and the husband and children carried on making dinners

and looking after themselves until she got up again and carried on as if nothing had happened. Doctors gave out really strong Valium as if they were lollies – so strong you couldn't drive, could barely dress yourself, and just sat smiling idiotically all the time. I think, unless you are clinically depressed, it is normal to feel down from time to time – just be patient. Go to bed with hot cocoa and let it pass. You'll soon feel better.

LONELINESS

Loneliness knows no age barrier. Most teenagers believe they are aliens, different or just losers. You can be surrounded by brothers and sisters, school, ballet lessons, busyness and still be lonely. I remember feeling that no one understood me, no one was speaking my language and it was going to be like that forever. Loneliness can come from constant travel, a job where you work alone, having a horrible personality, being so fabulous that you have scared off any man who has come within wine drinking distance, divorce or false pride. Is all pride false maybe? You can have the best job, the chicest clothes, good health and good looks, but if you don't have friends, people to talk to, workmates, family to love, you sink rather quickly and lose an idea of who you are. This is why it's so important to look after your friends, lovers and family because, like plants, they will die if not nurtured and so will you. You don't have to be lonely – in my opinion it's your fault if you are because it means your behaviour is making people not want to choose your company. If you drink too much stop it, if you are boring stop it, if you are argumentative stop it, if you're horrible to your mother stop it.

Stop thinking about yourself and your problems and think how you can contribute to other people's lives. The moment you start giving, people will be drawn to you.

LOW SELF-ESTEEM

These nasty little words are so disagreeable that just looking at them gives me low self-esteem. As we know, all women suffer from this but it's not that simple. We actually spend our lives lurching between having no confidence and being arrogant. People always say a woman who sleeps with a lot of men is desperate for approval and has no sense of self. Women like sex a lot, actually, and it is possible that women who have sex with multiple partners just like sex. Who could possibly say those ball-busting American women lack self-esteem? New Zealanders and Australians are known to be the stroppiest women in the world and French women just achieve, don't make a fuss when their husbands wander, and do a bit of quiet wandering themselves. A terrifying number of women give birth to children who do not issue from their husband and he, incredibly, never knows. Apparently, if some children were tested, fathers would get a huge surprise. Oliver James says our capitalistic attitude to everything we do – the winner-takes-all, competitive mentality thing – generates insecurity and blows up comparisons, turning us into losers with low self-esteem. We compensate by admiring celebrity and status.

WEALTH FATIGUE SYNDROME

Money doesn't make you happy. Hello? Yes it does . . . but only to a point. Happiness studies have repeatedly shown that being marginally better off than your neighbours makes you feel good, but being a hundred times richer makes you feel worse. Either you get rid of all your old friends and support networks and find new rich friends or you live with the envy and resentment of your peers. I personally do not suffer from wealth fatigue syndrome but some people do. It's because they're bored and depressed and are never happy, no matter how much they have. There are many more wealthy people in the world now – half a million American households have assets of more than US$10 million – and they're tripling their wealth every five years. Imagine how monumentally dull and isolating it is to live in a world where estates are traded like cornflake cards? In fact, everything is traded – houses, buildings, boats, planes, businesses, wives – everything is treated like shares. You'd tear your hair out. Whole gardens are delivered to new homes by truck and crane; fabulous art collections fill entire wings overnight, and the owners can't remember who the artists are. Soon they are tired of that look anyway and move it on for something else. They spend millions on refurbishing a house, change their mind and chuck it all into a skip. Erich Fromm, Marxist psychoanalyst and Buddhist, foresaw half a century ago, 'passive, anxious, empty, isolated people for whom life has no meaning who compensate through compulsive consumption.'

It's a drag being the one who has far more money when you're in a restaurant because you're always expected to pay. If your husband or wife becomes much richer than you it creates

imbalance because he/she who holds the purse strings always holds the power, no matter what you say. If a non-working woman is married to a very rich man she has to pay her way somehow and it usually involves acquiescing to sexual demands and being disadvantaged in decision making within the relationship. Effectively, she is unemployed and has the same mental issues as the real unemployed. She could be made redundant, she could have low self-esteem, she could get very sick of filling the void with inane, busy-making activities. The poorer ordinary people get relative to the rich, the more isolated the rich become, then they have to protect themselves from the poor with bodyguards, electric gates and sophisticated alarms. Not only are some super-rich gloomy and insatiable, they're also lonely and anxious because people feel they are unapproachable or too busy. And the children – imagine living with these adults? The only people the kids have relationships with are the staff of the summer camps they are sent to for counselling.

Here's the cure according to the psychologists to the rich – give something back. It's not what you have but what you do that makes you happy. Do genuine, non-publicised charity work, enjoy small pleasures with your family like walking in the park, playing cards, help other people succeed and above all, stop worrying about having bigger and better than everyone else. Let go of it. Share love around.

Gail

Dr Gail Ratcliffe is a psychologist who specialises in depression and anxiety. Her patients come to her with

existential problems, work, relationship and family issues. She always looks stylish and calm. Many people have told me she quietly saved their lives with her practical positive advice.

Gail gave me the list for the chemical basis of happiness.

'Whether you are happy or not is a biochemical matter. Your brain has the ability to produce thousands of different chemicals. Some of these make you feel positive, some of them make you feel negative. Whether you are happy or not depends upon the balance of these chemicals in your bloodstream as it goes through your brain at any particular time. If you have more of the positive-making chemicals, you are calm, confident and happy. If you have more of the negative ones, you are stressed or depressed or feel some other strong negative emotion. Your thoughts can determine which of these chemicals your brain releases. If you react to life's uncertainties, setbacks and disasters by dwelling on them, your brain floods your body with the negative chemicals. If you are able to be more philosophical about these events, it doesn't.

'Besides being philosophical, there are some other things you can do that will increase the release of positive chemicals from your brain. These include spending time in the sunlight, laughing a lot, exercising, doing yoga, having massages, eating, singing and playing music, and having sex. Also, being in love is a very strong producer of positive chemicals; it releases five different chemicals, some of which are the same as you experience when

taking cocaine or speed. And recent research has found that just thinking about the things you enjoy will also release positive chemicals into your system.'

'What is a happy person like?'

'A happy person is an optimist, someone who sees the half-full glass rather than the half-empty, someone who is not plagued by indecision but makes good choices, is action oriented, solves their problems and doesn't anguish over mistakes but moves on from them and is confident.'

'Why do some people seem to enjoy being miserable?'

'I don't think that they necessarily enjoy it, unless of course they get a lot of attention for being miserable and negative. In my experience it's more common that people either don't know how to stop being miserable or they don't see the consequences of continuing to be negative and unhappy. These consequences are that you drive people away, you're not fun to be around, you don't make the best decisions, and you are more likely to develop a vast number of diseases and disorders ranging from dandruff to death. You also lose your self-confidence, your creativity, the sense that you're in control of your life. You never reach your full potential if you're an unhappy person.'

'How do you become happy? Do you agree with the saying "Act as if and you will become"?'

'Yes, acting happy is certainly one way to be happier, because it means that people will treat you in a more positive way. They won't avoid you or handle you with kid gloves and you're more likely to do well at that job

interview or treat your employees in a way that will make them happy to work for you. But it's also easier to be happy if you're doing plenty of things on the list of activities that release positive chemicals, particularly if you exercise regularly, because exercise, as well as releasing positive chemicals, also gets rid of the chemicals that make you feel miserable – the stress chemicals.

'You also need to solve the problems in your life that can be solved, rather than sitting on your hands and being a passive victim of bad circumstances. And one of the most important ways to be happy is to be in the moment as much as you can and to appreciate what you have. If you spend your life eternally regretting yesterday and fearing tomorrow you never really have a life, or the one that you do have is unhappy. Most of what happens in any given day is actually not negative – it's neutral or positive to varying degrees. However if you search out and dwell on the things that are negative, you poison your ability to be happy.'

'Why do some people not recover from adversity? Do you feel that people attract negativity?'

'I think the reason some people don't recover from adversity is because of a tendency to dwell on it and to become bound up in their negative view, not only about what's happened but about everything else in their lives. Such bitterness prevents you from going forward. I don't really believe that people attract negativity. Bad things do happen to us. It's one of the few things you can guarantee in life – that bad things will occur. How you react to these

depends upon your ability to be happy.'

'Some people say they were happiest in their thirties: sex was reliably good, they were strong and they felt in control of their lives. Is that what you find?'

'I do find that we may feel happier at different stages in our life but that too is relative. Some people will tell you it's when they were teenagers; others when they retired; but what is universal is that it was a time when they felt that everything was under their control and going the way that it should.'

WHY HAPPINESS IS GOOD FOR YOUR HEALTH

Psychologists say you may be born with a felicitous gene, a positive nature, and if you're not, you can learn how to be sunny. I'm very glad to hear that, because I can only buy so many dresses and so many books before I have to start looking inward. Why are people in Indian slums not depressed? How did people in concentration camps crack jokes? How is it that the man whose three beautiful daughters were murdered is serene and positive? Unhappiness makes you sick by weakening your immune system. The Victorians said if you are happy, you will be good, and if you are good, you will be happy. When people see someone being kind or are being selflessly kind themselves, their disease-fighting antibodies increase. In an experiment conducted by Howard Cutler (who wrote *The Art of Happiness* with the Dalai Lama), people were chosen one day a week to perform five random acts of kindness – anything from opening a door for a stranger to secretly putting money in an

expired parking meter. After five weeks, the people doing this had a marked increase in personal happiness. No wonder – they didn't have to open all those doors anymore. Happiness lowers the risk of infection, including flu, reduces blood pressure and extends lifespan. Happy people have lower heart rates than unhappy people. Research shows that the more optimistic a woman is, the less artery disease she has.

Happiness is in the small, blissful moments of serendipity but you have to be tuned in enough to recognise them when they occur – a perfect simple meal on a beautiful day, lovemaking which periodically transcends the normal, the touch of a baby, music... Why is it some people are crushed by events that others recover from quickly? Happiness comes not in the content of our lives, but the context in which we hold it. Everything is a matter of attitude but you do have to teach yourself to quickly get back into the land of joy and wisdom after hardships, disappointments and betrayals and not suffer the long-term side effects of bitterness, sarcasm and holding on to pain. In a recent survey of teenagers in Australia, it was discovered their overwhelming worry was not drugs, alcohol, sexual disease, alienation, suicide, homelessness or the state of the world, but how they looked. Everyone fell over with astonishment. Why? Have they forgotten what it's like to be fifteen when you are a pimple factory, are insane with hormone imbalance, have thick ankles and can only communicate by grunting? How can you compare that with world peace? What is sick is if you are fifty-five and still think appearance is more important than a rich inner life.

There are surprising things that make you happy which you would never know about if you didn't try doing them – singing

with others in harmony, cooking slowly instead of seeing it as a chore, dancing, exercise (this is hearsay), meditation, altruism, Buddhism. Meditation or some sort of contemplation every day, greatly increases our ability to have positive responses to events rather than just helplessly reacting. The thing is, most normal people teach themselves to be happy when they are children which is when you really know the meaning of unmitigated misery – brothers and sisters trying to steal your mother off you, horrible shoes, endless vegetables, fainting in Mass and the general unfairness of it all.

ROLE MODELS

Aspiring to be stupid like Paris Hilton is not what is called effective or appropriate role modelling. I'm in two minds over singer Amy Winehouse, who is now top of the list for teenagers. Although she's a junkie, anorexic and has marriage problems, her R&B/jazz/soul mix of music is fantastic, she writes her own songs and I like her fuck-you attitude. She has brains, ability and is multi-multi-award winning. I recently watched, once again, *Some Like It Hot* and I marvelled at the incandescent charisma and sensuality of Marilyn Monroe. There she was, shimmering in that transparent dress with no bra, singing, or should I say gasping, 'I Wanna Be Loved By You'. Squirming all over Tony Curtis on the couch while he passively says, 'No, I don't feel anything yet.' My God – the screen practically melted. By today's standards of pulchritude, Monroe was positively plump and round – the closest I can think of these days is Scarlett Johansson. It's interesting to me that men have now

been trained to find thin, flat, hard muscled women sexy when it is actually anti-evolutionary – they look like boys. No, I won't go there...

In the past, we admired high-achieving women who had both style and substance, like Jane Austin, George Sand, Audrey Hepburn, Simone de Beauvoir, Jacqueline Kennedy, Susan Sontag, Coco Chanel and Germaine Greer. These women were beautiful, cultivated, intelligent, sexy and fun; they contributed to the human race, were philanthropic and influential. We should look up to role models who are worth looking up to, women who have insides as well as outsides, not sociopaths and airheads like Britney Spears and Victoria Beckham. Stupidity has somehow been glamorised. A role model is someone who is good, deep, honourable and even heroic. 'Sporting heroes' are not heroes – they are just people who are agile and work very hard at one thing. Cultivating an image is not the same as being cultivated; faking depth is different from insight and understanding; going to university bashes doesn't give you an education.

We are very attracted to instant fame and the idea of miraculous and spectacular transformation. We love it when someone with no ability is chosen out of an ordinary life to become something astounding – it is a fairytale and the ultimate fairytale these days is fame. This is why television shows like *Idol* and *Lose 10 Kilos in 10 Minutes* appeal to us – the impossible can happen and it can happen to the girl next door. Maybe to you too. Role models used to be aspirational – now they're for shallow escapism. We now seem to think that we all have the right to be famous but of course, we can't be and anyway we don't really want to be Jessica Simpson, we just want the vicarious thrill. These

flawed role models make us feel better about ourselves when we see them get fat, get dumped and get crushed under the wheels of the wagon once again. We actually hate it when they don't age like we do and get their pre-baby bodies back in five minutes, but we are prepared to go into debt to look like them. We admire people who are actors or television presenters more than lawyers, brain surgeons and politicians mainly, I think, because they are more visible. I don't think anyone goes up to an accountant in the street, grabs them and says, 'Oh my God, you're Mary the accountant – I SO admire you.' When I was a teenager I didn't know what a designer garment was. Now my friends' daughters dress in designer clothes they find on eBay. When I schlep into their parents' kitchen for a coffee, they know instantly where I bought my dress, shoes and necklace.

When, as a teenager, I met Kiri te Kanawa in my singing school, I absolutely wanted to sing like her, dress like her and wear her perfume. When my friend's mother, who was an actress, threw her corset across the stage and screamed at her stage husband, 'Your fingers smell of another woman, you bastard!', I wanted to be dramatic like her. When I read Margaret Atwood, I knew I wanted to write. I never aspired to be beautiful or wear fabulous shoes – I aspired to eat, cook, be the centre of attention and be cultured. I ended up with quite good shoes. If you want to write well, read, read and read writers you admire. If you want to sing opera, listen, listen and listen to singers you admire. Good role models now might be Kylie Minogue, Nigella Lawson, Helen Clark, Meryl Streep, Sophie Dahl, Hillary Clinton and your own mother.

HAPPINESS: HOW TO TELL WHETHER YOU'RE HAPPY OR JUST EASY TO PLEASE

WISDOM GAINED

- If you're happy all the time you are probably a pain in the neck or crazy.
- You can have therapy for guilt and it goes away. If you're still in therapy after ten years, you should feel guilty. On the other hand, if you're a Catholic or a Jew, you are guilty for life.
- The best things in life are free – happiness is a hot bath, an afternoon siesta, an unexpected passionate embrace.

10
MEN: SO MANY MEN, SO FEW BULLETS

Can't live with them, can't shoot them. If only men knew how easy it is to please women. All we want is a little romance and we'll put up with anything.

It's time to like men again but we are not here to save them. Various do-gooder people who write about the state of men in the noughts suggest we women should now be willing to open up to men's experience of powerlessness and help liberate them as we liberated ourselves. FOR GOD'S SAKE. I am not socially evolved or condescending enough to think it is my role to help men evolve. We dragged ourselves out from under thousands of years of male dominance and now we have to help them. Hello? I find the idea insulting to men. They have to look after themselves and solve their own problems, which they are perfectly capable of doing. If we did it, they can do it.

One of the several thousand differences between men and

women is the multi-tasking thing. When a woman is watching television she watches television, keeps the kids under control, snacks, and either does the ironing or reads reports from work. When a man watches television he is in a trance, he can only watch television. If he falls asleep while in this trance and you turn the set off, he jolts awake and says, 'I was watching that.' And men get worse as they get older, but it's not their fault. It's the corpus callosum. The brain has two hemispheres, which have different functions. Joining the two spheres is the corpus callosum, which is a white band of fibres. It allows us to bring to bear information from both sides to problem solve, achieve things, and do more than one thing at a time. It is a fact that the corpus callosum is 40 per cent smaller in men than it is in women and it gets smaller as men get older. Have you ever wondered why men get more rigid with age (and not where you want it)? Diminishing corpus callosum. One interesting thing about the corpus callosum, though, is that in musicians it is much thicker and healthier, so if you are in the market for an older man who's still firing on all cylinders, choose a musician.

The left-brain carries out analytical, sequential and textual thought – the sort of skills necessary to construct contracts or write computer programs. The right brain deals with big-picture and intuitive thinking, discerning patterns, emotional intelligence. All tasks require both hemispheres but one will dominate. Men tend to have more left-brain ability and women right, which is why we are so fabulous and empathetic but can't read road maps or understand how to make the video work. Because of our strong corpus callosum, women have better 'cross-talk' between the hemispheres.

All my male friends and relatives are perfect and have no problems with their corpus callosums, their attitudes or their sense of self – mainly because they are married or shacked up with my friends and relatives, who have trained them well. The men who are not with my friends or relatives have been chosen for such qualities as a sense of humour, brains and the ability to tell a really good story in less than five minutes. The ones I make eyes at are chosen for superficial and pointless qualities – sex appeal, good looks, their adoration of me. These qualities are guaranteed to keep both them and me happy for ten minutes.

EARLY EXPERIENCES

In my childhood, I socialised with Irish Catholic boys. They weren't like other boys because they somehow had sex appeal – they were rugged and confident and had humour and cheek. Confidence was the quality that attracted me most to a boy. Socials were held at the Irish Club in a seedy area of town. The club was a huge hall almost entirely bereft of decoration, save for enlarged photos of Irish politicians, IRA heroes and saints, green ribbons on the walls, and a stage that had no shortage of performers. Choreographed along the same lines as New Zealand socials, the three important rules of Irish dos were:

1. Boys lined up against one wall, girls against the opposite wall.
2. Complete geological and tactical survey of the dance hall situation including critique of dress, analysis of pimple situation and general testing of the atmosphere.

3. Complete ignoring of any boy who showed a vestige of interest in you.

It is a wonder the race has ever been able to reproduce itself.

But then the fiddles would strike up a reel, suddenly the posturing would cease, and all hell would break loose. The boys let out ear-splitting howls, grabbed the girls around the waist and led them blushing into one of the most charming group dances ever invented – the reel. Let's just say there was a lot of fancy footwork and partner changing involved in a reel, not the least of which was manipulating the situation and your friends to get the partner you wanted more often than your turn allowed. The delicious part was the anticipation of waiting until the boy of your dreams came back to you again. I loved the ritual of these ancient dances, which in their way were very erotic. We stamped, reeled and tapped on the wooden dance floor to a live Irish band, usually composed of a few fiddles, an accordion, a piano, maybe a guitar and sometimes a double base.

The band, the priests and the parents all got roaring drunk and forgot to keep an eye on the children, though that never happened with my parents, who didn't drink much. The boys would be out the back having conversations about the girls.

'She doesn't want to dance with you.'

'She does so. She's begging for it. I swear to God she'd let me kiss her or more if I could only get her on her own.'

'She's not the type. She'd have you for breakfast before you even realised your tie was missing.'

'Jesus, Mary and Joseph, but envy's a terrible thing. Would you ever like to go and take a shit for yourself?'

In fact, the most licentious thing that went on was hand-holding and that was enough to satisfy me, who still didn't know what else was supposed to go on anyway. All I knew was that you never let a boy put his hand anywhere but on your waist. We dressed in pleated skirts, twin sets and wore artificial shamrocks pinned to our cardigans. In regards to carnal activity, the Sisters of Mercy said 'Save it for marriage', so I saved it. I wanted a husband and I didn't want sex.

Emma

Emma is a twenty-one-year-old university student. She is attractive, fun, bright, hard working, well adjusted and popular. She is studying marketing, burns the candle at both ends, and is desperately untidy. She had her first serious relationship when she was sixteen. This love affair lasted for three years and she is currently 'interviewing'. Contrary to all the depressing research results, Emma confirmed what I suspect every time I read surveys about the dire state of men: men are doing just fine.

'These days most parents allow their teenagers to fall in love and start relationships if they want to while still at school. My boyfriend and I were allowed to sleep over at both our parents' homes, nobody made a big deal about it and it seemed like the natural thing to do. We both continued our studies and both graduated. I think this makes for happier, well-adjusted adults in the future. My friends who had very strict, repressive parents, who controlled their every move, have not turned out to be

very good at relationships. When they leave home, either they go mad, sleep with anything that moves and can't form proper attachments, or they get a boyfriend and go all clingy.'

'What do you think girls and boys want in a relationship?'

'Obviously you are attracted to a boy sexually first but then other things quickly become more important, like trust, honesty and a sense of humour. Boys are much more interested in having a girlfriend than the other way round – they need the security, comfort and company. Both sexes are equally possessive but boys probably more so. I have a lot of non-sexual friendships with boys – I find them good company, relaxing and non-judgemental in comparison to girls.'

'What do boys talk to you about?'

'They talk about their lives, study, jobs, problems with girls. They are very open and emotionally intelligent and want to find out how to make girls happy and what they want – sexually, emotionally and physically.'

'When I was your age free love and sleeping with whoever you felt like was considered healthy and normal for both sexes. We had no hang-ups or controls and exploded out of very strict families. Is it still like that?'

'No. Things have pulled back quite a bit from that. We are more conservative and I think fear of sexually transmitted disease keeps the brakes on activity. Also, girls are absolutely terrified of pregnancy, not for moral reasons but for fear of ruining their education and planned futures.

We think girls who got pregnant straight out of school have made a big mistake. They see all these people like Britney Spears and Nicole Ritchie having cute designer babies and think they will be the same.'

'Do you think the parents' relationship affects how young people behave in relationships?'

'Oh yes, very much so. It's pretty predictable – if your parents were nice to each other and got along, that is your first lesson and you think it's normal.'

'Are boys judgemental about girls who enjoy one night stands?'

'No, not really – up to a point though. If a girl is doing this too often, they think she has a problem.'

'What are the sort of issues that make a relationship split up?'

'Mostly a breach of trust. If you can't trust someone, it poisons everything.'

'Do young people still want to get married?'

'Definitely, but later. Girls all plan on working once the children go to school. Not necessarily for the money but because they need that life balance.'

'What shape are boys in? Are they depressed? Are they doing okay? Do they know who they are?'

'Boys are doing great. They are happy, feel secure, are blokey, talk a lot and share feelings. We like them a lot.'

TWO TYPES OF WOMEN

1. The girlie type who always looks unbelievably perfect, with nails and hair and make-up and everything. They are charming, smile easily and have polished social skills. They see men as wealth objects. If I was being uncharitable, I would call them succubuses (female demons fabled to have sex with sleeping men).
2. The liberated type who dress how they like and don't wear much make-up because they figure he's going to find out in the morning anyhow. They are difficult, bolshy and exciting. They see men as sex objects and have no interest in their money at all. I call them Aphrodites (goddess of love, lust, beauty and sexuality).

Occasionally the girlie type genuinely enjoys sex, but mostly she sees it as an exchange against the man's success and money. Occasionally the liberated type marries a man with money by mistake and ends up enjoying it, but is nevertheless thankful she didn't put all her eggs in one bastard.

TWO TYPES OF MEN AND SOME TIPS

1. The tall, dark, handsome types who just want sex.
2. The short, witty, intellectual types who just want sex.

I know, I know, men are like buses – you wait for ages then two come at once. Sometimes three. Here's a message to all those rich guys who can't find love – maybe you're looking at the wrong type of woman. Maybe if you gave up on young, beautiful and

dependent and instead considered a woman who doesn't need or want your money, you would find genuine affection and serendipity. In my survey, many wealthy men told me all they really wanted was to feel genuinely loved. With a hot, high-maintenance Barbie, that ain't gonna happen, no matter what she is telling you. Of course your money blinds her. I'll tell you who you need honey – watch my lips – a woman who likes your type A personality, that secret bit on your neck, and your brain. And trust me, she won't be wearing vaginal deodorant or breast implants.

WHAT MEN WANT

When I tried to get men to talk about the other topics in the questionnaire I sent them they wouldn't have it and kept sliding back to relationships, men, women and sex. They were determined to get to the crux of the matter. They couldn't stop talking about it. They would go to the beach, walk into the house and continue a thought they had two hours ago over lunch. One friend was particularly smitten with the topic. He would walk in and say, 'The thing is, it's an impossible question – too complex – depends on too many things.' And, 'I know – men like women who like them.' The best one came from a guy who ran into the house and said, 'I've got it. What men want and what women have and what makes the whole thing go round is encapsulated in two words. These two words control men's lives: "pussy power". It all boils down to that.'

WHY MEN LIKE BLONDES

The true story about dumb blondes is that they are perfectly intelligent creatures who reduce a man's IQ to around the level of a coat hanger or a gerbil – just the sight of them makes a man want to eat a chair. They even make brunette women lose their marbles and the proof lies in this story: at primary school the queen of everyone was the sweet, beautiful, honey-blonde Vanessa Pratt, who was Grace Kelly in miniature. I, along with the rest of her subjects, was charmed by Vanessa – I carried her school bag for her until I finally got a life. I didn't do well initially in the get-a-life department, but caught up fast. Something had to be done about the fact that I wasn't Vanessa Pratt. I could see that I would never be as pretty, blonde, ladylike and indifferent. I could dye my hair but I couldn't dye my personality, so I decided to improve my personality and stick with the brunette waves. I went on to lead what could be termed an exciting life of adventure and romance despite not being blonde and finally came out of the closet as the redhead I felt I truly was. One day I was in the supermarket and a dowdy, tired-looking housewife came up to me and said, don't you remember me? Thank God it was the baking isle and I was able to faint into the packets of flour.

It's true, men do go ga-ga over something as ridiculous as hair colour. Scientific research has discovered that when men are exposed to images of blondes, their mental agility falls sharply. Not because they are testosterone-poisoned drongoes who can't control themselves, but because their subconscious gallantly lowered itself to mimic the perceived IQ levels of a blonde female. Another study decided that because most white

babies are born fair, we all instinctively view the adult versions as adorable, tiny-minded infants who need protecting for their own good. This theory might be hard to explain to men, so you'll have to talk slowly, the way you normally should to men (when you're not screaming at them). But don't try it while there is a blonde in the room because they only have enough blood supply for one organ to function at a time. All this spurious research is necessarily based on white men who are dumb anyway, but what if you're black? I reckon if you placed a photo of a voluptuous redhead in front of a black man, he would not be answerable for his actions. What probably happens is a man's IQ drops when in the presence of a blonde because he hopes she will drop hers long enough to make the mistake of falling for him.

HOW TO GET A MAN

1. Stand in one place and breathe. If the man is normal and understands his role in the scheme of things, he will find you. Complication: men are genetically hard-wired to protect women, so if you look too independent or unblonde . . . do I need to elaborate?
2. Open a shop – it's like a heaven-sent trap – at least one attractive man will come in every day. I have a friend in France who has met all her boyfriends in the last five years this way.
3. Move to a foreign country – foreign women with cute accents are always desirable to men.
4. Go online but don't believe a thing the man says. Having

said this, people do meet good mates online. What happens is, if they like each other in the flesh, they immediately start telling the truth and like each other even more for it. Most people who use online dating are over thirty-five and the big surge in mate-finding happens in January, with New Year's resolutions: FOR GOD'S SAKE I'M FORTY AND I STILL DON'T HAVE A HUSBAND.

HOW TO FEED A MAN

The expression 'the way to a man's heart is through his stomach', comes from an era when men were seen as financially interesting but culinary incompetents and women as lurking in dark corners waiting to snare a supporter and keep him dependent with cream cakes and strong beer. Man-catching recipes were rampant in women's magazines, something that seems barely believable now. If I told my gorgeous teenage nieces they would keep their boyfriends by cooking them delicious meals, they would fall over laughing at the quaintness of it.

In nineteen-forties' recipe books, the wonderful cooks tell us about meals most men prefer. They are soups (thick – nothing poofy like watercress consommé), a bit of fish (but not much), steak and kidney pie, Irish stew (made properly please), roast meat, mixed grill, tripe and oysters (boy oh boy), rabbit and bacon, brawn, sardines on toast, apple pie and steamed puddings. It was permitted to occasionally give your man a treat if you felt he deserved it. If you were Italian that probably meant sex; if you were English and didn't know what sex was, it probably meant toad in the hole with extra gravy.

In most modern households, the person who likes cooking, cooks. Only very unenlightened men can't cook and it's not thought to be smart or cute. Like swimming, cooking is considered a lifesaving skill. Just floating and shouting 'help' won't cut the mustard. New Zealand women are quite bolshy and if the mothers haven't taught their sons to do obvious things like cook and clean, their wives will. Meals that make men happy now are simple and fresh – roast lamb rack with rosemary, sautéed potatoes and steamed bok choy; bruschetta with acid free tomatoes on top; whole baked snapper with wasabi sauce, mixed greens salad with vinaigrette and a glass of pinot noir; a selection of prosciutto, mozzarella, tapenade, artichokes, stuffed baby peppers and pasta salad from the deli with a glass of chardonnay; raw milk cheese, especially goat or sheep, with quince paste and sourdough; cardamom and orange ice-cream with home made preserves sent up from the country cousins. There is no special treat in New Zealand because most of us aren't Italian. Besides, the food is so good, the idea of special treats has become redundant.

GEORGE

60 Minutes correspondent George Rooney said as he's aged he's begun to value women over forty most of all. He gives a number of reasons for this. A woman over forty will never wake you in the middle of the night and ask, 'What are you thinking?' She doesn't care what you think. If a woman over forty doesn't want to watch the game, she doesn't sit around whining about it. She does something she wants to do and it's usually more interesting.

Rooney reckons women over forty are dignified. They seldom have a screaming match with you at the opera or in the middle of an expensive restaurant. Of course, if you deserve it, they won't hesitate to shoot you if they think they can get away with it. Older women are generous with praise, often undeserved. They know what it's like to be unappreciated. Women get psychic as they age – you never have to confess your sins to a woman over forty. Once you get past a wrinkle or two, a woman over forty is far sexier than her younger counterpart. Older women are forthright and honest. They'll tell you right off that you're a jerk if you are acting like one – you don't ever have to wonder where you stand with her. Rooney says older men praise women over forty for a multitude of reasons but that unfortunately it's not reciprocal and that for every stunning, smart, well-coiffed, hot woman over forty, there is a bald, paunchy relic in yellow pants making a fool of himself with some young waitress. Well here's an update for all those men who say, 'Why buy the cow when you can get the milk for free?' Nowadays 80 per cent of women are against marriage. Why? Because women realise it's not worth buying an entire pig just to get a little sausage.

IN RETROSPECT

Sometimes I regret deeply that I was not more vindictive to the men who betrayed me. I regret all the right arm suit sleeves I didn't cut off, all the Mercs I didn't splatter with paint and all the prawns I didn't put down the back of couches. Here's a message for all the men who thought I was a raving, capricious, maniac – YOU GOT OFF LIGHTLY. That was my heart you ripped out

of my chest while it was still beating, and all you got was a few slammed doors and colourful adjectives. At the time, though, calling someone a pig-dog-male-ego-testicle-imperialist felt great. Wait, there was the time I threw a man's entire wardrobe out the window on to a busy Parisian street below and had to watch the local tramps and hookers wearing his clothes for months afterwards.

Gwendoline

This is a typical Gwendoline look – white jacket held together with ties over black lace camisole, cow skin print pants, cow skin print shoes, cow skin print handbag, red or blonde hair (depending on the month), great make-up. She's a star – no wait – a constellation. I didn't know whether to interview her on fashion, hormones, work, men or sex, but because her first book was on men, I tried to stick to that. Gwendoline is a clinical psychologist who should also be a stand-up comedian. She is the author of two books, a columnist, regular guest on talkback radio, and a social commentator for the local media. I asked her what she thinks women want in a man.

'Women want different things at different times in their lives. All humans are basically looking to have their needs met. Knowing what you want and need hopefully allows for a more refined process of selection and we get to choose the man accordingly. Well that's the theory! Women now have developed their own set of double standards – we have decided we don't want macho, but we don't want

wimpy either. SNAGS (sensitive new age guys) came and went quickly, hints of "weakness" appeared to be the problem. We thought that was what we wanted our men to be, ever supportive, ever listening, and forever sharing feelings. Many writers now address the female requirement of men to be "success objects" with all the power and wealth that comes with that.'

'How are boys and men doing?'

'The sons of left-of-centre baby boomer parents from my observations seem to be becoming the most flexible and best adjusted. However, the sons of the wealthy, leaning-far-to-the-right-of-centre parents appear to be sticking with the old school stereotypes and roles.'

'Have men and women really changed?'

'It's as they say: "You can take the human out of the cave but it'll be a lot longer before the cave comes out of the human." People don't change the way they relate to each other in just a couple of generations – it'll take a lot longer. Nowadays, people are living approximately ten years longer in the developed world. But on saying that, it's not like fifty is the new forty; it's more a case of there being a new fifty. Vibrant and alive, the baby boomers now enjoy the luxury of the empty nest; they're out to play and grow and learn . . . this is the second half, ladies. You've had the oranges, now get on with it!'

'What about the so-called man drought?'

'I'm not quite sure what to think about this one – perhaps it's a myth and a good explanation for your girlfriends for those "unsuccessful encounters"? I've thought about that

new book, *He's Just Not That Into You*. The idea is – he's just not that into you if he's not asking you out. This is may be because he doesn't want to, because from my experience, if a man wants to be with a woman he will find a way. If he's not calling you/only wants you for sex/is unfaithful/whatever – DO THE MATHS. Perhaps he just doesn't like you that much.'

'What makes men happy?'

'You can't generalise – it depends on the individual man. Often a man wants a direct copy of his parents' relationship. I never cease to be quietly entertained when women make decisions about this based on gut feelings. It's like:

Girlfriend with gut feeling: "He must be commitment phobic. I think he's just worried about getting hurt so he's trying to defend himself against falling in love with me. His last girlfriend cheated on him. I wish I could convince him not all women are the same."

Me on the other end of the phone: "How can you be sure? What has he said?"

Girlfriend still with gut feeling: "He hasn't said anything, I just know."

Me: "Yeah, but how do you know if he hasn't said anything?"

Girlfriend with gut: "Look I've told you it's a gut feeling, you just know, the feeling just takes over you, and you know this is the man for you."

Me: "Hmmm, a gut feeling. Tried an antacid? Eno, Mylanta? A tortured gut tends to be less about soul mate

detection than it does gastrointestinal problems."

'So what *does* make men happy?'

'Men do tend, over a long period of time, to want sex more often (after the first six months that is) and women want more romance (definitely after the first six months). I would say that sexual fidelity is very important to both sexes, in our modern world anyway. What women have a hard time understanding is that for men, sex is intimacy, so if you are too tired for them too often, it's not just that you are saying no to sex, they feel you are rejecting them as a man and a person.'

'Is it important for a woman to have a man in her life?'

'It's nice, but I don't believe that to have a satisfying life you "must have" someone in it. The healthiest relationships stem from enjoying, sharing, complementing – inter-dependence not dependence. We complement each other – the combination brings balance. Even if we don't "need" a man, we like having them in our lives.'

'Is your attitude to men different to what your mother's was?'

'Yes. In my mother's day the male was the financial plan. If the marriage was unhappy, you stayed in it because you had no choice, particularly with children involved, no benefits, no support and the disdain of the community at large.'

'What is the most criminal thing you ever did with a man?'

'I colluded with a lover on the non-payment of parking fines.'

'What's the way of the future?'

'My favourite construct would be from Terry Gorsky, who coined the phrase "serial monogamy" – a series of long-term, meaningful relationships, not expected to last forever, but built to share a stage of your life with someone else. Sort of different men for different stages, bit like shoes really.'

WISDOM GAINED

- If you think your best friend or sister is having an affair with your boyfriend, she probably is.
- Men just cannot grasp the nuances of life, the soupçons, the tiny flickers of information that make up the emotional symphony of a woman's life. They can only deal with the broad picture. They can't help it but they could try.
- Don't trust your gut feelings when you meet a man – that churning sensation is probably a badly digested oyster.